COASTAL
HOMES
OF THE WORLD

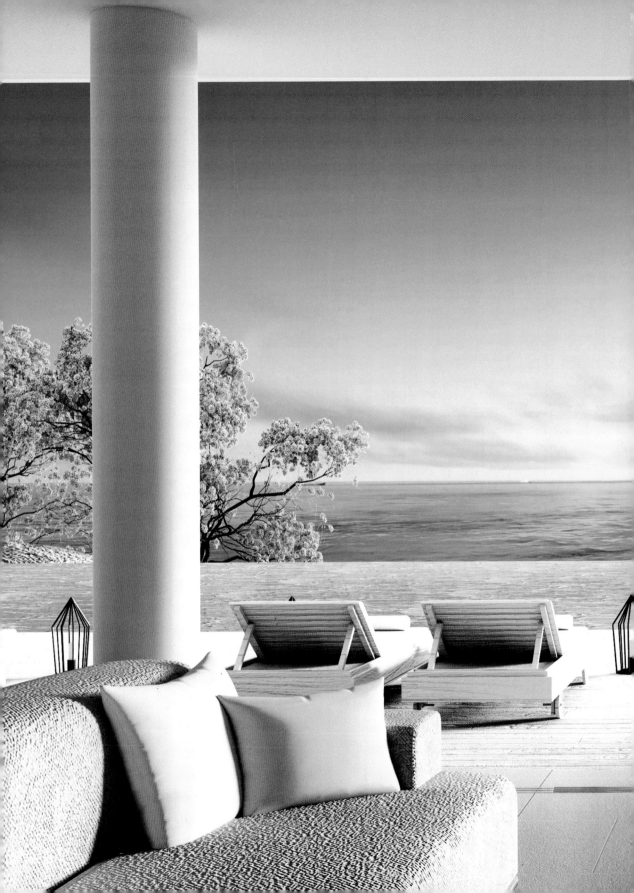

COAST

Monique Butterworth

NH
NEW
HOLLAND

CONTENTS

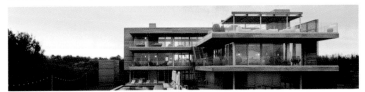
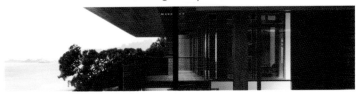
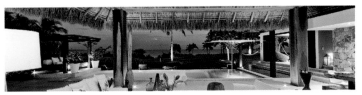
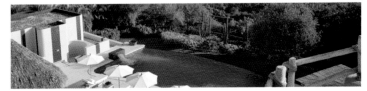
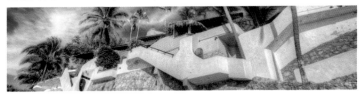
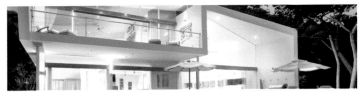

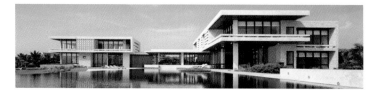

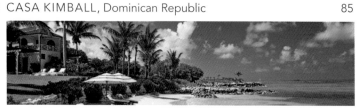

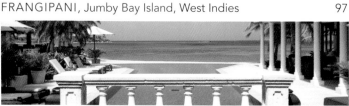

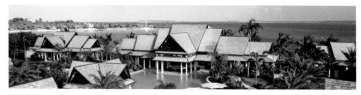

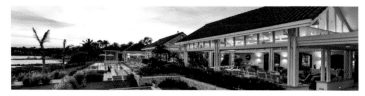

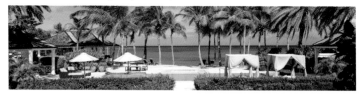

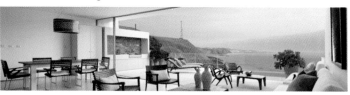

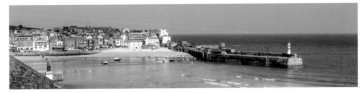

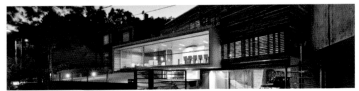

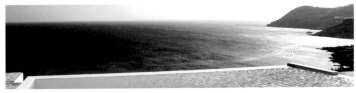

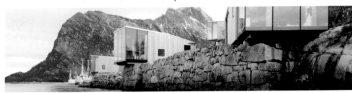

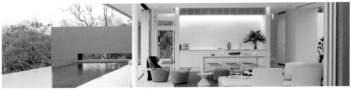

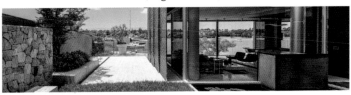

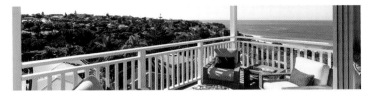

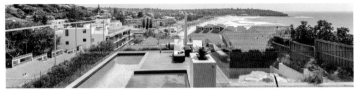

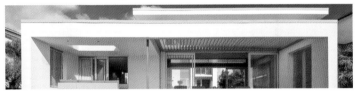

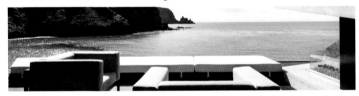

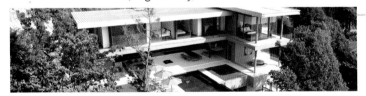

INTRODUCTION

Earth is blessed with five great oceans – the Atlantic, Pacific, Indian, Antarctic and Arctic. Romantically and historically speaking, Earth is also often said to have seven seas. No matter which number you attest to, the surface of planet Earth is seventy one per cent water. That's a vast expanse of coastline to aspire to living by.

We too, on average, are sixty percent water. We are nearly the same mass as water, enabling us to float. Water is very much a part of who we are and since time began, we've been captivated by the sea.

Our ancestors came from the sea evolving to who we are today. We spend the first nine months of life in the liquid surrounds of our mother's uterus.

Many dream of living an idyllic existence by the sea. For more fortunate others it's a wonderful reality.

In fact, approximately eighty percent of the earth's people live within 100 kilometers (sixty two miles) of the coastline of an ocean or other bodies of water.

There's something about the sea that attracts and mesmerizes us.

We're inspired by it, the sound of the ocean and the scent of it in the breeze.

From walking along the shoreline with waves gently lapping our toes to diving headfirst under a wave; fishing in it to surfing or sailing upon it; writing about it; painting or photographing it – the ocean connects with us.

We know intuitively that being by the sea makes us happier, healthier, less stressed and more peaceful.

Studies have shown people living near the sea are happier than their land-locked counterparts.

Little wonder we dream of owning a coastal home to live out our days.

Be it a simple, relaxed beach life or a more glamorous and aspirational verve, the coastal home design aesthetic is perennial in its appeal.

Light, airy, calm and the embodiment of natural beauty, coastal home design goes beyond kitsch seashells and nautical themes.

Showcased in this book is a broad snapshot of seaside living at its very best – a collection of some of the world's most stunning waterfront properties, award-winning architecture, lavish interiors and spectacular views. A selection of innovative and striking coastal projects from around the globe, the variety reflects the countries diverse style, landscape and environment. Whether it's the sound of the surf that you long for, spectacular views over vast oceans or seas, or the sheer luxury of living in a well-designed, elegant seaside home, you'll be drawn to these coastal homes and the lifestyle they embody. Take this collection of homes and be inspired to create your own coastal abode, in your own personal style.

From the more traditional Hampton's style to the contemporary; modern; minimalist; ecological; bohemian; rustic; cottage or bungalow; Mediterranean, Scandinavian, North American, Caribbean or Asian, coastal homes are much more than whites, blues and neutrals. Enjoy.

"The ocean stirs the heart,
inspires the imagination

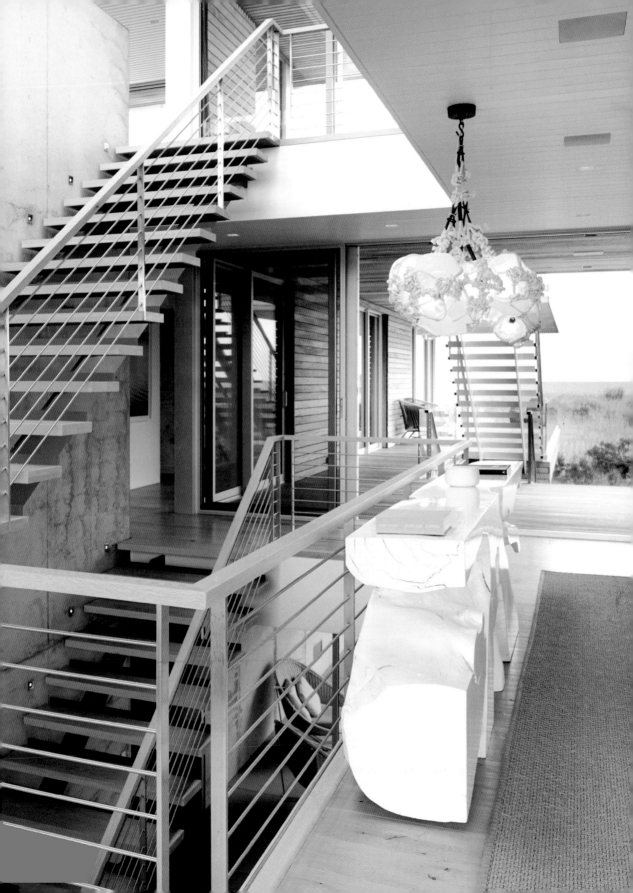

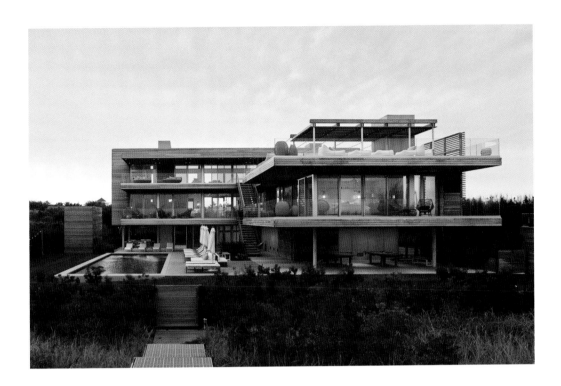

OCEAN DECK HOUSE, Bridgehampton, New York

Ocean Deck House, an exceptional beachfront residence in Bridgehampton, New York, is pure architectural porn for those who love to entertain.

Designed by Stelle Lomont Rouhani Architects for an energetic family who love nothing more than to cook and entertain, the strategy was to capture the sense of indoor-outdoor living with large cantilevered decks, roof decks and an open plan layout.

With 14,714 square feet of living space, the ability to accommodate gatherings on each level was a driving element of the design. Maintaining the integrity of the sand dune, the property was pulled back from it to create three distinct experiences on each level.

OPPOSITE PAGE: The main floor of the ocean front residence is accessed from an exterior cantilevered stair that leads to the central light filled atrium. This main level houses all the bedrooms and a centrally located family room.

ABOVE: As a measure to preserve the integrity of the sand dune, the house is pulled back from it to create three distinct experiences on each level. The home mixes the natural beauty of polished wood with the permanence of concrete, outdoor fireplace and pool.

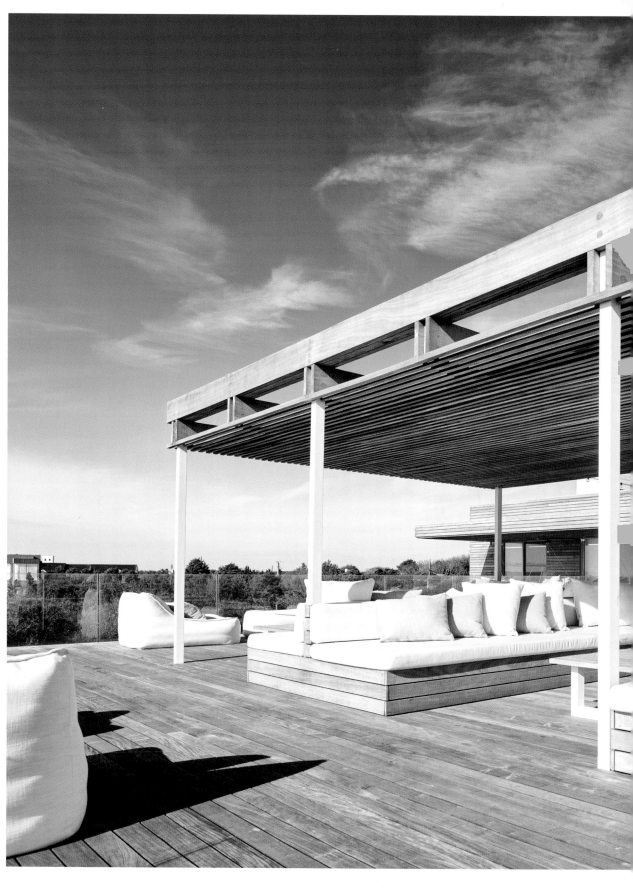

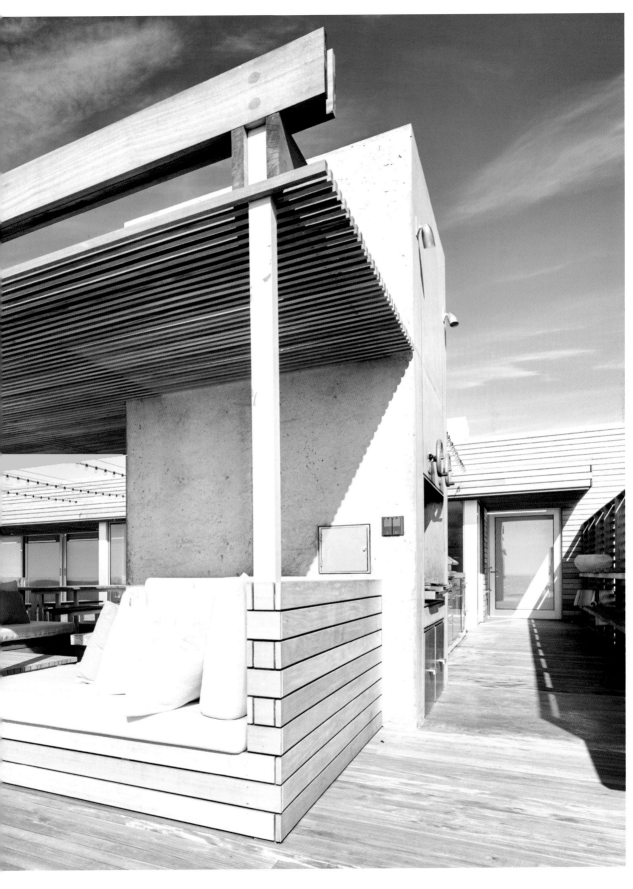

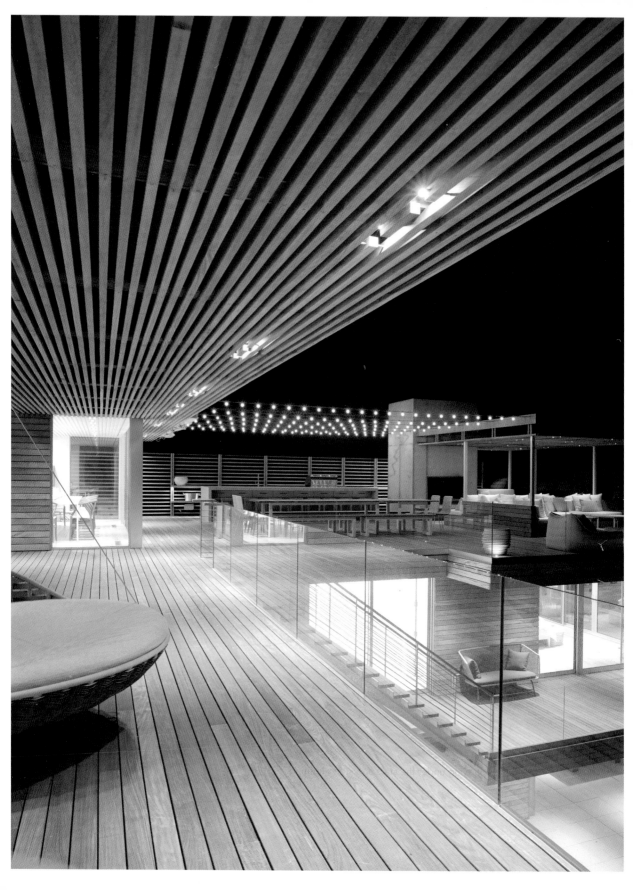

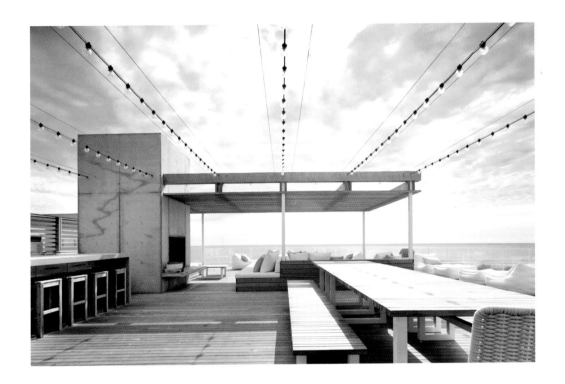

The house was designed as an 'upside down' house, gifting the most stunning views to the living, dining and kitchen areas on the top floor and allowing direct access to the main, rooftop deck which is a seriously beautiful spot to throw a party.

The ground entrance level, which is nestled behind the sand dunes, showcases a mixed wood and concrete paved patio with a pool, outdoor fireplace and covered table tennis area.

The main floor is accessed from an exterior cantilevered stair that leads to the central light-filled atrium. This main level houses all the bedrooms, a centrally located family room and the main deck is home to an extensive herb and vegetable garden and outdoor cooking area.

ABOVE: With endless ocean views, space and seating for a crowd, the top floor is the social hub of the home when it comes to partying under the stars and string lighting.

OPPOSITE PAGE AND PREVIOUS SPREAD: Seamless indoor-outdoor living is captured by introducing large cantilevered decks and roof decks, designed for entertaining.

FOLLOWING SPREAD: Designed as an upside-down house, the property saves the most spectacular views for the living, dining and kitchen on the top floor.

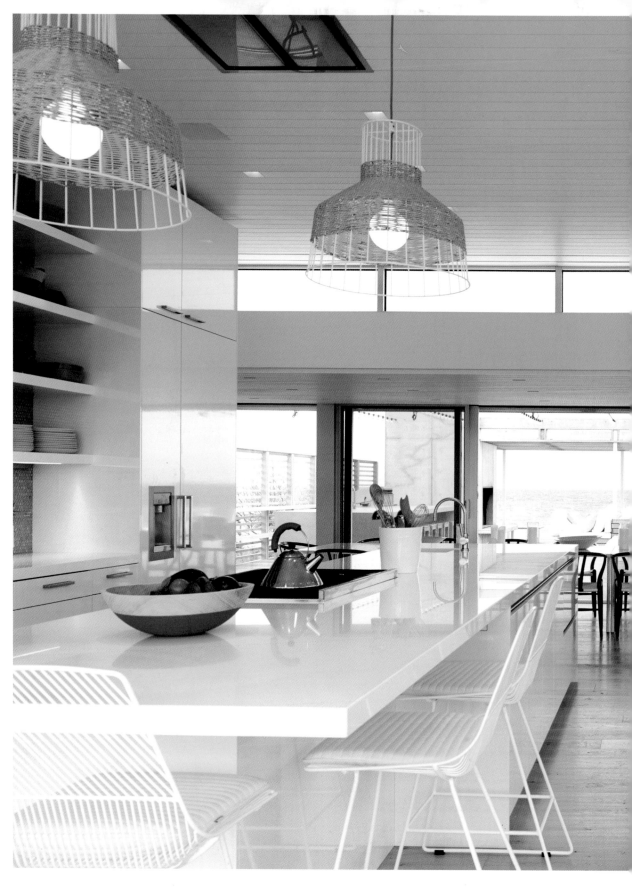

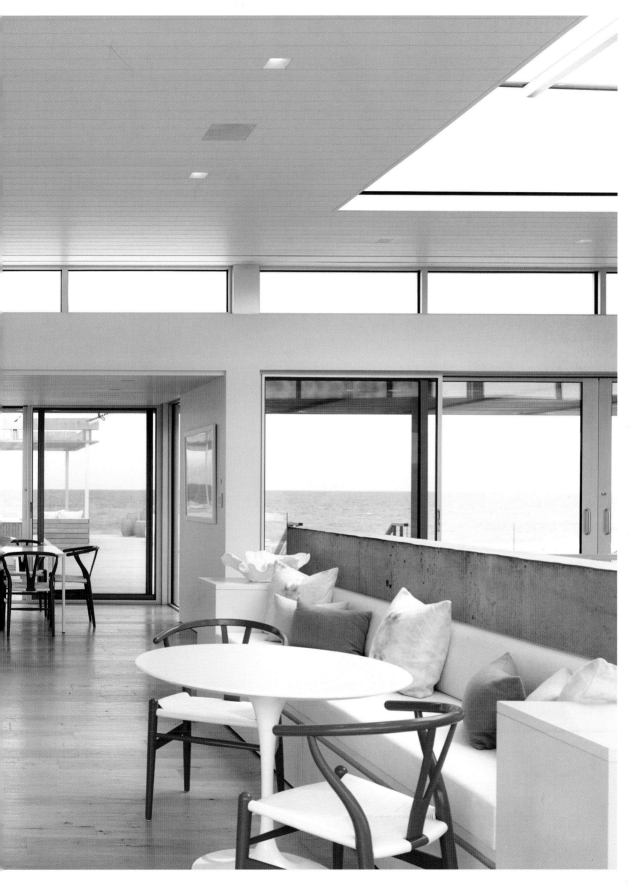

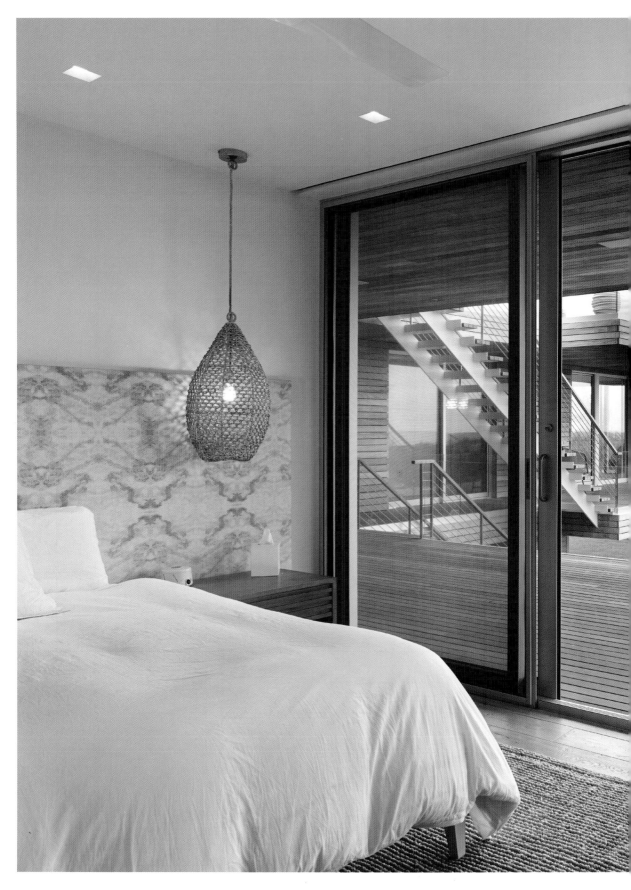

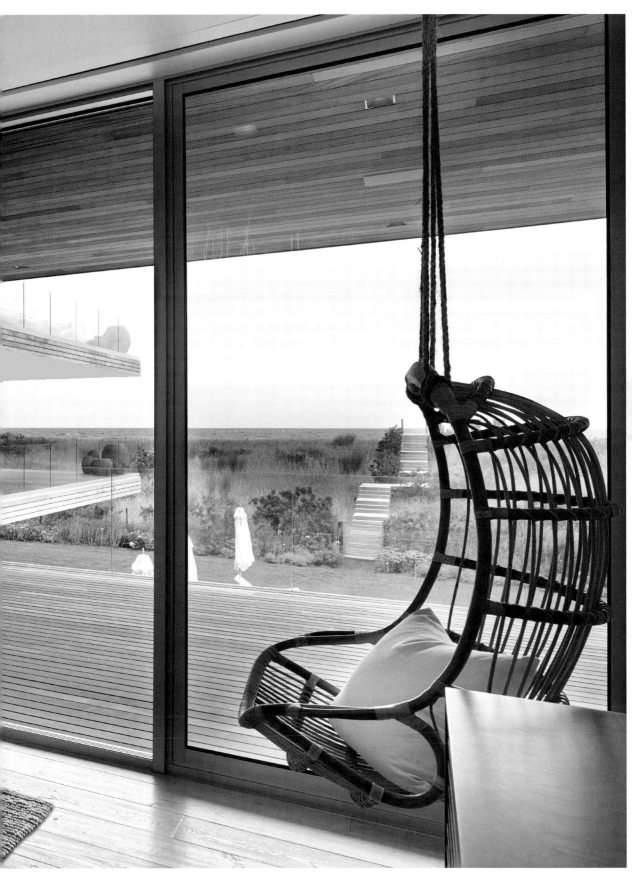

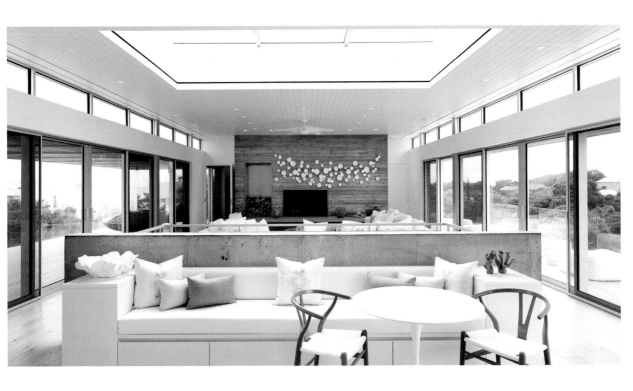

ABOVE: Contemporary beach luxury with exquisite use of white, greys and muted blues. Wood and concrete combine with soft furnishings for cosy ambience without distracting from the hero of the property, the view.

RIGHT: The central light-filled staircase and atrium is enclosed by a combination of glass and concrete walls. The white, blue and neutral aesthetic is contemporary Hamptons at its best.

PREVIOUS SPREAD: Waking up overlooking gardens created by landscape architect Edmund Hollander with the ocean on the horizon couldn't be more delightful.

OVERLEAF: Stairway to Hamptons party heaven. From the beach sand to chic sundowners, Ocean Deck House is the envy of many.

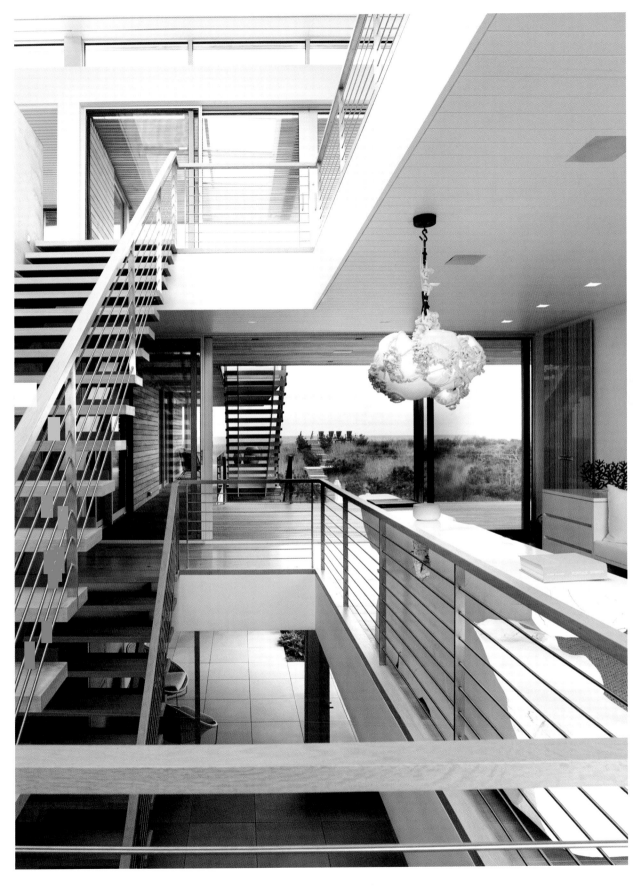

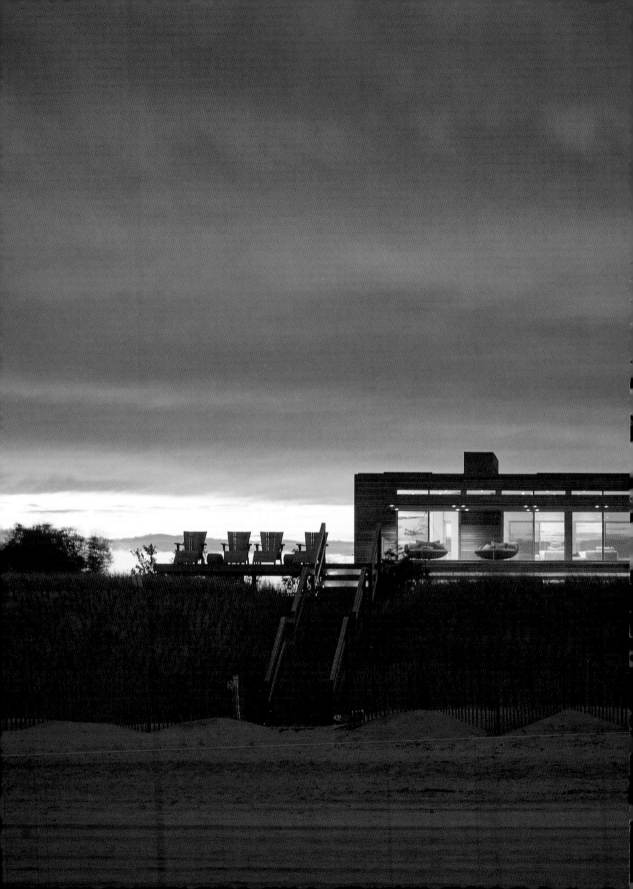

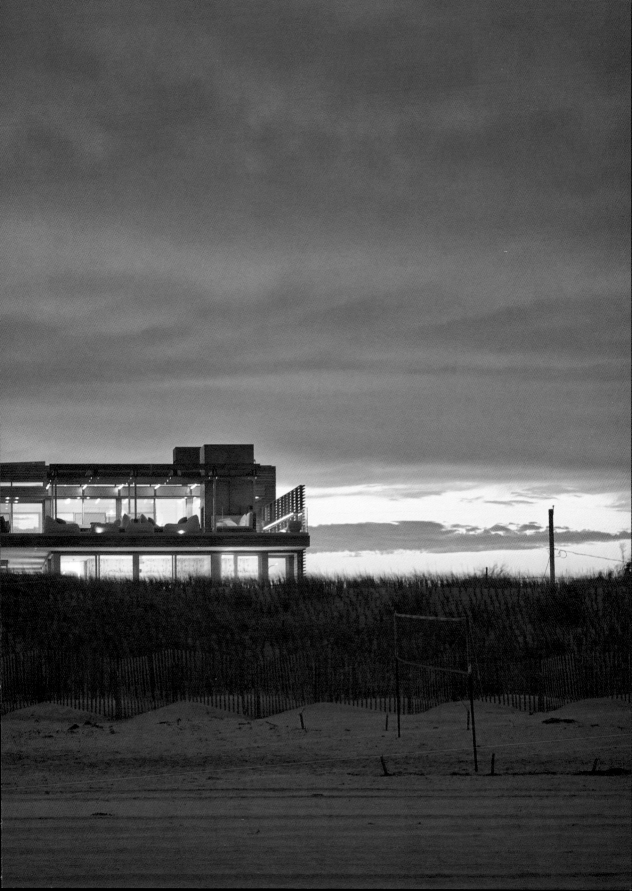

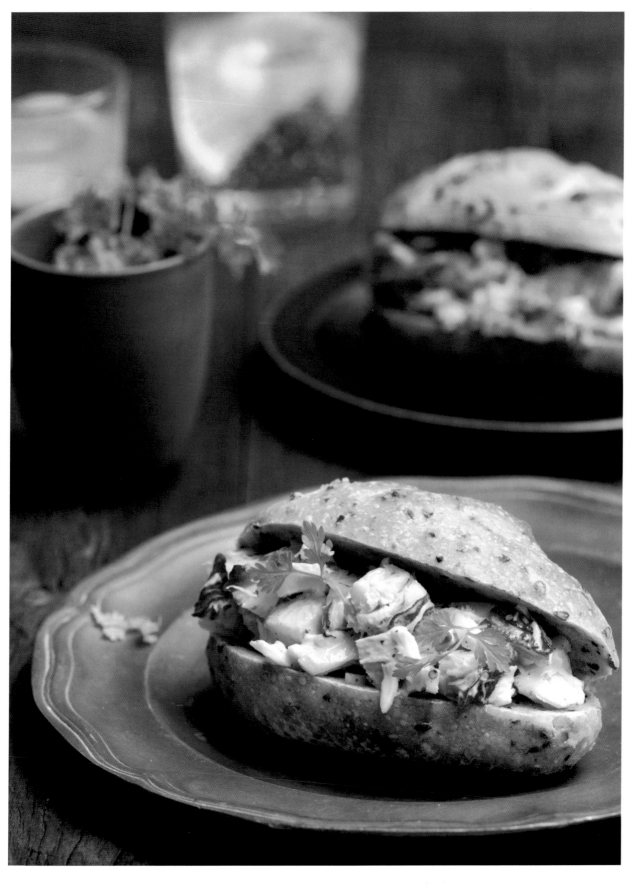

LOBSTER ROLLS

INGREDIENTS

17½ oz/500 g cooked
 lobster or crayfish,
 chopped
1 stalk celery,
 finely chopped
2 tablespoons mayonnaise
2 teaspoons Dijon mustard
1 tablespoon capers,
 chopped
1 tablespoon lemon juice
salt and pepper
12–14 rolls of your choice
butter
watercress or cilantro/
 coriander leaves,
 to serve

Serves 12–14

METHOD

» In a bowl, combine lobster, celery, mayonnaise, mustard, capers and lemon juice. Add salt and pepper to taste. Refrigerate until ready to use.

» Slice the rolls part way through and toast under a grill. Butter the inside and fill with lobster mixture.

» Put rolls on ovenproof plates, warm in oven for a few minutes.

» To serve, top with watercress or cilantro.

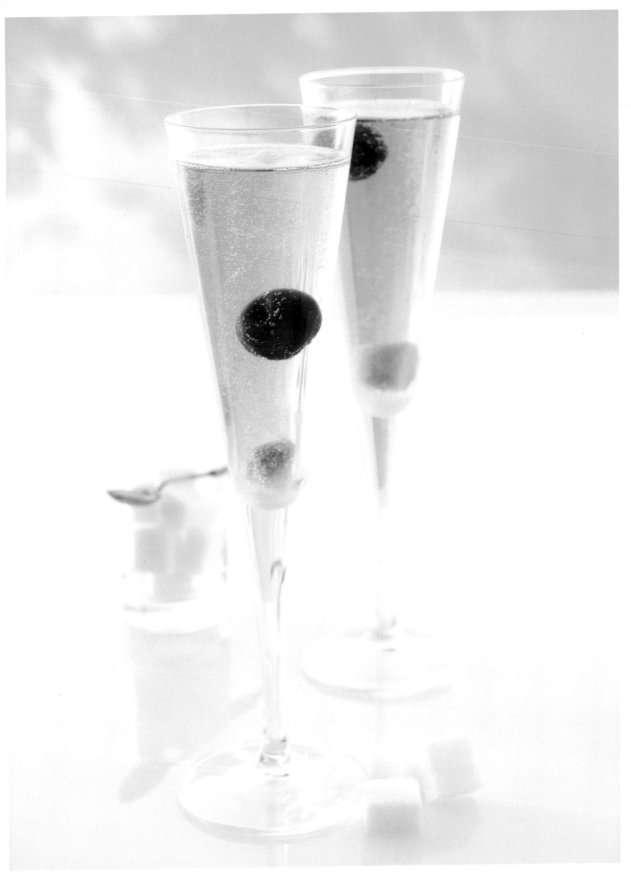

CHAMPAGNE COCKTAIL

INGREDIENTS

1 sugar cube

6 drops Angostura bitters

1 tablespoon Cognac

125 ml (4 fl oz) Champagne

1 cherry

GLASS

150 ml (5 fl oz) Champagne flute

Serves 1

METHOD

» Soak sugar cube in Angostura bitters in the flute before adding Cognac, then top with Champagne. Drop cherry into glass.

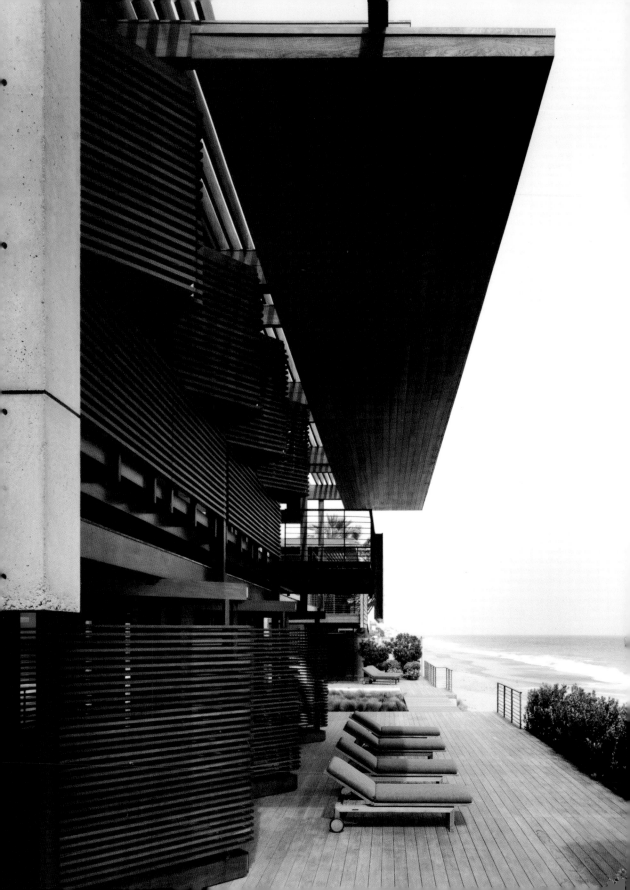

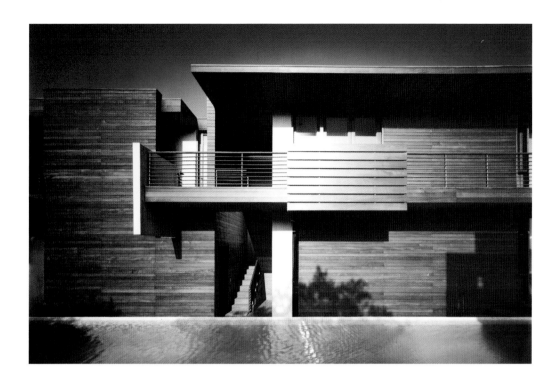

MALIBU BEACH HOUSE, Malibu, California

Architect Richard Meier was forced to rethink his signature architectural style of using white when the mogul owner of this Malibu beach home commissioned him to design his new abode.

The house, clad entirely in teak shutters that can be opened or shut like an accordion, extends inside and out with floor to ceiling finishes.

Meier says of his design, "The opportunity to design an oceanfront residence is a privilege that cannot be overstated. The site for this house and guesthouse is exceptional in its size and the amount of ocean frontage it enjoys compared to other properties on this south-facing Malibu beach."

OPPOSITE PAGE: Lounging on the teak deck overlooking Malibu beach.

ABOVE: To maintain the sheen of the plantation grown wood, the entire house is oiled four times a year. It is said an employee of the owner works full time on this project.

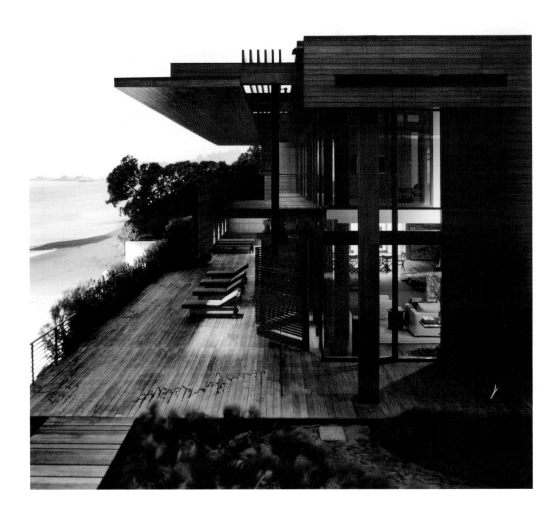

"The figure ground is designed to maximize the potential of the additional lot area which is a precious commodity. By splitting the program into separate structures, the beach's sand and grasses are allowed to migrate into an entry courtyard as an extension of the landscape," says Meier. "Both of the structures have views to the ocean and courtyard that are filtered and framed by a layer of operable shutters that are independent of the building enclosure."

"A cast-in-place concrete wall bisects the plan and is the physical link from the entry gate at the street elevation to the ocean gate and stairs leading to the beach," adds Meier. "Detailed in bronze metal copings and finish hardware, the palette of materials – concrete, teak and bronze – is designed to weather and patina in response to the harsh oceanfront environment."

OPPOSITE PAGE: The infinity lap pool is a necessity for the health conscious Malibu resident.

ABOVE: As day slips into night, the character of the natural teak comes into its own.

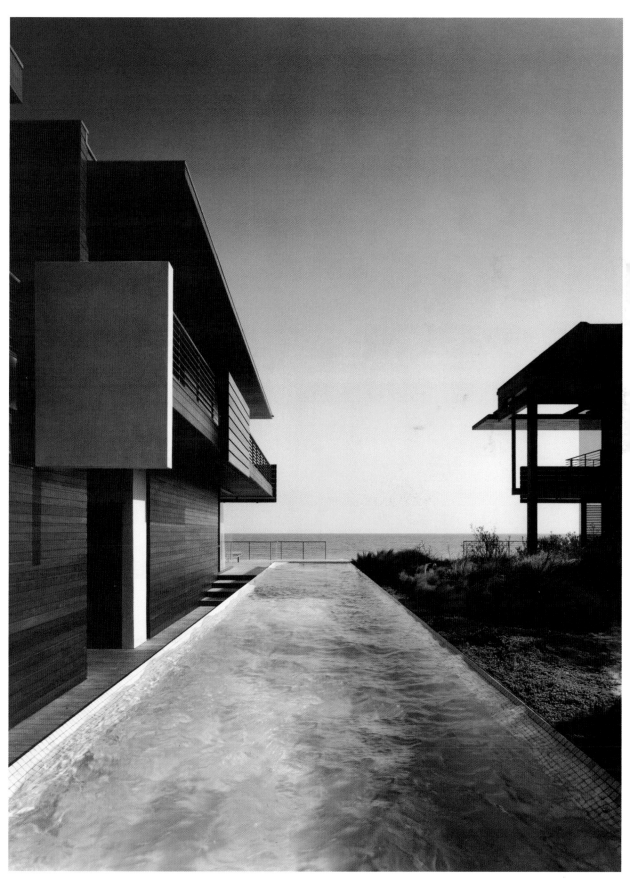

COSMOPOLITAN

INGREDIENTS
1½ fl oz (45 ml) vodka
1 fl oz (30 ml) Cointreau
1 fl oz (30 ml) cranberry
 juice
½ fl oz (15 ml) freshly
 squeezed lime juice
wedge of lime, to garnish

GLASS
5 fl oz (145 ml) cocktail
 glass

Serves 1

METHOD
» Combine the liquid ingredients in a cocktail shaker
 with cracked ice and shake well. Pour into a chilled
 glass. Garnish with the lime wedge.

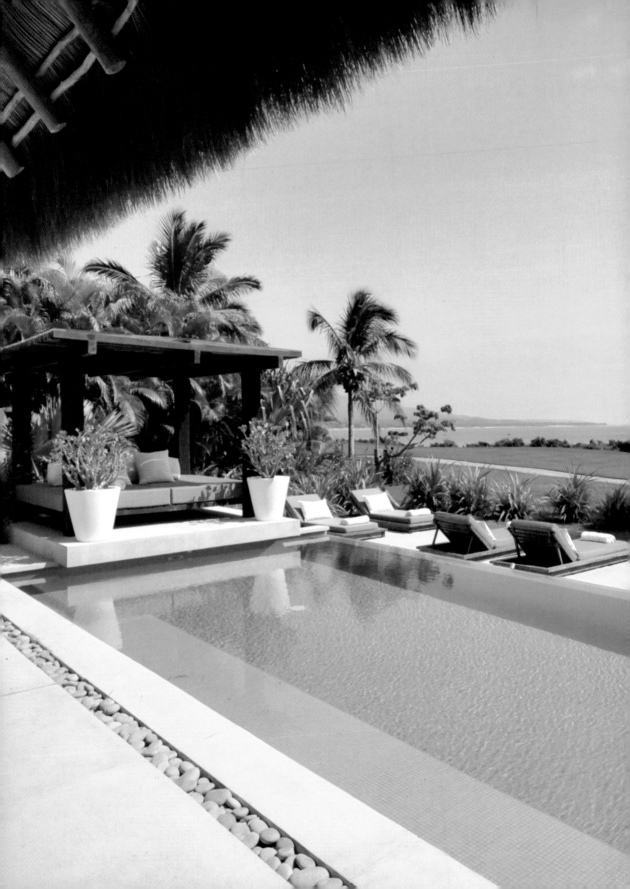

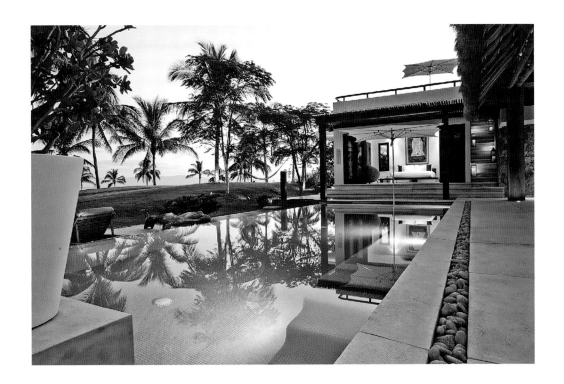

CASA KALIKA, Punta Mita, Mexico

With sensational crystal clear water views of the Pacific Ocean's Bay of Banderas, this is every golf fanatic's dream location – Casa Kalika is set on the ninth fairway of the Jack Nicklaus Golf Course within the Four Seasons Punta de Mita community.

Architect Guillermo Michel Renteria drew upon modern Balinese influences for the contemporary tropical palapa-style design, building the home with traditional, natural and organic materials, making the most of the indoor-outdoor flow.

Boasting five bedrooms and six bathrooms, the property is an impressive 10,000 square feet of fluid spaces. With an infinity saltwater pool, wet bar and three jacuzzis to choose from, the perfect margarita sipping spot is never far.

OPPOSITE PAGE: A large salt water infinity edge pool with swim jets and a built-in lounge overlooks the Bay of Banderas on the Pacific Coast of Mexico, the lush Sierra Madre Mountains, the Marietas Islands and the Puerto Vallarta skyline.

ABOVE: The spacious wood pergola with its large day bed located at the end of the infinity pool provides a dreamy spot for lounging with amazing views of the Marietas Islands.

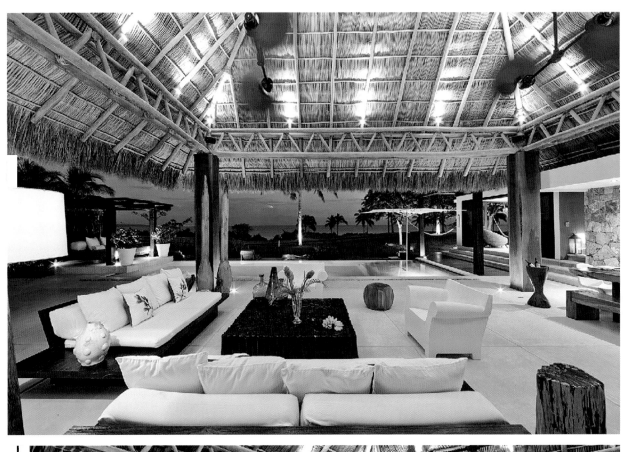

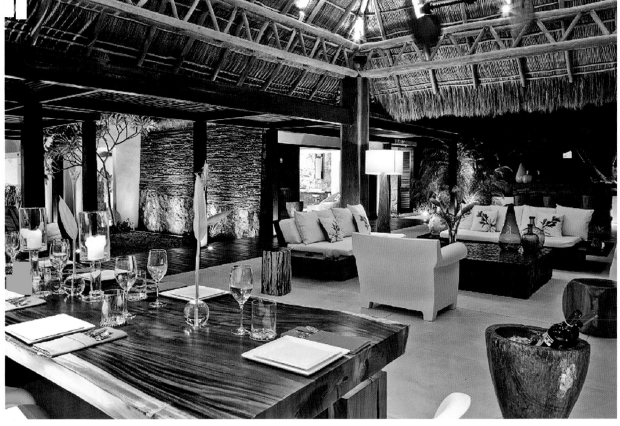

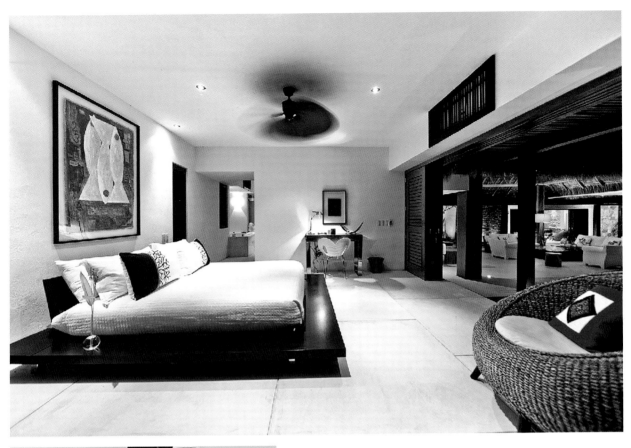

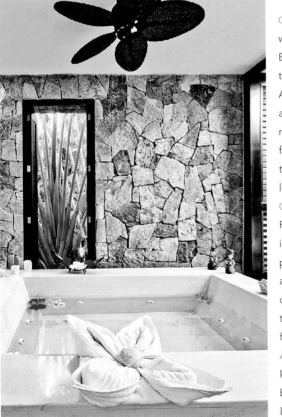

OPPOSITE PAGE ABOVE: The large open living and dining area covered with a Palapa thatch roof with crystal blue water views of the Bay of Banderas is a favorite of the owner Fabienne Dufourg. "You are very in touch with nature and the amazing views change every hour," he says. Architect Guillermo Michel Renteria says "I wanted to create a sexy and airy home that integrates the beautiful Punta Mita environment with multiple elements including natural rocks, stone walls, exotic woods, fountains, landscape and interior patios. The elements of nature flow together within the open house where one room stretches into the next, leading to an infinity pool with an exotic cabana overlooking the bay."

OPPOSITE PAGE BELOW: Sue Chitpanish of Dao Home and owner Fabienne Dufourg used innovative design to create a relaxing "Zen" interior. Sue and Fabienne utilized organic custom furniture made of precious thick hardwoods from Bali, antique statues, local Mexican art and paintings, recycled glass vases and reclaimed wooden furniture to complement the Philippe Stark contemporary furniture. "Every piece of the décor was either custom made in Bali, Los Angeles or brought back from our trips," says Fabienne.

ABOVE AND LEFT: One of the luxurious four master suites, three with kingsize beds and the fourth with two beds. All complete with en suite bathrooms featuring sunk-in marble Jacuzzi bathtubs opening up to lush landscape gardens, inside and outside showers.

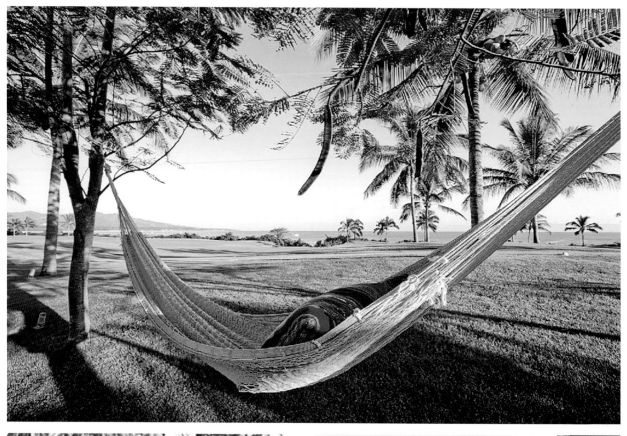
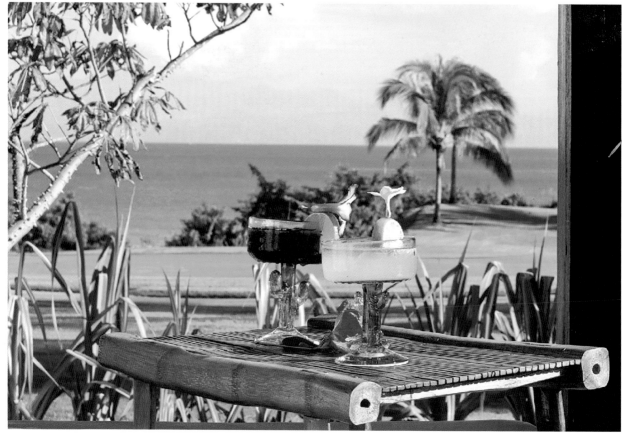

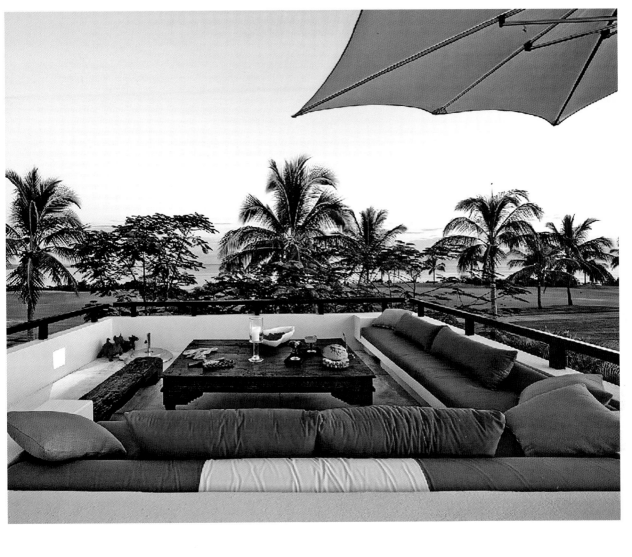

OPPOSITE PAGE ABOVE: Hard pressed to find a better spot for a hammock. Plenty of hammocks supplied to hang wherever the moment of relaxation takes you.

OPPOSITE PAGE BELOW: Overlooking the ninth fairway of the Jack Nicklaus golf course 'Pacifico' at the Four Seasons Punta de Mita.

ABOVE: The roof terrace above the master suite with large sofas provides the perfect spot for a sundowner, stargazing and relaxing. Owner Fabienne Dufourg says "We fell in love with the land and its amazing views. We had just returned from the North Island in the Seychelles islands and were inspired to design something Zen and organic."

MARGARITA

The history of the Mexican margarita cocktail is highly romanticised and there are a number of theories that explain its origins. Several are rather convincing, including:

» It was created at the Caliente Race Track in Tijuana in the early 1930s.
» In 1936 Danny Negrete invented the drink for his girlfriend, Margarita, while he was working at the Hotel Garcia Crespo.
» In 1938, Carlos Herrera invented the drink for Marjorie King, who apparently couldn't drink anything except tequila.
» On 4 July 1942, a customer requested a Magnolia from barman Francisco Morales. However, he couldn't remember the recipe, so made up another drink and called it Daisy instead. (Daisy is Mexican for margarita.)
» In the 1940s, Enrique Bastante Gutierrez created the drink for Rita Hayworth, whose real name was Margarita Carmen Cansino.
» In 1948 Margaret Sames created the drink for a special party.
» In 1948 it was created in Galveston, Texas, by Santos Cruz, who mixed it for Peggy Lee.

GLASS
150 ml (5 fl oz)
 margarita glass

INGREDIENTS
2 slices of lemon
salt
30 ml (1 fl oz) tequila
30 ml (1 fl oz) lemon juice
15 ml (½ fl oz) Cointreau
½ egg white (optional)

Serves 1

METHOD
» Rub rim of glass with 1 slice of lemon and frost with salt. Shake all ingredients except lemon with ice and strain into glass. Garnish with remaining lemon slice on side of glass.

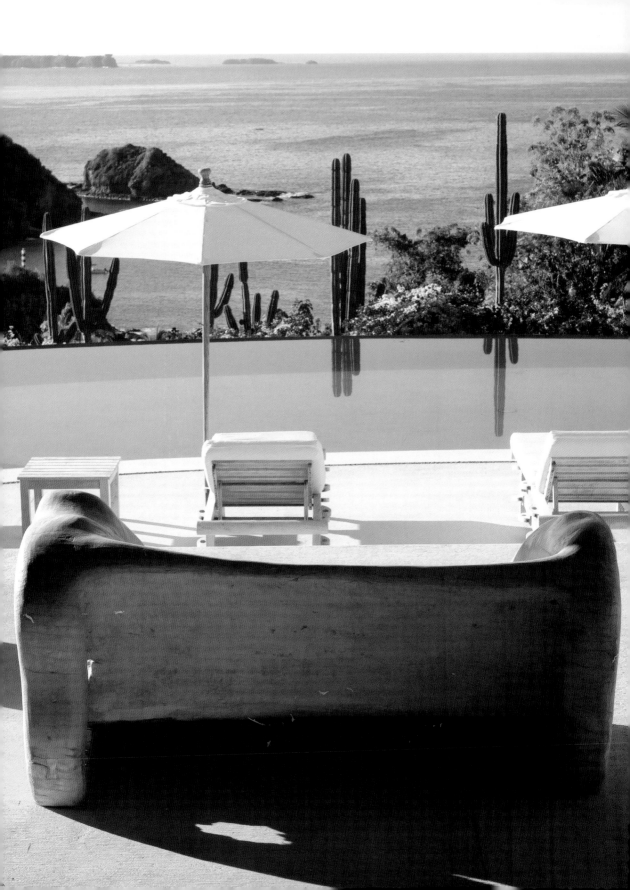

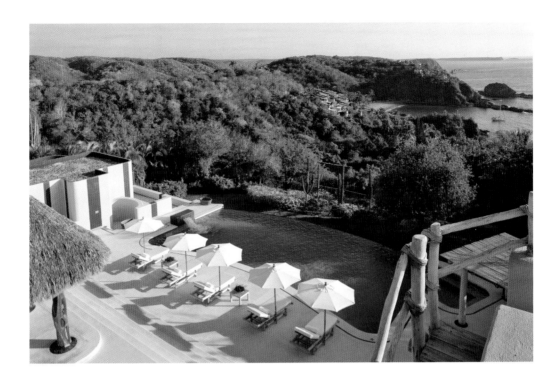

CASA ALTIPLANO, Jalisco, Mexico

Eccentric and glamorous are two words that come to mind when describing Costa Careyes, the unique community along the expansive coastline between Manzanillo and Puerto Vallarta in Mexico.

In 1968, Gian Franco Brignone, a famed banker and real estate developer from Turin, Italy spotted the then uninhabited stretch of sand and islands from a light aircraft. Without setting foot on shore, Brignone snapped up the almost 15 kilometers (approx. 9 miles) of coastline by wiring $2 million to a local friend's bank account. It would become the playground for aristocrats, billionaires, celebrities and playboys alike.

Costa Careyes is renowned for its 50 architecturally inspiring villas and Casa Altiplano, overlooking Playa Rosa, does not disappoint with its curious yet chic aesthetic.

OPPOSITE PAGE: Overlooking Playa Rosa along the Costa Careyes, between Puerto Vallarta and Manzanillo, the villa takes advantage of one of the most beautiful year-round climates and protected bays on Mexico's coastline.

ABOVE: Built in the famous architectural fashion of Costa Careyes, the property is a combination of Mediterranean sensuality and clean, minimalist style. The infinity pool area includes a heated Jacuzzi, water feature, sundecks and outdoor shower.

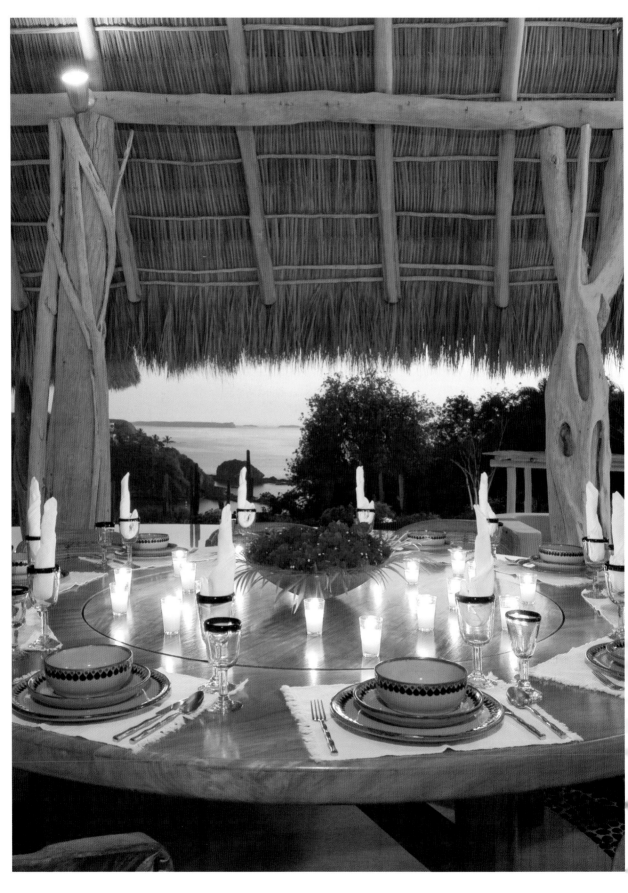

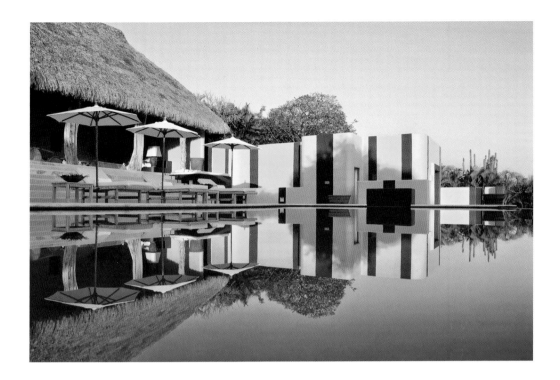

Clinging dramatically to the cliff edge, Casa Altipano is an elegant mix of natural materials mixed with a modern take on adobe brick construction and an expansive central palapa – an open-sided dwelling with a thatched roof made of dried palm leaves. The main house, with its bold yellow and black stripe design, acts as a contrast to the older style, rustic elements.

The living room and dining areas are situated under the palapa while the main house boasts five bedrooms with ensuites. The master bedroom is the perfect parent's retreat with its own living room and terrace with divine garden outlook.

The coastal landscape, complemented by an infinity pool, dreamy loungers atop generous sun decks, urge you to take in the magnificent view.

Costa Careyes maintains its bohemian roots which means homeowners not only need several million dollars to buy in, they must meet 27 conditions such as being multilingual, appreciating the music of sky, earth and sea, as well as having committed most of the seven deadly sins.

ABOVE: The yellow and black striped main house is bold and dramatic and acts as a counterpoint to the traditional and rustic elements.

OPPOSITE PAGE: The rustic, dining area seats twelve, the scene of many a memorable meal where you have the option of preparing it yourself in the gourmet kitchen or calling on the private chef to turn fresh, local fare into a gourmet feast.

OVERLEAF: Lazing the day away from perfectly placed hammocks overlooking the cool and inviting infinity-edge swimming pool.

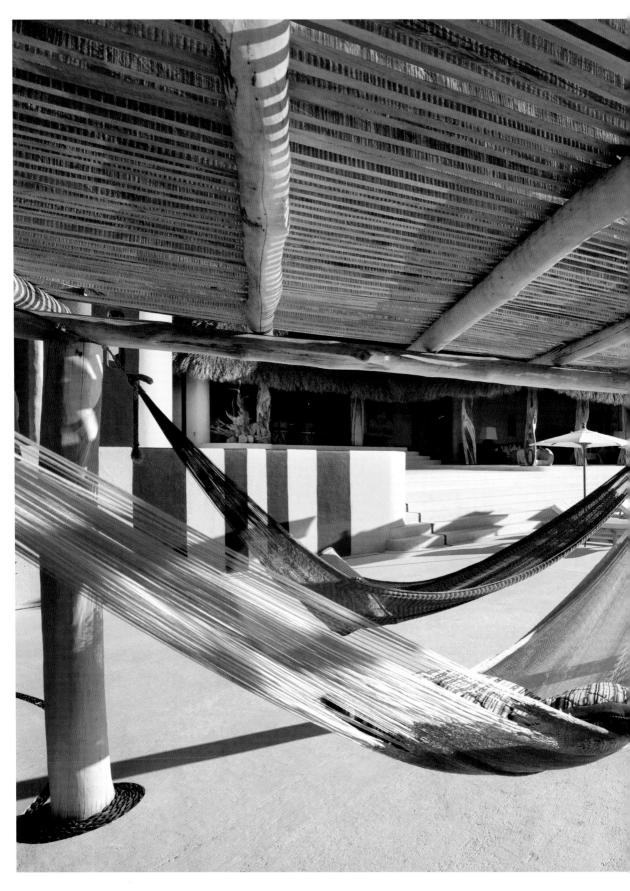

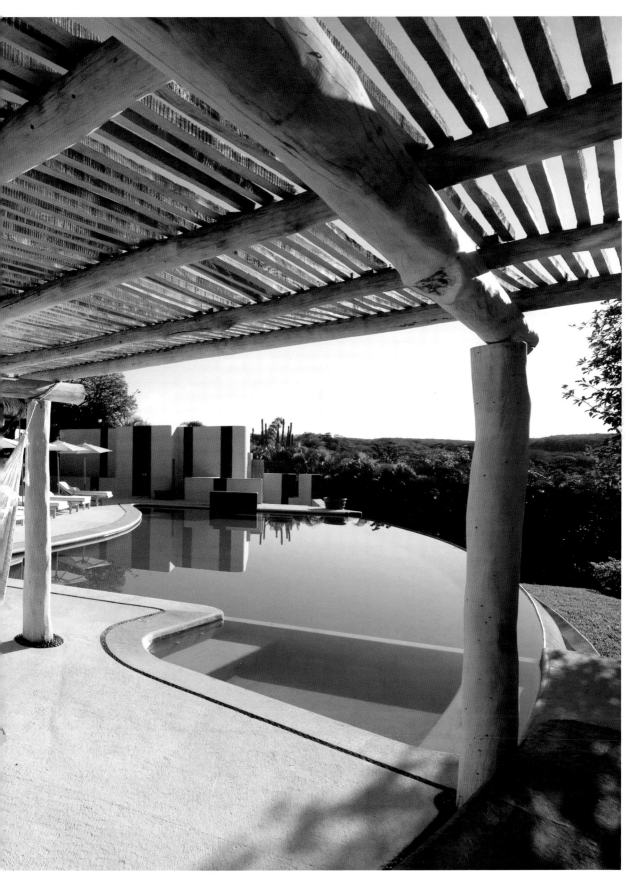

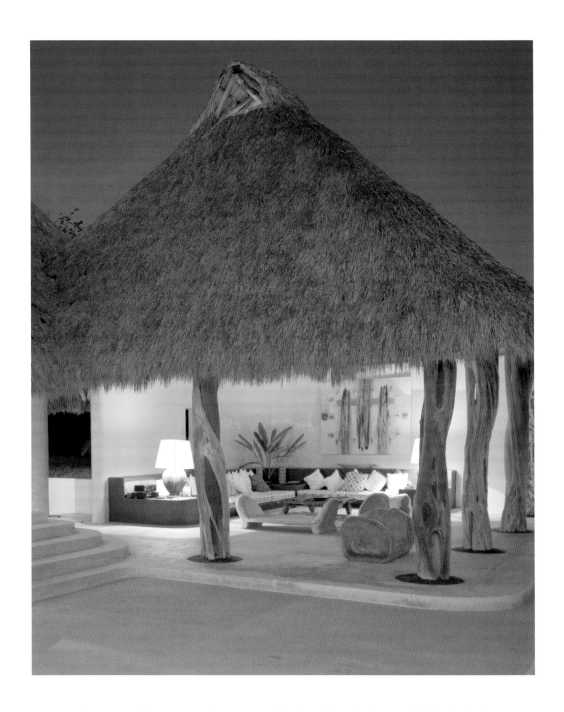

ABOVE: In the evening, the open main living room under the traditional palapa (roof of dried palm leaves), is a magical place to relax and listen to the relaxing sound of waves crashing on the coastline below.

OPPOSITE PAGE ABOVE: The main house features five bedrooms with en suite bathrooms. The master bedroom features its own living room and terrace opening out to the gardens.

OPPOSITE PAGE BELOW: The main living room under an expansive traditional palapa (roof of dried palm leaves) is a masterful use of all natural materials skilfully mixed with a modern version of adobe construction.

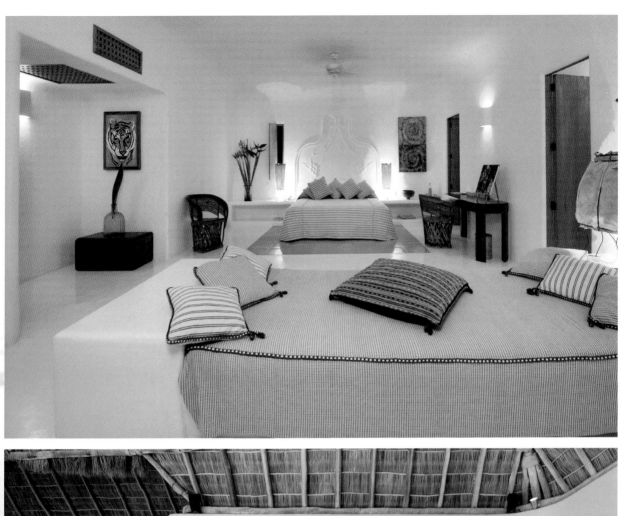

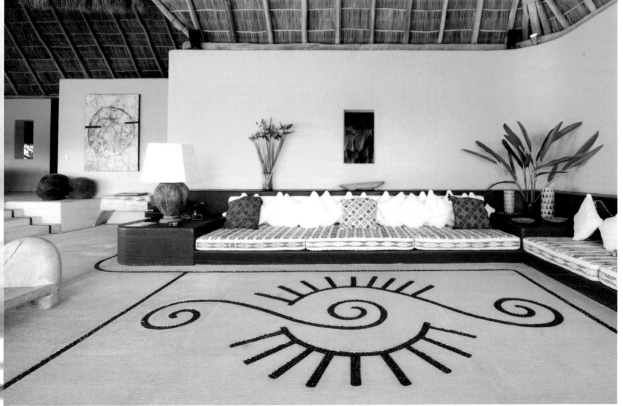

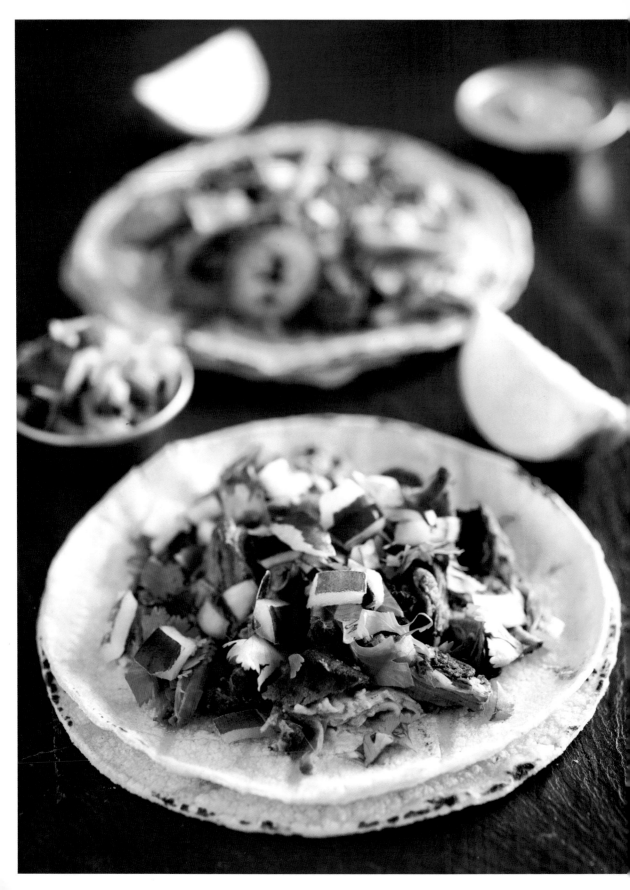

TACOS

INGREDIENTS
500 g (17 ½ oz) cooked
 pulled pork
1 diced red onion
1 sliced habanero chili
 if you like it spicy
bunch fresh coriander
1–2 tablespoons
 apple cider
tortillas
2–3 limes

AVOCADO
AND LIME
MAYONNAISE
1 small avocado
½ cup mayonnaise,
 store bought
1 teaspoon lime rind
juice of ½ lime
pepper, to taste

Serves 4

METHOD
» Place pulled pork in a skillet and warm through.
 Add some cider a little at a time if the pork is dry.
» Warm your tortillas in the oven wrapped in aluminium
 foil while warming the pork.
» Stack your taco with pork and the other toppings
 and a squeeze of lime or a drizzle of avocado lime
 mayonnaise.
» To make mayonnaise, combine all the ingredients in a
 food processor and blend until smooth.

Note: Add green jalapeño sauce if you like it spicy. This
recipe is great for using leftover pulled pork or substitute
with cooked mince. You can make the mayonnaise ahead
of time and refrigerate until ready to use.

VILLA AZUL CELESTE, Puerto Vallarta, Mexico

Perched above the sea on the Bay of Banderas, is one of Puerto Vallarta's most sophisticated and exclusive hillside locations, Conchas Chinas. Here you'll find Villa Azul Celeste.

With stunning panoramic views of the Pacific Ocean from all levels of the three bedroom, 3.5 bathroom abode, Villa Azul Celeste boasts relaxed luxury from the moment you step inside the courtyard entry of the villa which boasts 4,000 square feet of interior space and an additional 2,000 square feet of terraces, gardens and a dreamy, heated infinity pool.

Acclaimed local designer Peter Bowman created the vibrant interiors, which feature traditional Mexican furniture, artefacts, an extensive folk art collection, terracotta floors and antique hand-hewn beamed ceilings overhead.

With sapphire waters lapping your private beach and cove below, the master bedroom suite on the second floor with king bed, fireplace and open shower for two is romance personified.

OPPOSITE PAGE: Stunning panoramic views overlooking Banderas Bay in the Pacific Ocean from every aspect of the five level, eight bedroom villa.

ABOVE: Villa Azul Celeste is nestled into Conchas Chinas, Puerto Vallarta's most exclusive hillside neighborhood.

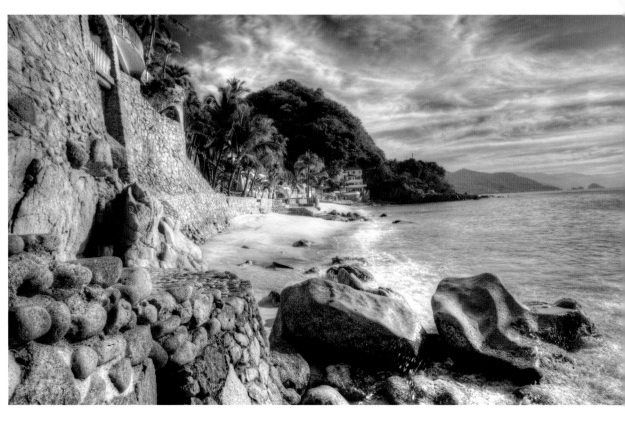

Two guest bedrooms are situated poolside. One features a king bed and large garden bath with a sculptured rock formation while the other also boasts a king bed and large private bath.

Owner Sharon Tognietti explains how she found and fell in love with the home.

"In August 2010 my husband and I were on a short four-day visit to Puerto Vallarta. A realtor friend of ours took us to look at homes just for fun. After viewing 11 homes in one afternoon we headed for our last showing," says Sharon. "Imagine our surprise when we first opened the door of Villa Azul Celeste. From the courtyard entry it seemed nice but once the doors opened we were in total shock."

ABOVE: The villa overlooks the Bay of Banderas and features its own private beach and cove.
OPPOSITE PAGE ABOVE: Traditional Mexican furniture graces the terracotta floors and antique hand-hewn beamed ceilings hang over the master bedroom suite, featuring rustic four-poster bed and private terrace.
OPPOSITE PAGE BELOW: The azure blue of the Pacific Ocean is reflected in this bathroom off the master suite, featuring a cupola shower open and overlooking the sea.

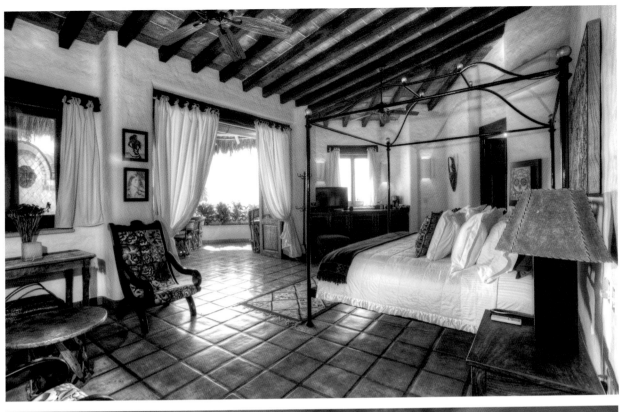
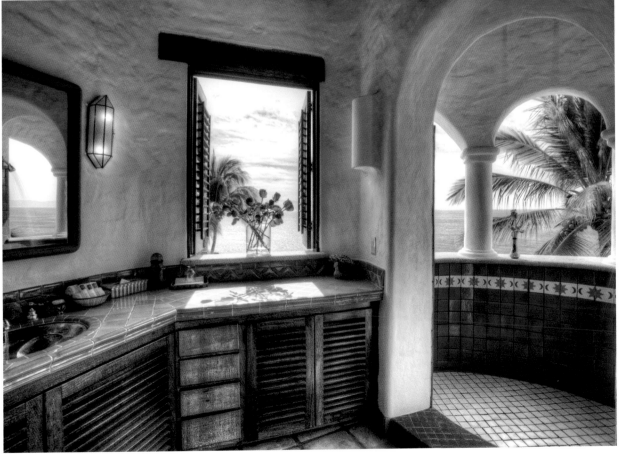

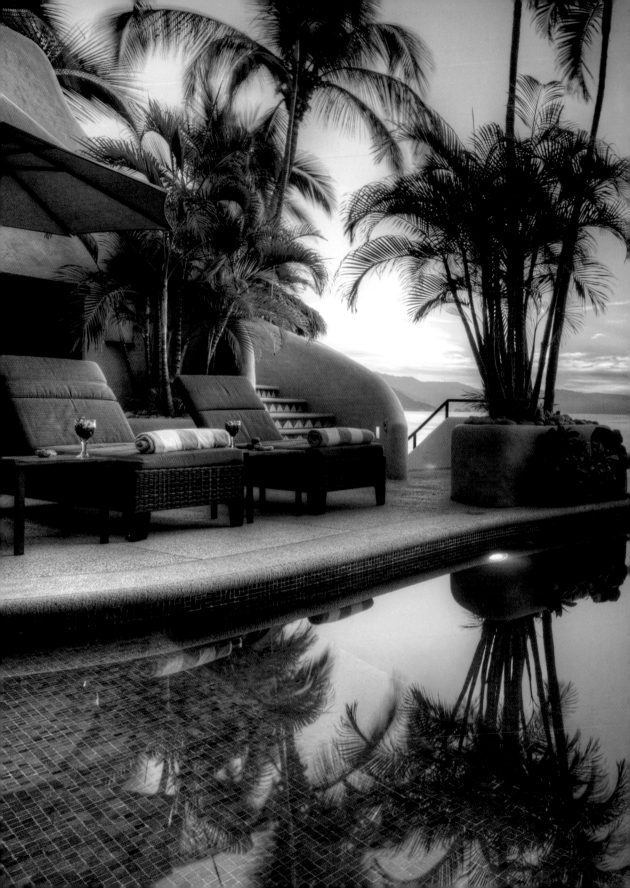

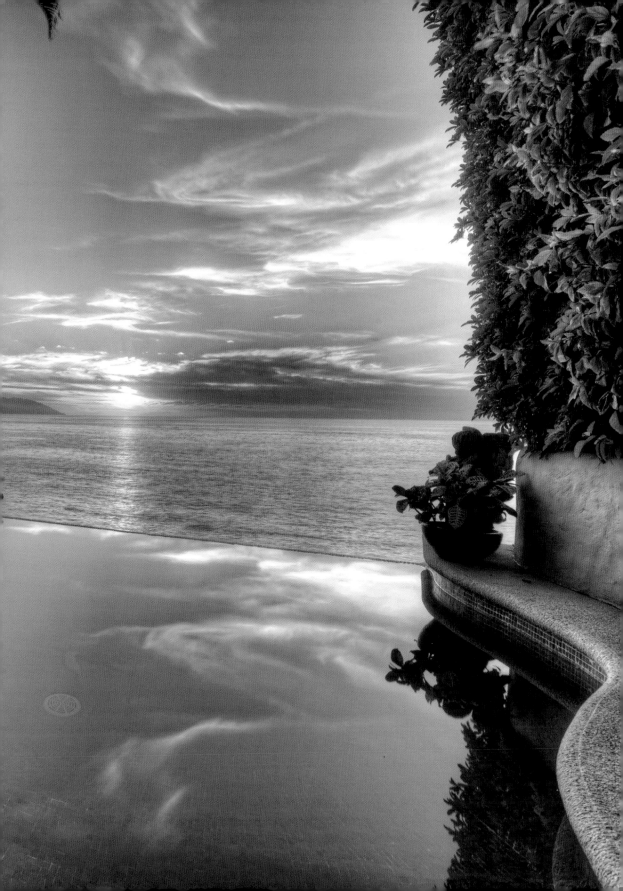

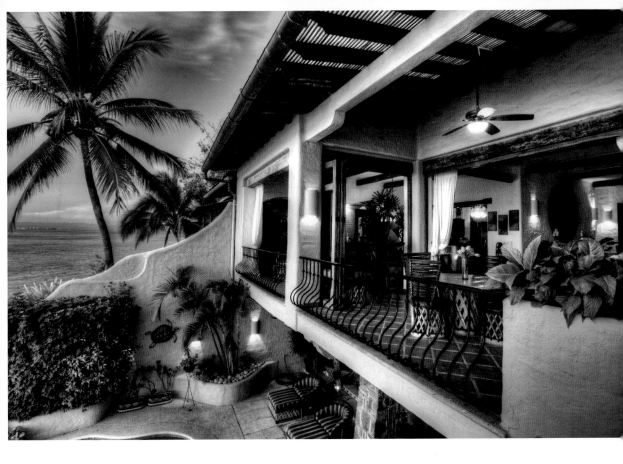

"A perfectly framed picture of old world charm with the ocean as a backdrop. Terracotta floors and rough-hewn beamed ceilings framed the picture. The home has a magical charm to it, all inspired by nature," she adds. "The house is a Vallarta Style house. Open to the elements. No doors or windows in the common areas. It just felt like home the minute we opened the door."

As if staged for Sharon's benefit, a pod of whales chose that moment to breach right before their eyes from the dining area.

"We were sold!" reveals Sharon.

"The decor was dated so everything was replaced with the exception of the antique pieces. Mexican folk art was purchased including local Huichol Indian beaded pieces and Oaxacan textiles and black pottery.

ABOVE: The terrace overlooking the free-form swimming pool with its own swim-up bar is the perfect spot to relish a tropical sunset complete with breezy palm trees.

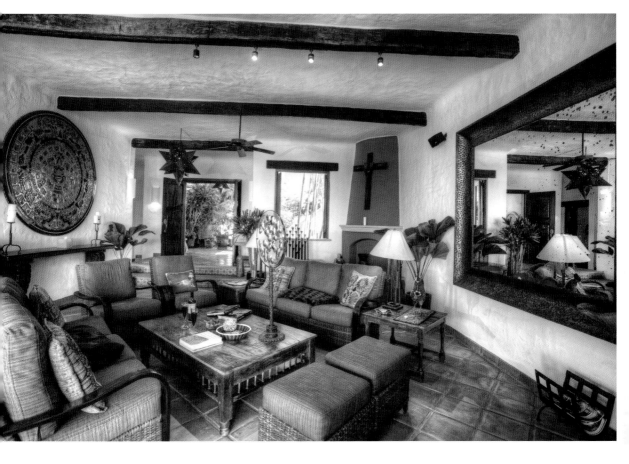

All the textiles are made with vegetable dyes and hand loomed," explains Sharon. "We wanted to showcase the arts and crafts of Mexico. Our collection is extensive and ongoing. The art is fun and colorful. No structural modifications were necessary as the home was perfectly planned. We wanted to keep the feel of Vallarta style and not upset the balance nor modernize it."

Sharon's favorite room is the master suite.

"It is the entire second floor. It has an outside terrace covered by a typical palapa style roof with ocean vistas to enjoy in complete privacy. There's seating for four, a stone fountain, a four-poster bed and Huichol Indian yard art pieces," she says. "The cupola shower is open to the elements with outstanding views. All the furniture is antique Mexican."

The focal piece in the living room is a two-meter (2-yard) handmade wooden Aztec calendar.

"It is crafted of small pieces of wood depicting the dawn of creation and the end of civilization. An extensive handbook is provided for those wishing to explore the deep meanings depicted," adds Sharon.

ABOVE: The villa refreshed and lovingly restored with attention paid to every detail – new folk art blends seamlessly with the traditional Mexican furniture and art already in situ.

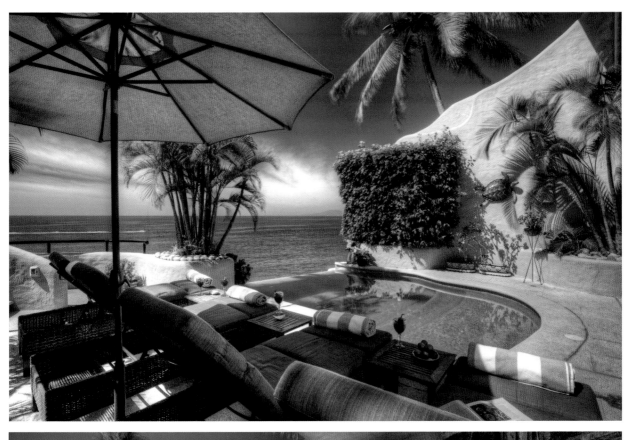
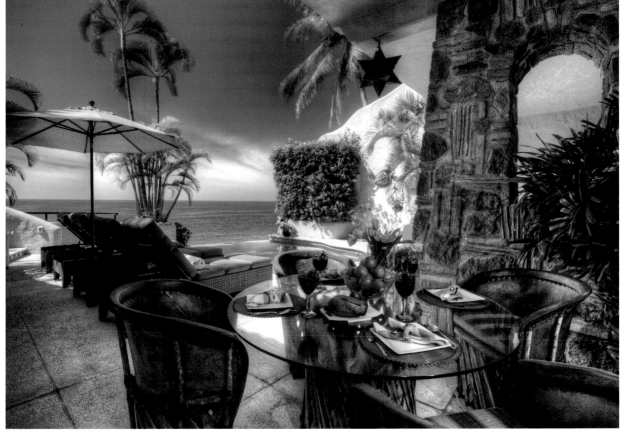

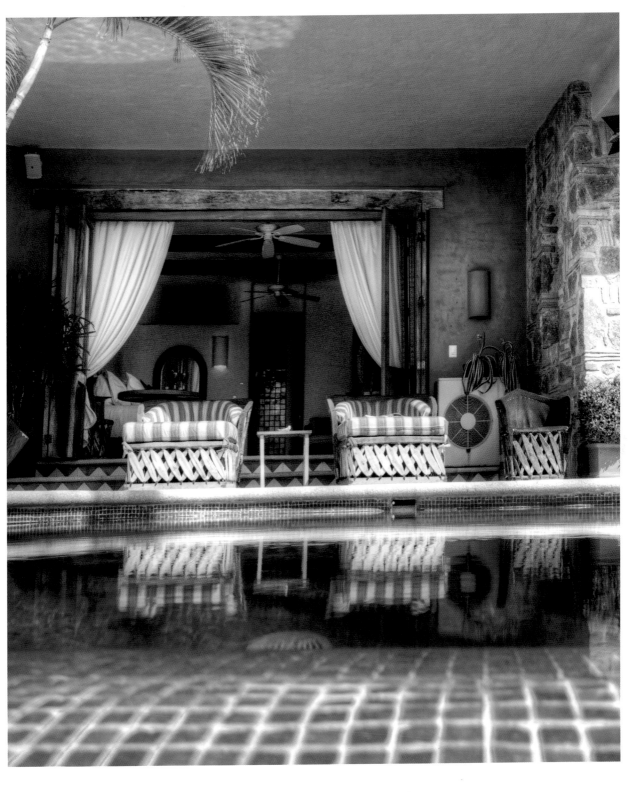

OPPOSITE PAGE: With the breathtaking views, cooling sea breezes, tropical gardens and cool drink by your side, leaving the infinity edge pool area is difficult.

ABOVE: One of the two guest bedrooms poolside. One has a king bed and large garden bath with a sculptured rock formation and tropical plants. The other has a king bed and large private bath.

GUACAMOLE
WITH SOUR CREAM

INGREDIENTS

2 large avocados
2 teaspoons sour cream
juice of 1 lime
1 clove garlic minced
1 small white onion very
 finely chopped
salt
1 lime for garnish

Serves 4

METHOD

» Mash the avocados with a fork to smooth or a food
 processor for extra smoothness then add all the
 ingredients except for the sour cream and mix till
 combined.
» Set aside till needed then whisk in with a fork the sour
 cream just before serving with a slice of lime.

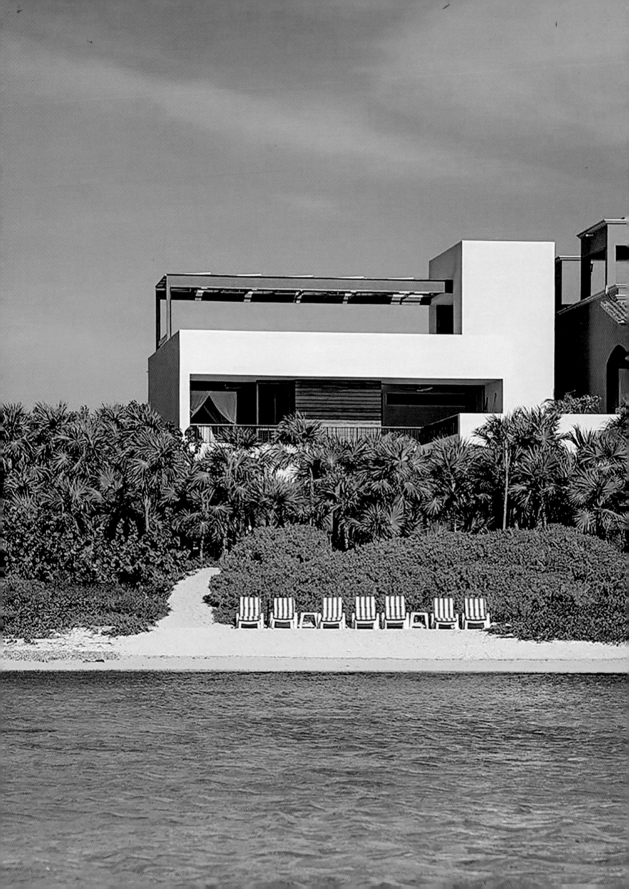

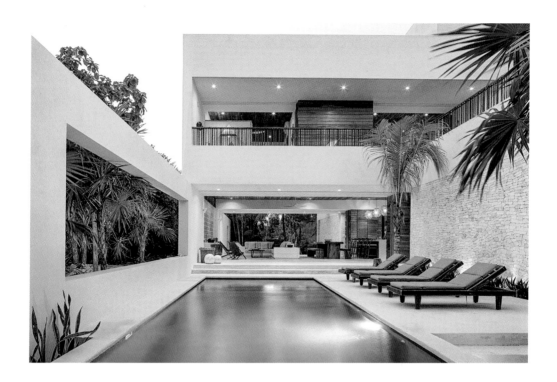

TULUM VILLA/CASA XIXIM, Soliman Bay, Yucatan

Ecological luxury at its finest, Tulum Villa (also known as Casa Xixim) makes the most of its stunning natural surroundings. Perched on the beachfront of the turquoise blue waters near Tulum and backing onto the lush vegetation of the jungle, the property brings together modern architecture, traditional building practices and permaculture principles to blend in.

Situated on the Riviera Maya, Bahia de Soliman is a tranquil turquoise bay alive with a coral reef and wildlife.

OPPOSITE PAGE: Literally seconds from the beach, Tulum Villa brings together elegant design, decadent luxury, environmental sustainability, blending in with its natural surrounds.
ABOVE: Hours spent lounging by the pool, taking in the sunshine and seaside views, is where most time is spent by guests of Tulum Villa.

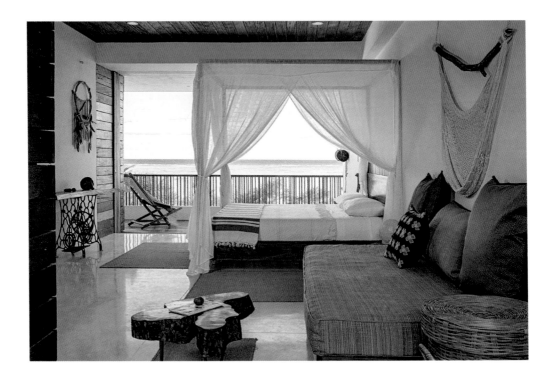

The line between interior and exterior is a blurred one with screened wood louvers instead of glass windows to allow the fragrant sea breeze to waft throughout the home. In some spaces, windows and walls have been removed completely to allow the azure ocean views and gentle swaying palm trees to engulf the property.

The four-bedroom design includes huge living spaces, lower-level and rooftop terraces, an outdoor pool, native tropical garden and inviting hammocks sprinkled throughout.

Sustainability is key with the home running on solar power, featuring a green roof collecting rainwater as well as recycling and composting practices.

The native tropical garden supplies the owners with home-grown bananas, coconuts, vegetables and herbs.

ABOVE: Dream bedroom featuring four poster bed complete with romantic netting, separate sitting area, opening out to the view.

OPPOSITE PAGE ABOVE: Screened wood louvers, instead of glass windows, feature throughout the villa to allow the sea breeze to waft through.

OPPOSITE PAGE BELOW: Interiors and their surroundings merge bringing the pool and ocean views beyond the swaying palm trees into the villa.

OVERLEAF: A relaxing row of hammocks perfectly positioned to take in Bahia de Soliman (Soliman Bay) of the Riviera Maya.

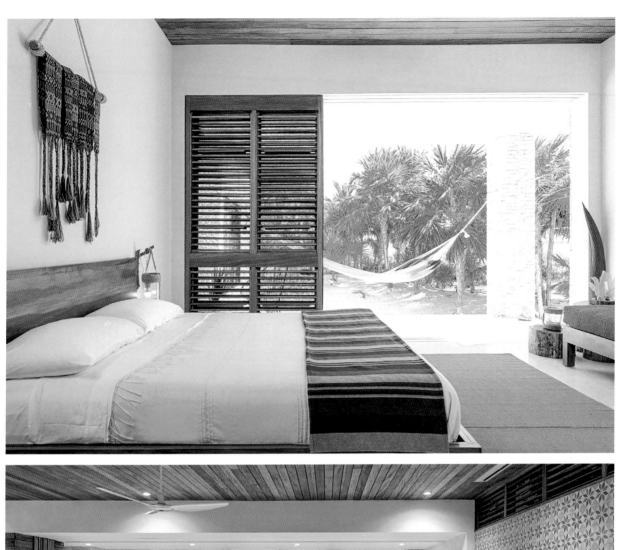
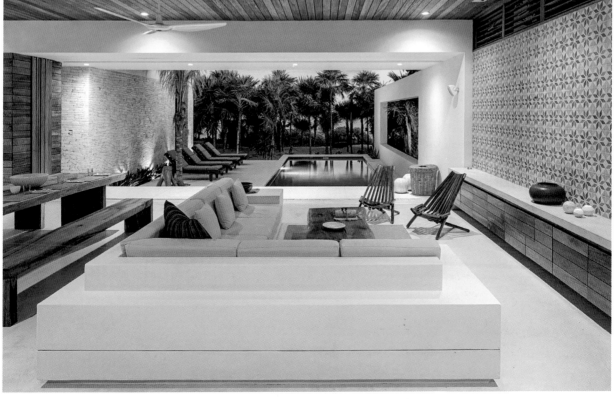

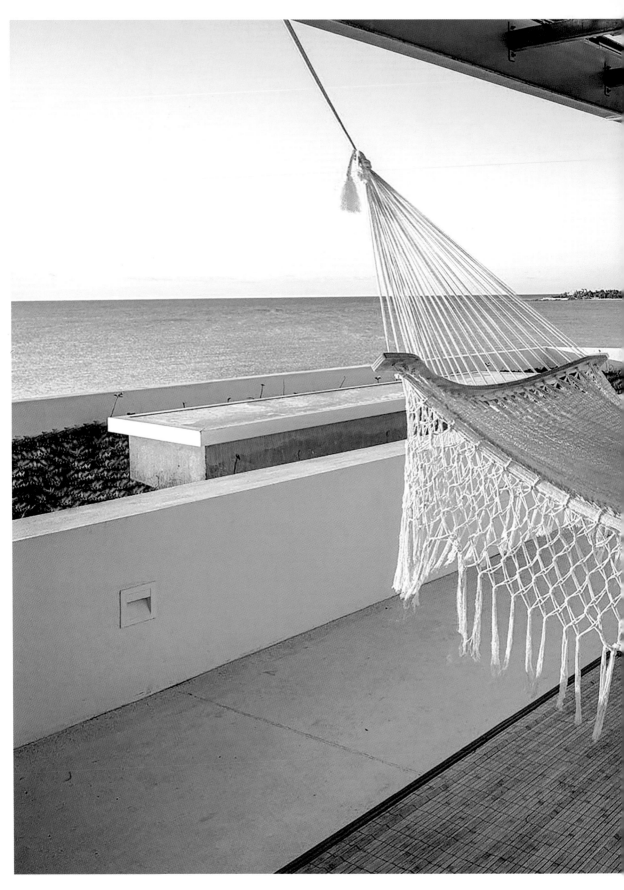

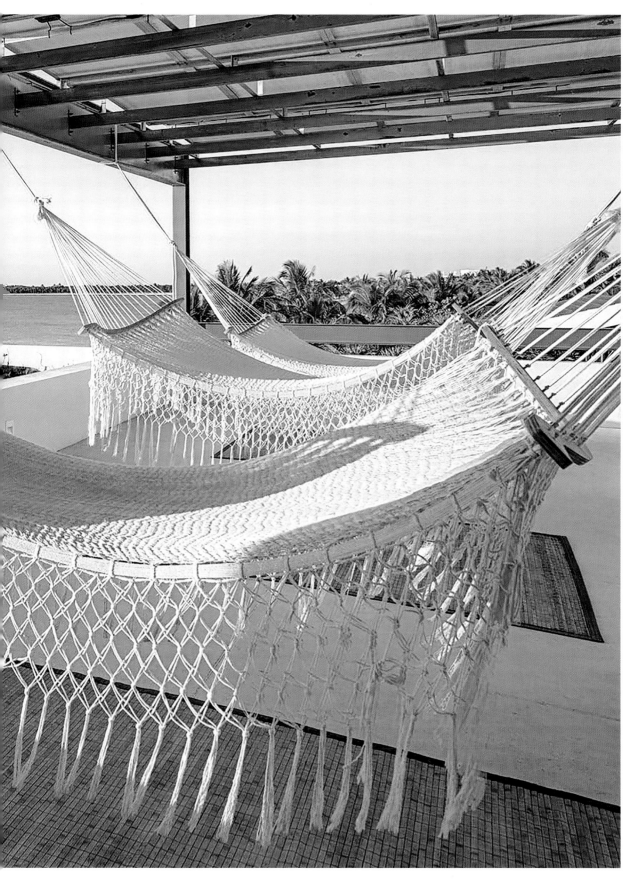

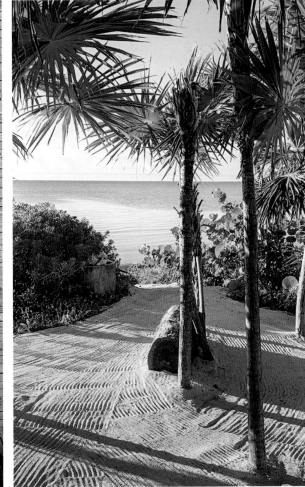

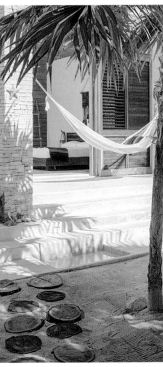
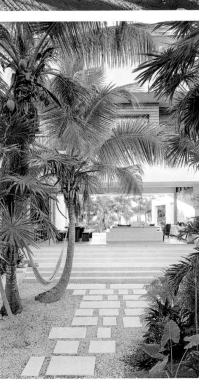

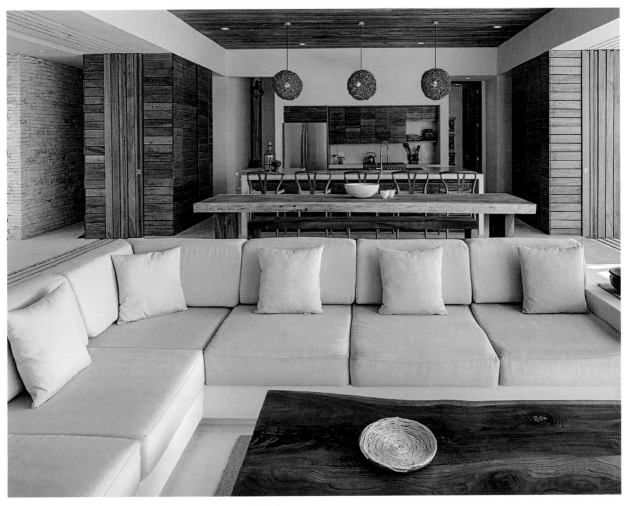

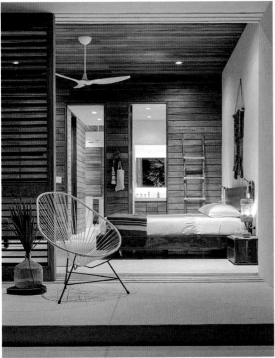

OPPOSITE PAGE: Hammocks are sprinkled throughout the native tropical grounds which feature home-grown coconuts, bananas, vegetables and herbs.

ABOVE: Ecological luxury, Tulum Villa is a beautiful combination of wood, pasta tiles, limestone, polished concrete and neutral soft furnishings.

LEFT: The superb craftsmanship of wood – from wall panelling to furniture to louver detail – is eye catching.

OVERLEAF: The turquoise blue swimming pool invites you to step outside and take a dip whilst still enjoying the ocean vista beyond the swaying palm trees.

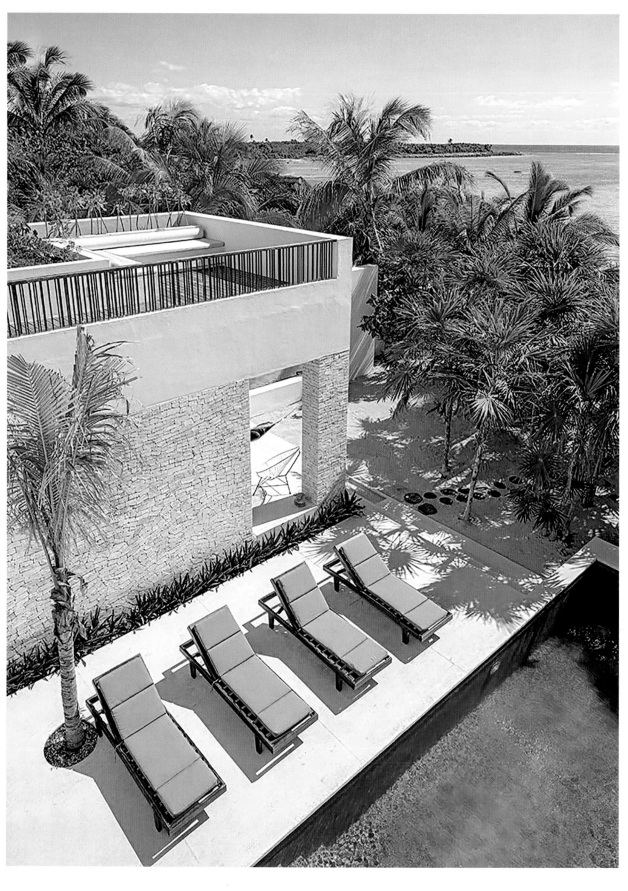

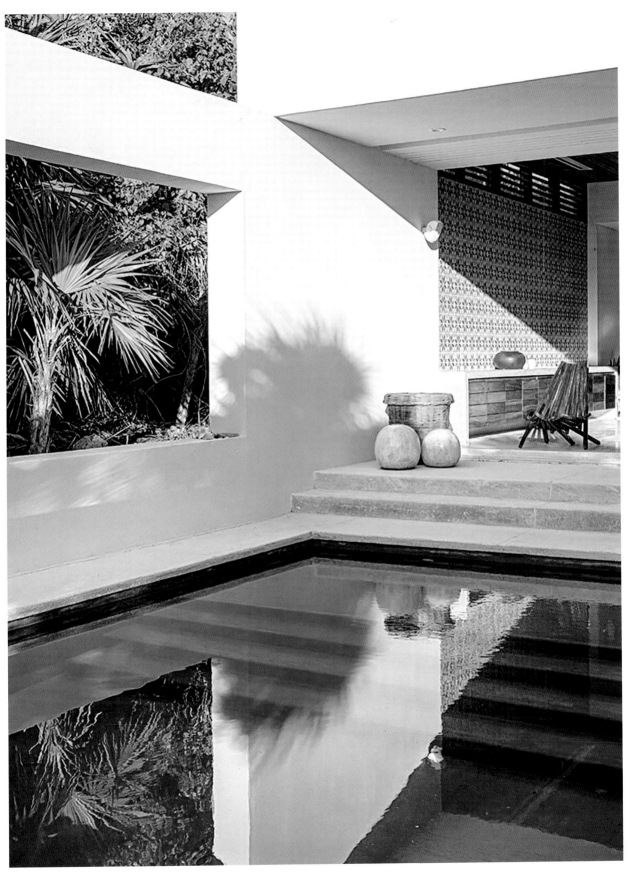

YUCATAN MARGARITAS
WITH TROPICAL FRUIT

The golden rule when assembling this cocktail, is to use a proper ratio of the ingredients used, in order to present a balance of flavours. A perfect margarita is tart and not too sweet. It is served ice-cold in a salt-rimmed margarita glass. There are many serving variations including straight-up, on-the-rocks and frozen, all of them giving the recipient a wonderful taste sensation and each perfect to drink on a hot afternoon or evening. For best results use 3 parts tequila, 2 parts triple sec and 1 part freshly squeezed lime juice. Always make sure that you have clean ice cubes and plenty of them!

INGREDIENTS
12 lime wedges
175 ml (6 fl oz) papaya nectar
40 g (1½ oz) granulated (white) sugar
175 ml (6 fl oz) guava nectar
750 ml (1¼ pints) sweet-and-sour mix
120 ml (4 fl oz) canned cream of coconut
16 ice cubes
1 cup tequila
12 lime slices, to garnish

GLASS
200 ml (7 fl oz) footed tulip

Serves 12

METHOD

» Rub the glass rims with a lime wedge and frost with sugar. Combine half of the remaining ingredients (except lime slices) in a blender. Process until well blended. Pour into glasses. Repeat with remaining half of the ingredients. Garnish each glass with a lime slice.

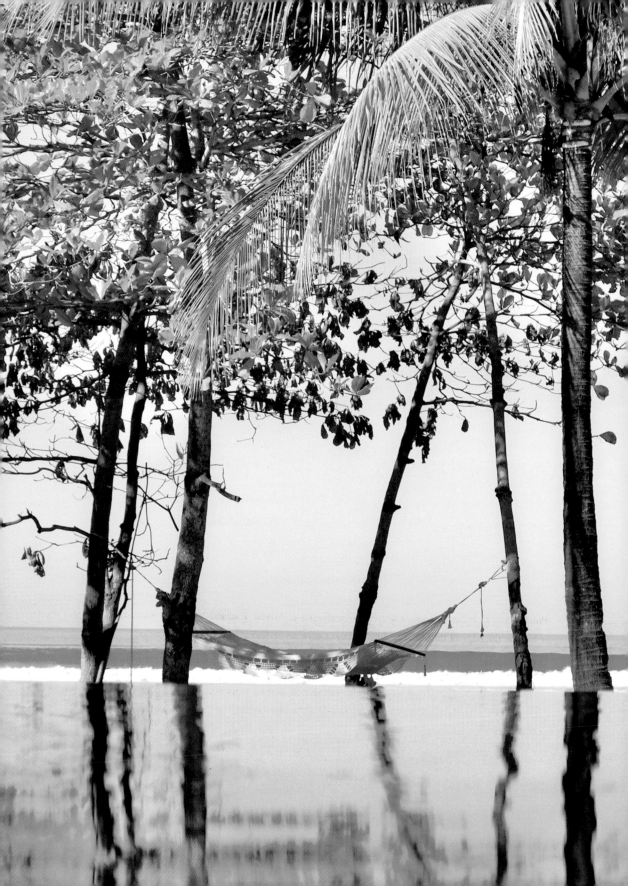

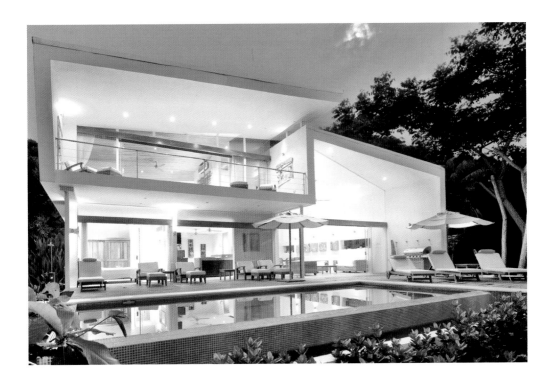

THE WHITE HOUSE, Santa Teresa, Costa Rica

You'll feel the sand in your toes in this architectural piece of heaven on the beachfront of Playa Hermosa, just north of Santa Teresa in the Mal Pais area of Puntarenas, Costa Rica.

Designed by Los Angeles architect, Michael Poirier of Poirier Designs, the contemporary design influenced by the local 'Tico Style' of Costa Rica allows an indoor/outdoor holiday experience, no matter the weather, in this pristine location known for its large surf.

Poirier drew inspiration from the tropical aesthetics of Miami, Thailand and Costa Rica for this holiday home built at the edge of the high tide line and next door to exclusive yoga resort, Pranamar.

The construction is a constant concrete framework with wood ceilings and floor to ceiling frameless glass allowing the lines of interior and exterior to blur.

The double-height spaces and large overhangs offer protection from the local climate conditions which vary from the extreme heat and sun in the dry season to the monsoonal rains in the wet season.

OPPOSITE PAGE: The absolute ocean front position never fails to impress and the ocean front infinity pool is the easiest feature to fall in love with.

ABOVE: A beachfront architectural jewel adjacent to Pranamar, Costa Rica's most exclusive yoga resort. Playa Hermosa is home to a plethora of tidal pools and vast expanses of soft white sand.

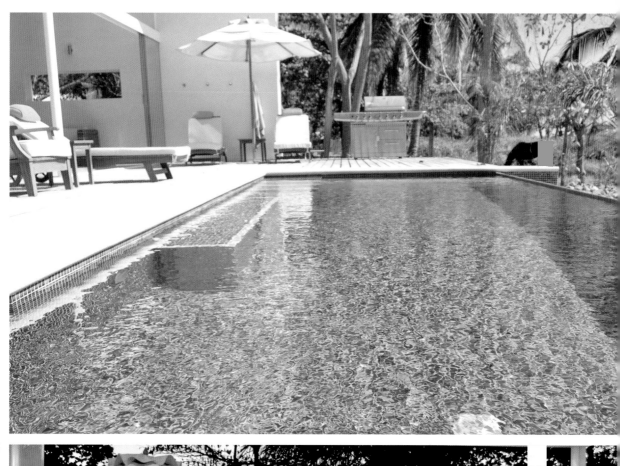

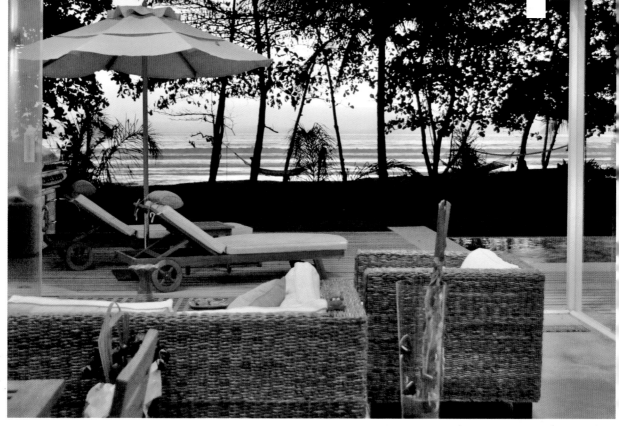

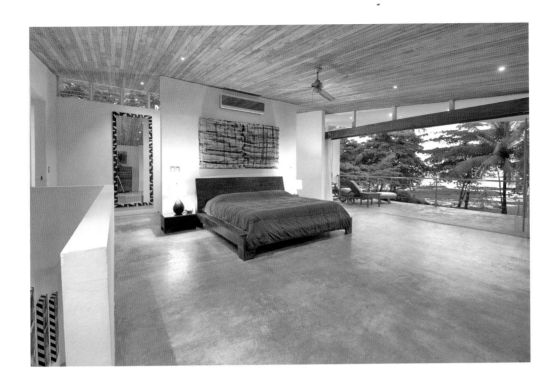

With the Pacific Ocean literally as your backyard, there are beach views from almost every room in this three-bedroom home.

The master bedroom, situated on the top floor, enjoys generous proportions with polished concrete floors, private bathroom, king-size bed and large covered balcony extending the room outdoors.

Downstairs, just beneath the master bedroom, is the poolside queen room with a view and easy access to the deck and stunning infinity pool whilst the back bedroom features two single beds – a peaceful retreat from the action.

The gourmet chef kitchen, also with incredible ocean view, allows for meal preparation with a side of sunset at the end of the day.

The living space is the real "Pura Vida" – a term popular in Costa Rica, which translates to "Pure Life" in English, but to Costa Rican people has a far more profound meaning – allowing for spirited or relaxed gatherings for family and friends.

OPPOSITE PAGE ABOVE: While away the days floating in the infinity pool taking in the stunning scenery which even includes friends of the equine variety.

OPPOSITE PAGE BELOW: Rattan outdoor furniture and wooden sunbeds allow for relaxing choices poolside.

ABOVE: The expansive master bedroom features a kingsize bed, private bathroom, polished concrete floors and balcony overlooking the infinity pool.

OVERLEAF: The indoor/outdoor living and dining area is easily the favorite room in the home with its muted neutral tones of wood and white furnishings that overlooks the beachfront of Playa Hermosa.

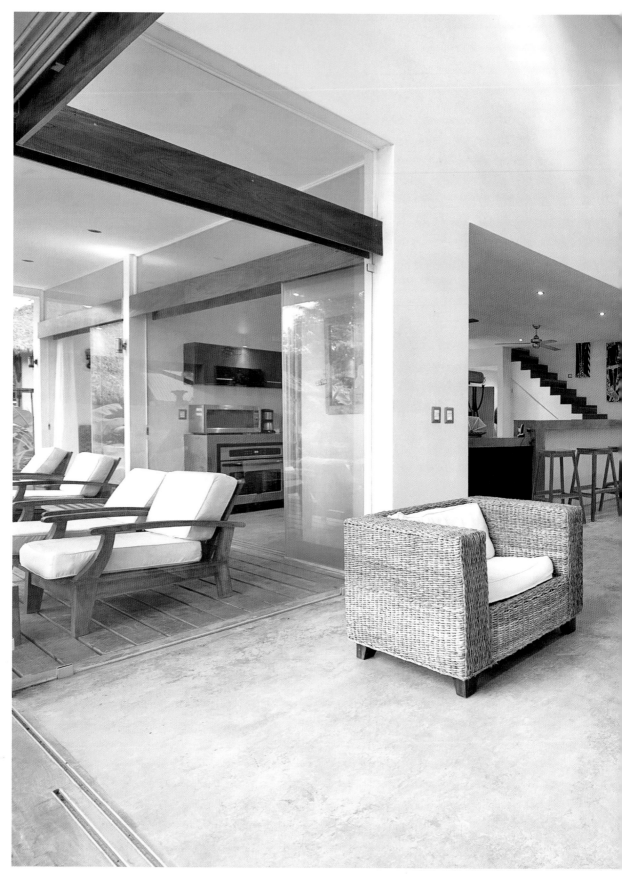

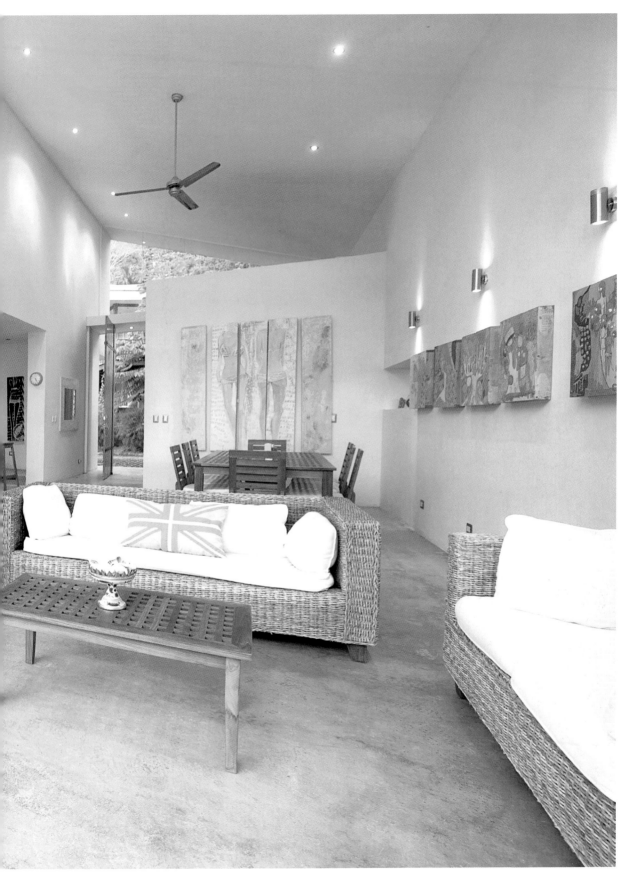

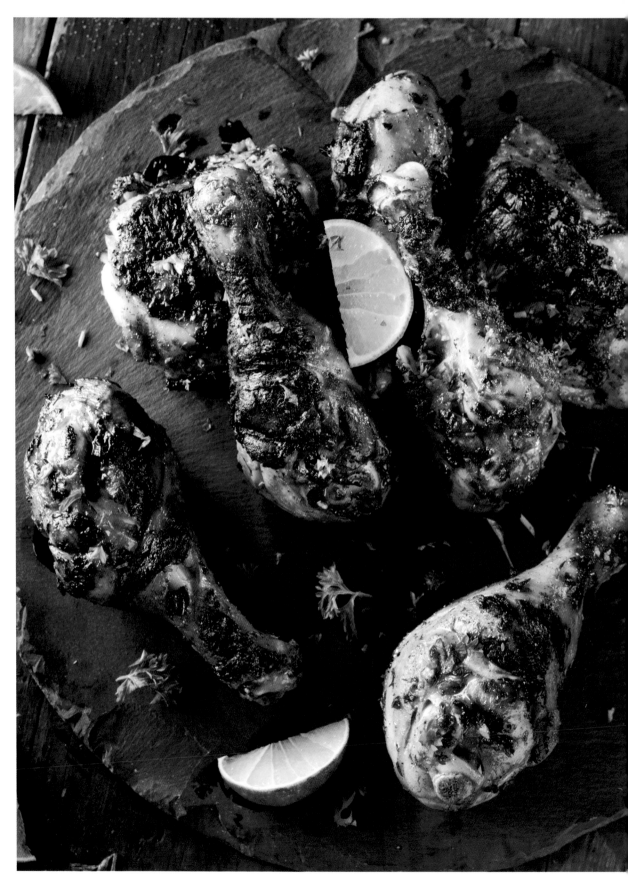

JERK CHICKEN LEGS

INGREDIENTS

12 chicken legs

1 small onion, finely chopped

2 stalks of spring onions (scallions),
 finely chopped

1–2 teaspoons fresh thyme
 (you can use ½ teaspoon dried thyme)

1–2 teaspoon allspice

½ teaspoon nutmeg

½ teaspoon cinnamon

2½ cm (1 in) piece fresh ginger

2 cloves garlic

½ teaspoon chilli
 pepper (add more if needed)

1 teaspoon vegetable oil

60 ml (2 fl oz/¼ cup) cider vinegar
 (you can use white)

juice of 2 limes

salt and pepper, to taste

FOR GARNISH

coriander (cilantro) leaves, chopped

4 limes, cut into wedges

Serves 4

METHOD

» Add all the ingredients except the
 chicken to a food processor and
 combine to make the marinade (or
 mix them in a bowl with a whisk if you
 don't have a food processor).

» Place the chicken in sealable plastic
 bag, cover with marinade for 4 hours
 minimum or overnight if possible.

» Preheat your barbecue to medium –
 use a charcoal barbecue if possible.
 Remove the chicken from the
 marinade, allow 10 minutes to come
 to room temperature and cook for
 20 minutes turning until the chicken
 is cooked through. When pierced,
 the juices should run clear. Rest for
 10 minutes.

» Serve on a platter. Garnish with
 coriander leaves and lime.

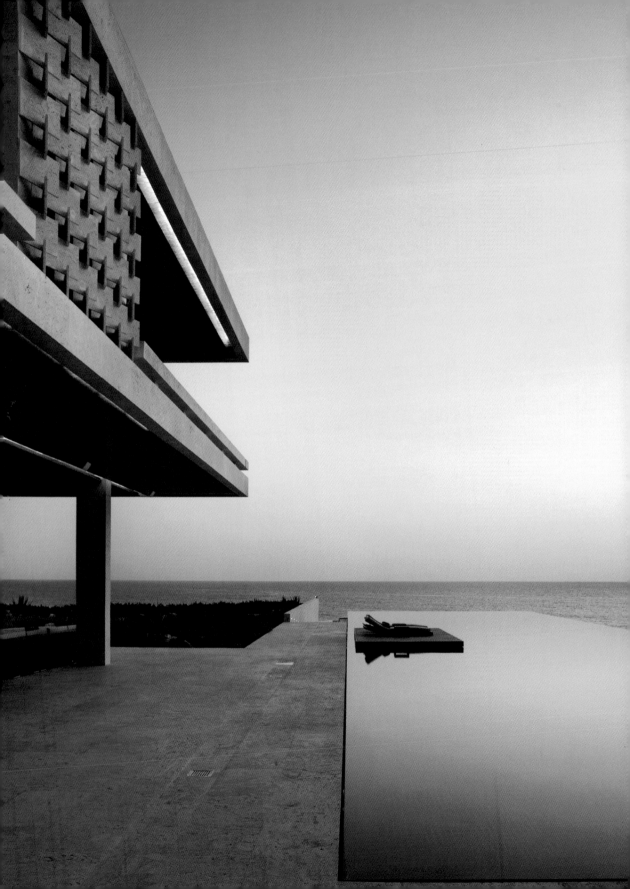

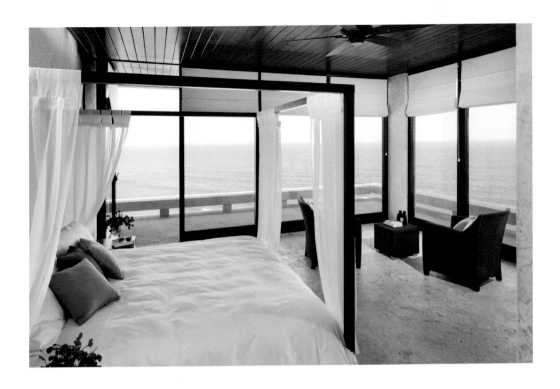

CASA KIMBALL, Dominican Republic

Just east of Playa Grande in Cabrera, you'll find Casa Kimball, an exclusive eight bedroom villa on the north coast of the island of the Dominican Republic.

The stunning Caribbean getaway was designed by New York architectural firm, Rangr Studio, for a New York client wanting a space large enough to accommodate his family and friends.

Situated on a cliff with a panoramic view of the Atlantic Ocean, the villa is approximately 1,850 square meters (20,000 square feet).

OPPOSITE PAGE: The jawdropping 45-meter (148-foot) infinity edge pool that appears to flow into the Atlantic Ocean is the focal point of the property.

ABOVE: One of the stunning bedrooms of the eight bedroom villa can accommodate up to eighteen people.

OVERLEAF: The dramatic infinity edge pool extends right to the sea cliff edge, taking in the expansive ocean views with a choice of sunbathing and seating options.

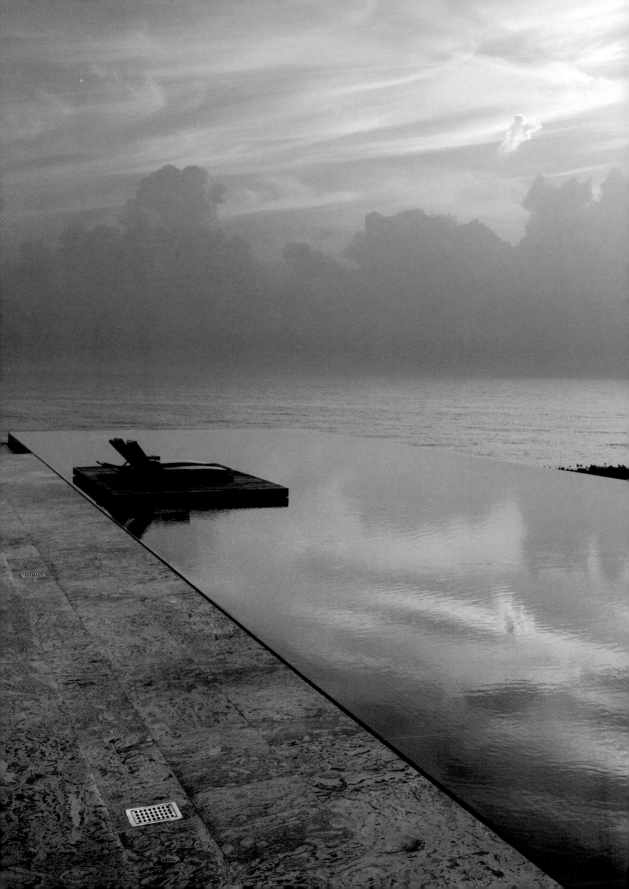

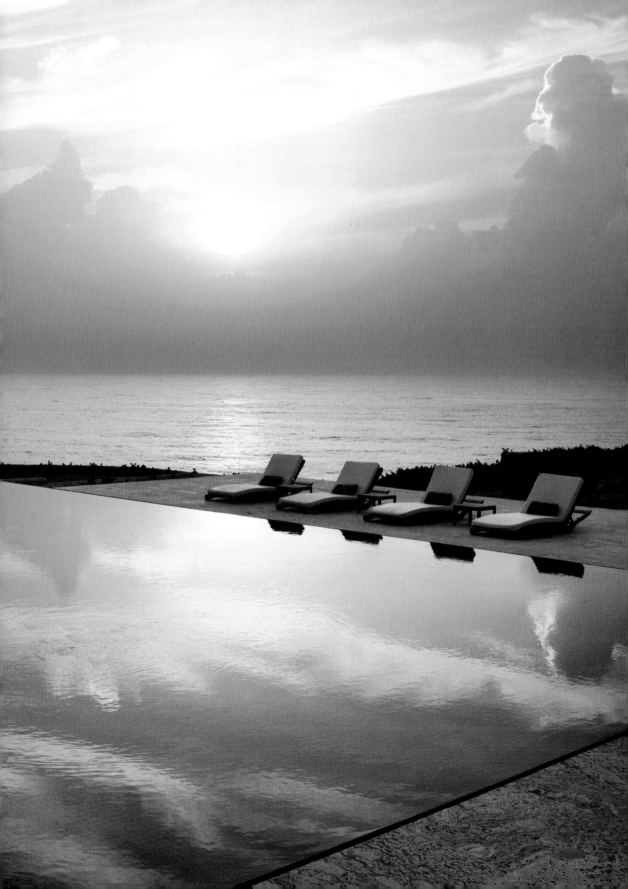

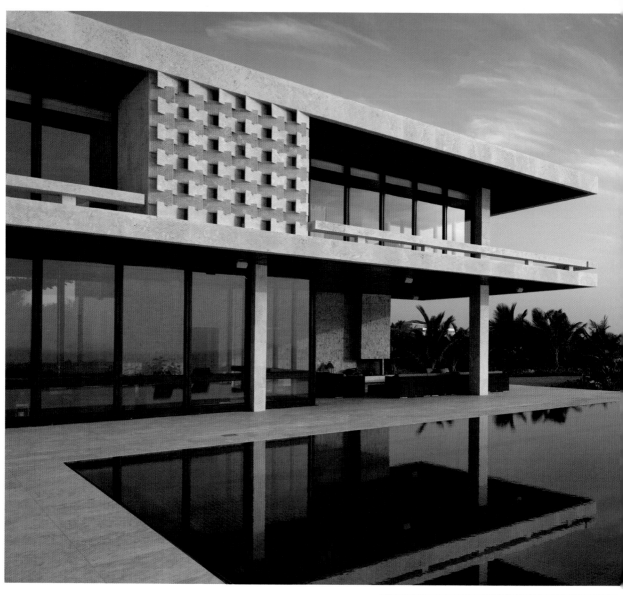

ABOVE: The infinity edge pool also features an oceanfront jacuzzi for a dramatic clifftop experience. Its discreet location is not visible from any point on the property.

RIGHT: Even the bathtubs take advantage of the amazing view.

OVERLEAF: This luxury private estate is situated on three acres (1.2 hectares) of pristine property facing the Atlantic Ocean surrounded by almond trees, coco palms and many flowering vines and shrubs native to the Dominican Republic.

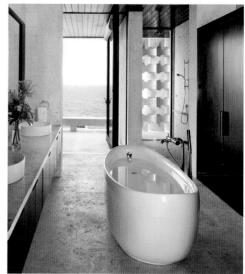

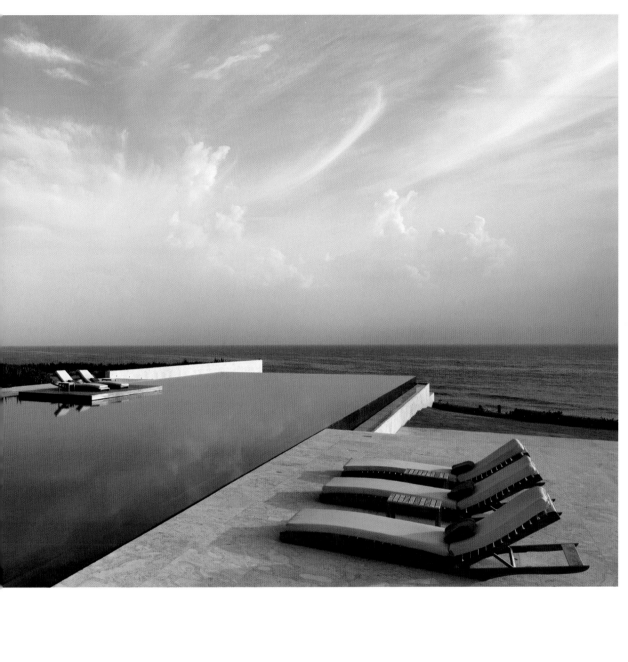

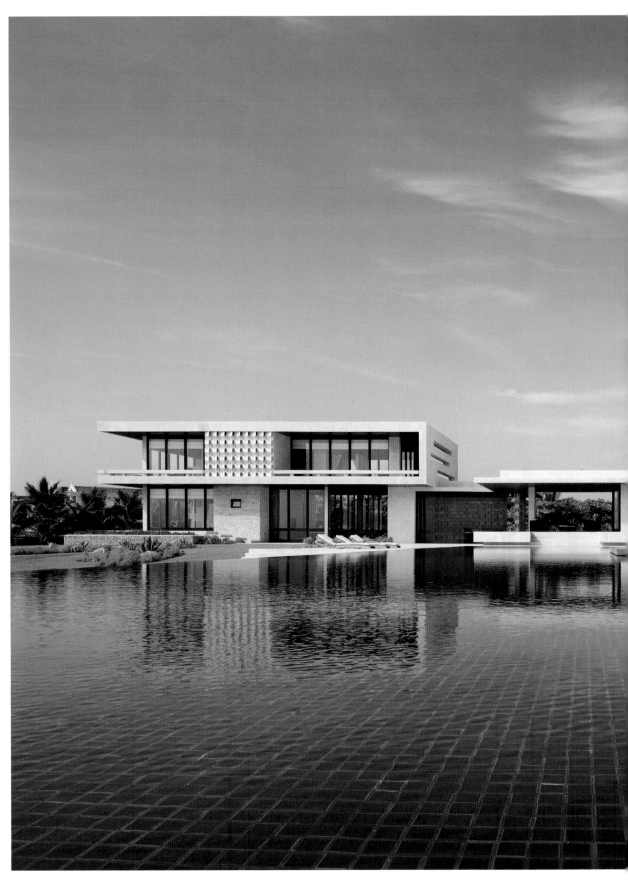

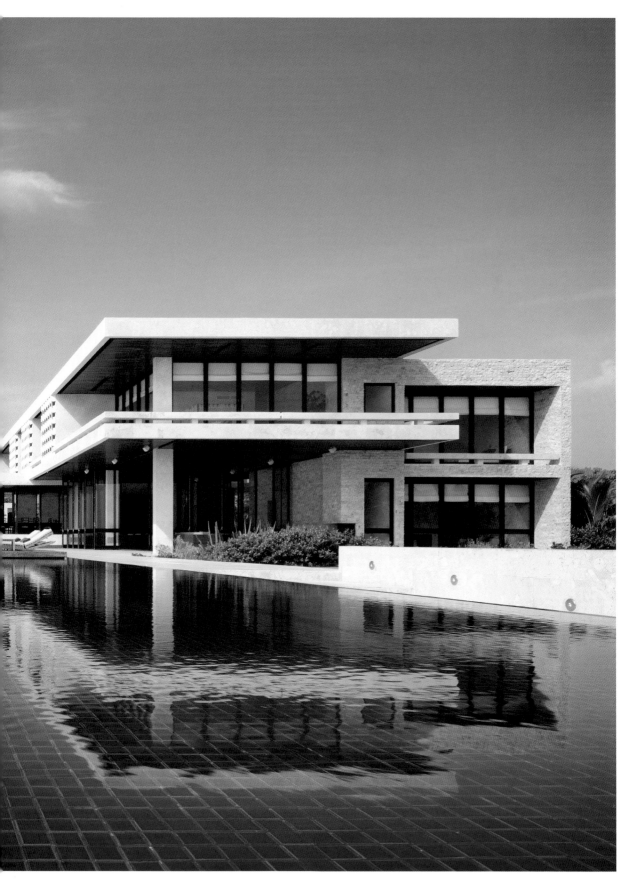

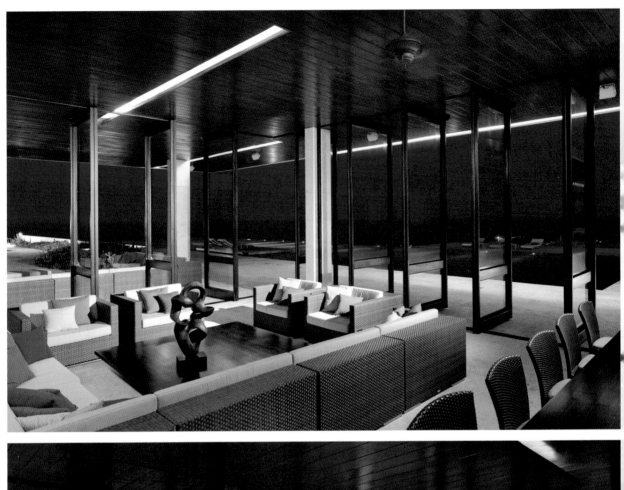

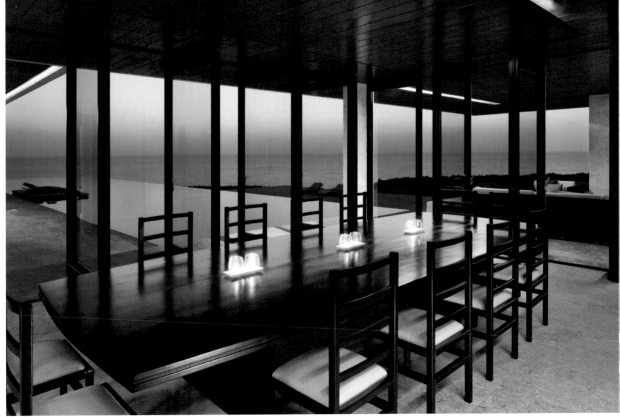

OPPOSITE PAGE TOP: The contemporary design features floor to ceiling windows constructed of dense Brazilian hardwood that swivel on wheel bearings to allow interior spaces to merge with the exterior.
OPPOSITE PAGE BELOW: The villa features a dining room with an impressive custom-made table that seats 20.
RIGHT: Landscaped gardens add to the indoor/outdoor ambience of the villa.

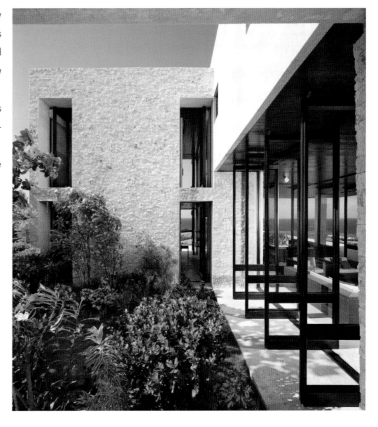

The villa features two indoor and two outdoor lounges, a dining room with an impressive custom-made table for 20 that takes in a breathtaking view centered on the 45-meter (49-yard) infinity edge pool out to the ocean and outdoor bar area. A jacuzzi at the cliff's edge showcases the power of the ocean as waves crash on the rocks below.

The design is contemporary and constructed of reinforced concrete, clad with local coral stone, with buildings designed to optimize privacy, protecting views from neighboring properties. The windows, constructed of dense Brazilian hardwood, swivel on wheel bearings, to allow interior spaces to merge with the exterior and cool ocean breezes to waft through the home.

The villa is nestled on three acres of oceanfront property surrounded by coco palms, almond trees, flowering vines and native trees.

A pathway along the cliff leads to a hidden terrace cut into the rocks with a fire pit as its centerpiece, an amazing location to contemplate life with a cocktail. The pathway continues to a private beach hidden away at the bottom of the cliff.

CARIBBEAN MARTINI

INGREDIENTS
1 slice lime
granulated (white) sugar
45 ml (1½ fl oz) light rum
1½ teaspoons dry
 vermouth
lime rind twist, to garnish

GLASS
90 ml (3 fl oz) martini glass

Serves 1

METHOD
» Run the lime slice around the rim of a chilled cocktail glass. Coat with sugar. Combine the liquid ingredients with ice in a cocktail shaker and shake well.
» Strain into the glass and garnish with the lime twist.

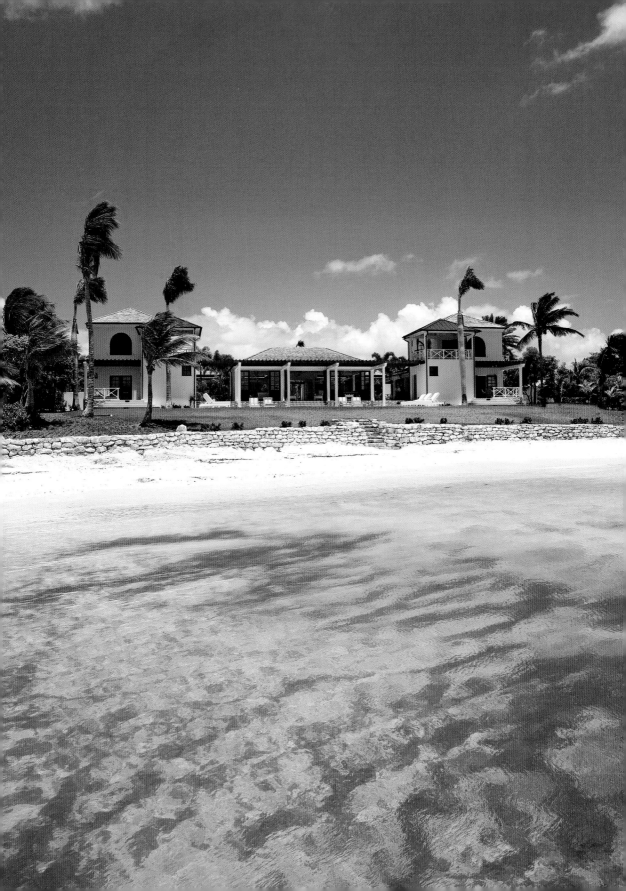

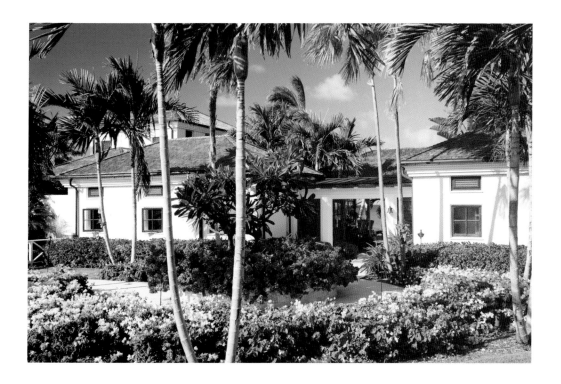

FRANGIPANI, Jumby Bay Island, West Indies

A long meandering driveway through a lush tropical landscape is your welcome to this stunning Caribbean-style estate.

The four-bedroom luxury villa sits on a secluded oceanfront property, positioned to take advantage of the cooling trade winds for natural ventilation. The rooms of the home are oriented to face the ocean and the breathtaking view. Rooms are configured around a grand outdoor living and dining pavilion with sweeping panoramic ocean views.

Perfect for entertaining, the home features a professional kitchen, dining table that accommodates 12 guests, barbecue area and family room with a built-in daybed to comfortably accommodate extra guests.

The villa has four bedrooms, five bathrooms, a private beach, swim dock and a freshwater swimming pool with trellised seating area.

OPPOSITE PAGE: The luxury four bedroom villa on the private island of Jumby Bay is positioned to take advantage of the passing trade winds for cool, natural ventilation.

ABOVE: Frangipani sits at the end of a long meandering driveway, passing through a mature and lush tropical landscape.

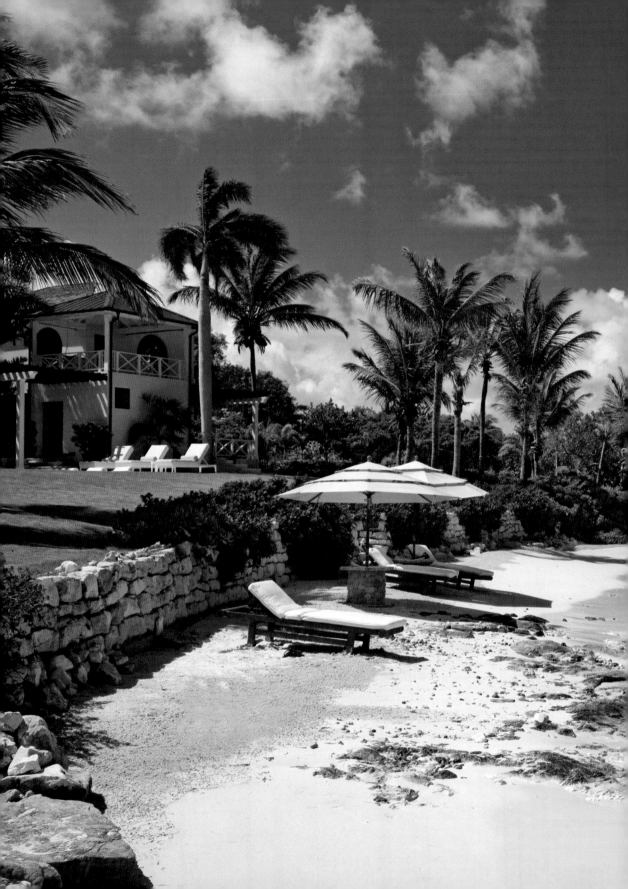

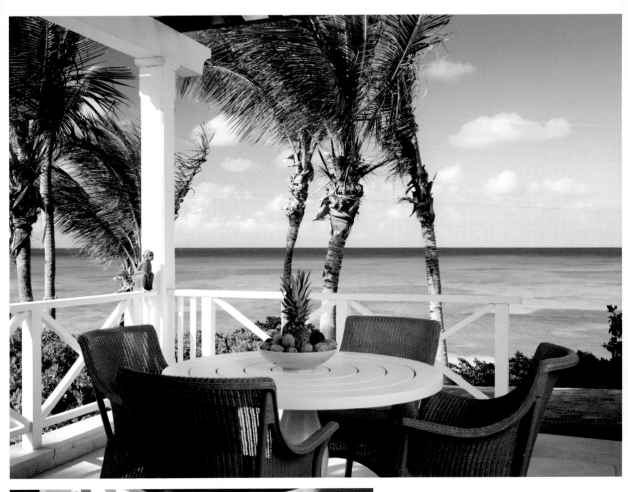

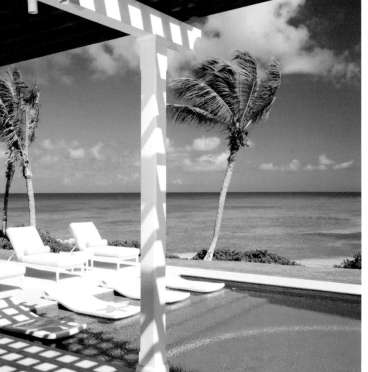

PREVIOUS SPREAD: Frangipani features its own private beach of blinding white sand and swim dock as well as a freshwater swimming pool with trellised seating area.

ABOVE: One of the finest spots in the villa to take breakfast amongst the gently swaying palms.

LEFT: One of your days toughest decisions will be whether you relax on the chaise lounges on the beach or the lounge furniture on the terrace by the infinity pool. Here your private chef will bring you delicious barbecued local seafood accompanied with fresh herbs from the garden.

OVERLEAF: Bright colors, open-sided rooms and vaulted ceilings lend irresistible charm to the interiors of Frangipani. The kitchen, living and dining rooms feature casual arrangements of white-painted furniture with cheerful blue upholstery with accents of yellow.

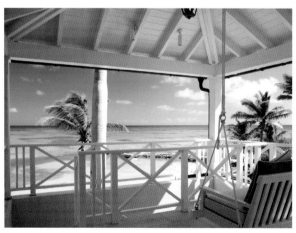

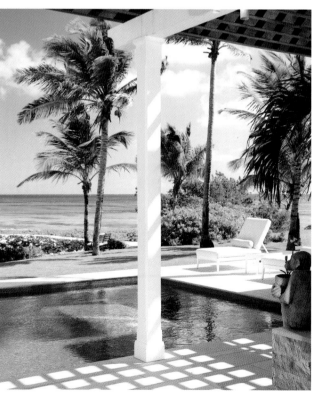

ABOVE TOP: Chic and relaxed, the bathrooms reflect the dreamy blue hues of this tropical getaway highlighted with crisp white accents.

ABOVE: Essential for the ideal tropical getaway is a porch swing for relaxing in the breeze.

RIGHT: Most of the rooms in Frangipani face the stunning azure blue ocean, configured around the outdoor living and dining pavilion.

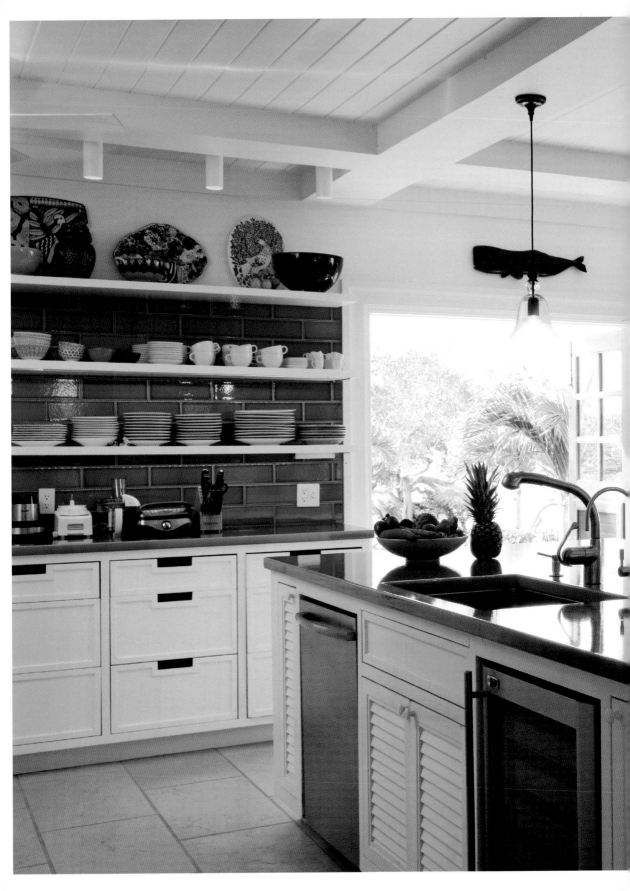

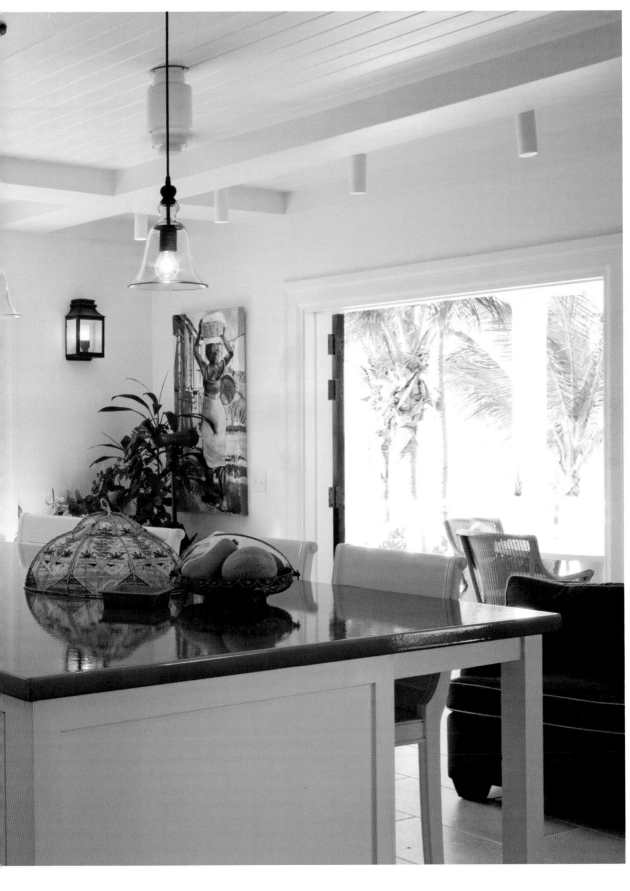

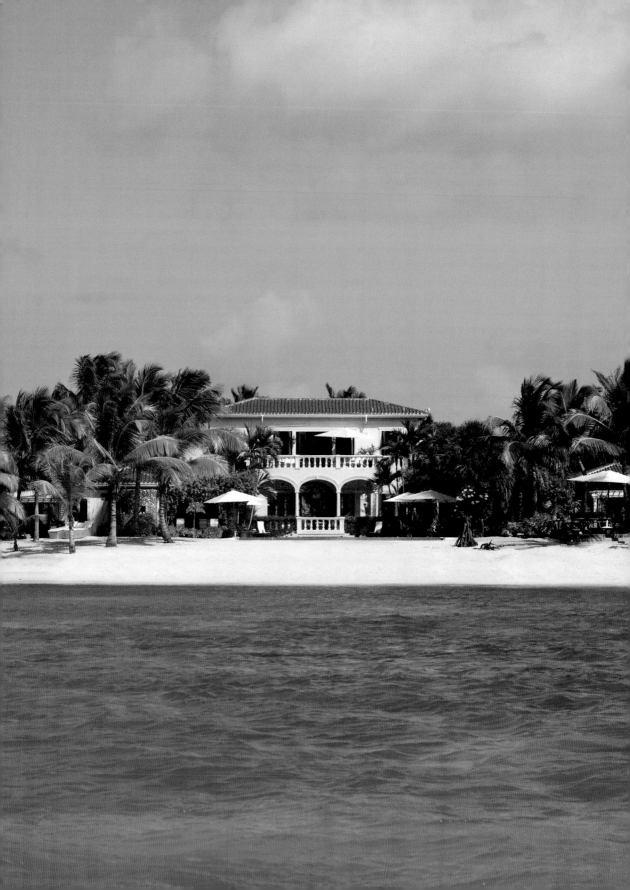

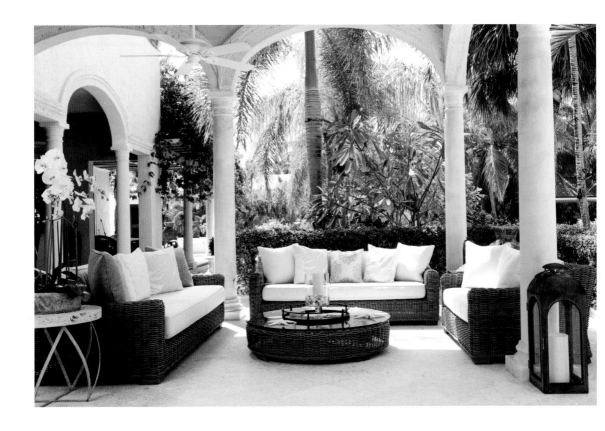

LA CASA, Jumby Bay, West Indies

This exquisite British Colonial style villa – 930 square meters (10,000 square feet) – is set on three acres (1.2 hectares) of lush tropical gardens. The home is located on the breathtaking coral sands of Pasture Bay.

Inside the house you'll find a drawing room, dining room and a modern, fully equipped kitchen. The library with vaulted wood ceiling and overstuffed sofas offers the perfect spot to curl up with a good book.

The master bedroom, on the second floor, features bespoke furnishings with an ensuite bathroom complete with claw foot soaking tub. The suite opens onto a furnished private balcony that overlooks the pool and beach.

OPPOSITE PAGE: La Casa, a traditional British Colonial style villa, is set on three acres (1.2 hectares) of lush tropical landscaped gardens on the stunning coral sands of Pasture Bay.

ABOVE: Luxury reminiscent of another era, the generous rattan sofas provide a relaxing space on the terrace with graceful archways and beamed ceilings.

OVERLEAF: Overlooking the coral sands of Pasture Bay, covered terraces with graceful archways and beamed ceilings and sumptuous furnishings bring an indoor feel to the outdoors.

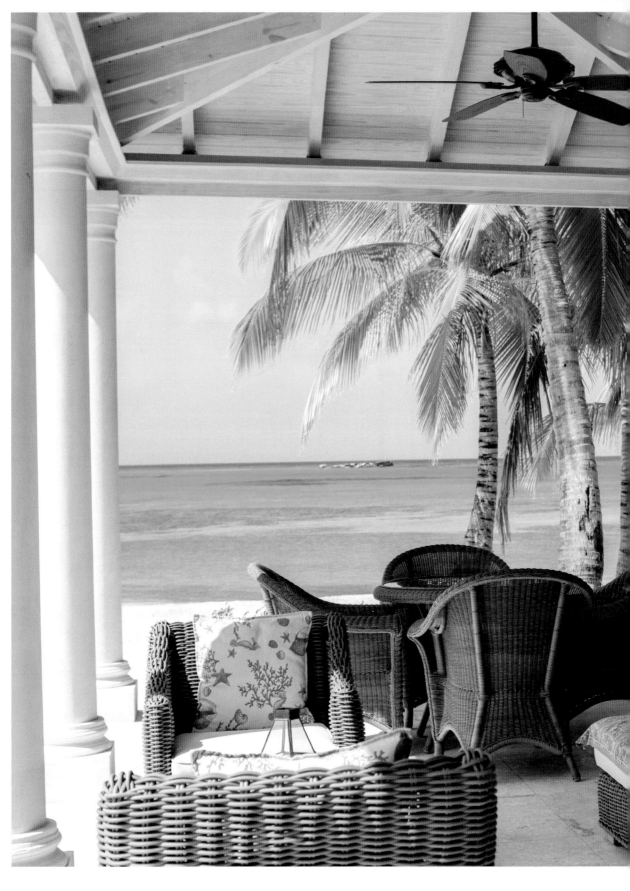

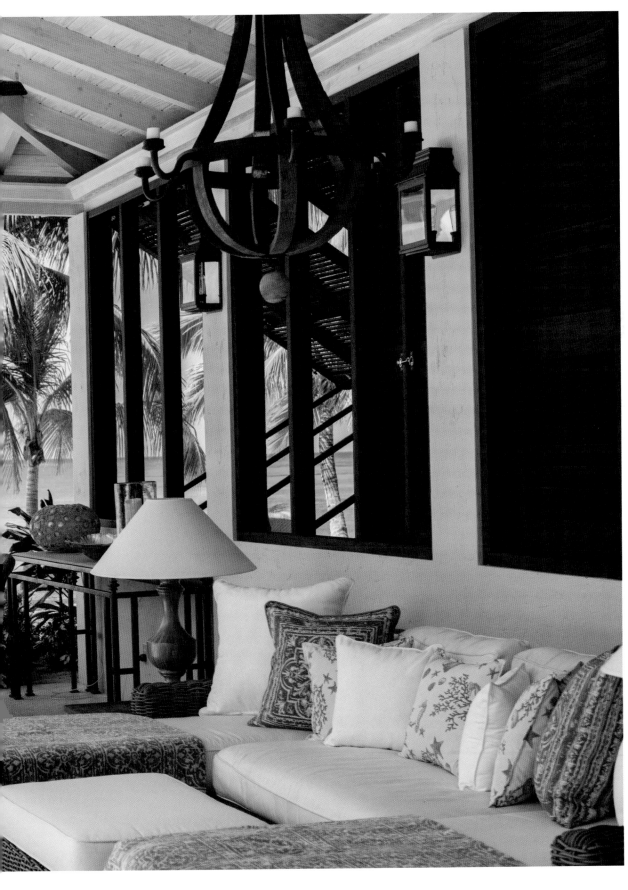

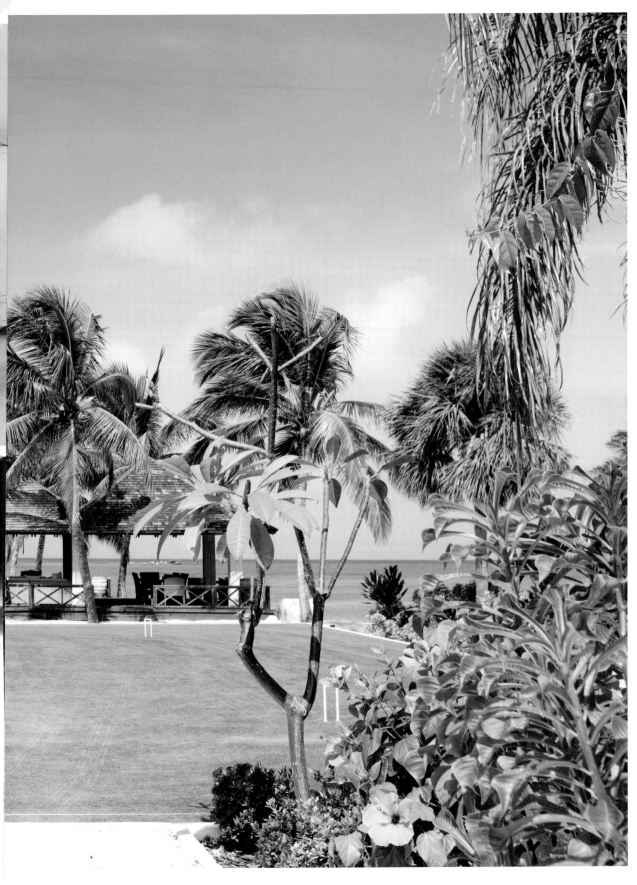

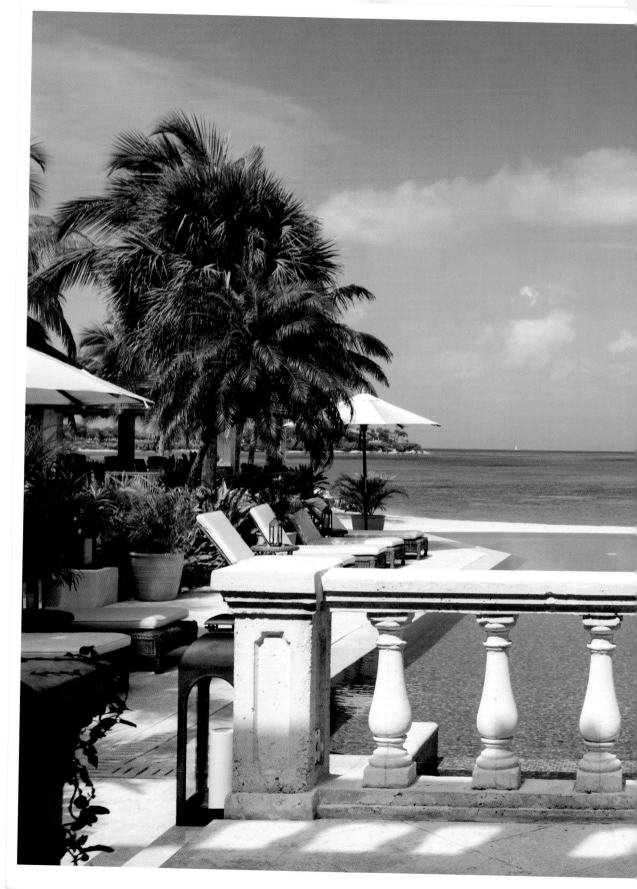

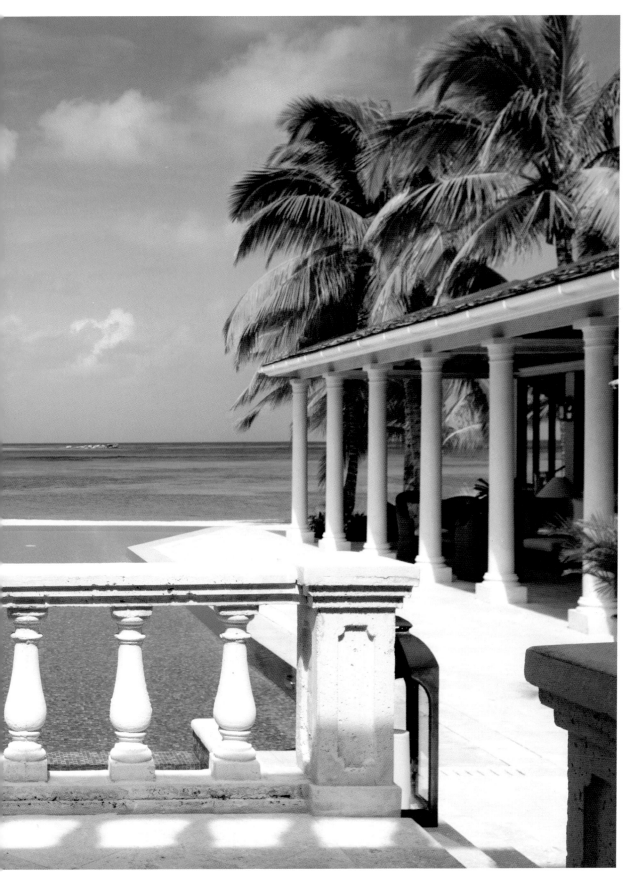

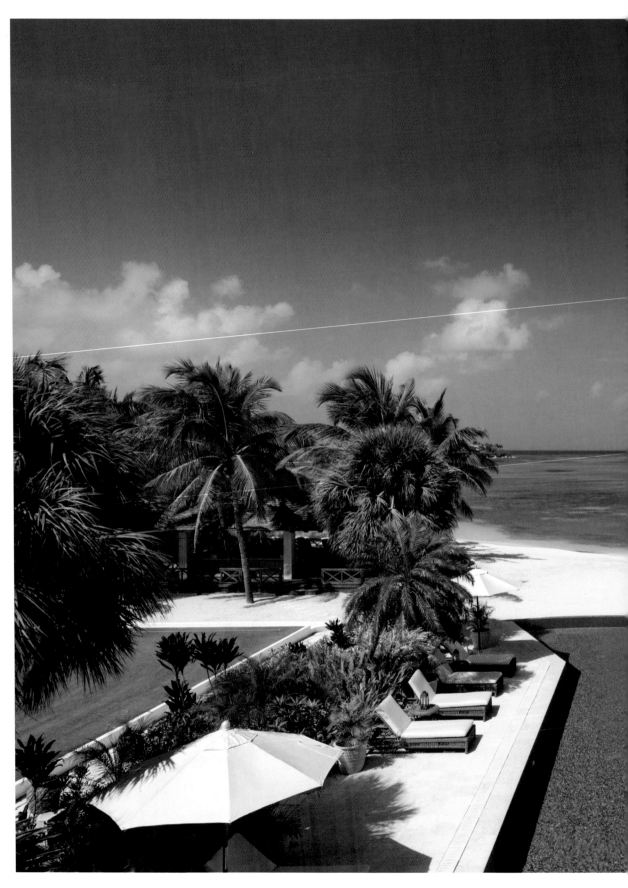

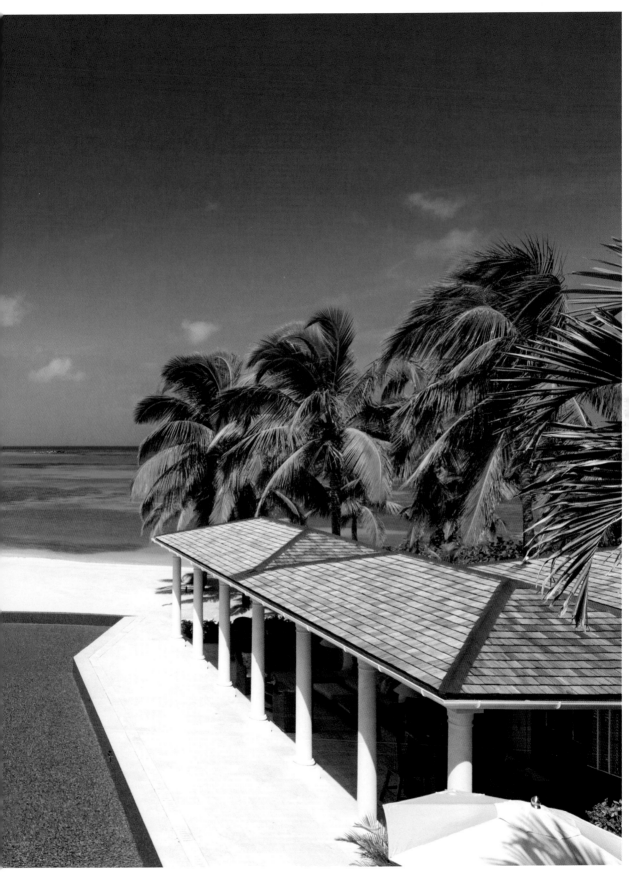

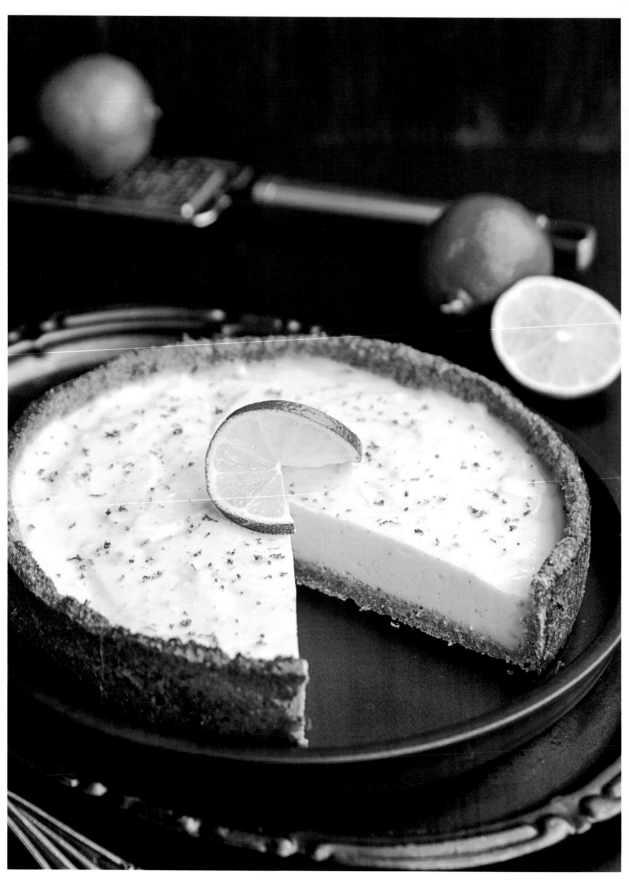

KEY LIME PIE

INGREDIENTS

200 g (7 oz) wheatmeal or
 Granita biscuits
4 tablespoons (¼ cup)
 ground almonds
1 tablespoon caster sugar
100 g (3½ oz) butter,
 melted
4 eggs, lightly beaten
395 g (14 oz) can
 condensed milk
150 ml (5 fl oz / ⅔ cup)
 cream
4 limes, juice and rind,
 finely grated
extra lime rind,
 finely grated, to garnish
slice of lime, to garnish

Serves 4

METHOD

» Preheat oven to 170°C (325°F). Line base of a 20cm
 (8in) springform pie dish with baking paper.
» Process biscuits until fine crumbs. Add almonds, sugar
 and butter, process until combined. Press mixture
 firmly into the base and 3cm (1.2in) up the side of
 dish. Refrigerate.
» Whisk eggs, milk, cream, lime rind and juice until
 smooth. Pour into the biscuit crust.
» Place the pie dish on a baking tray and bake for 40–45
 minutes or until set. Cool. Sprinkle with finely grated
 lime rind. Add a slice of lime and serve.

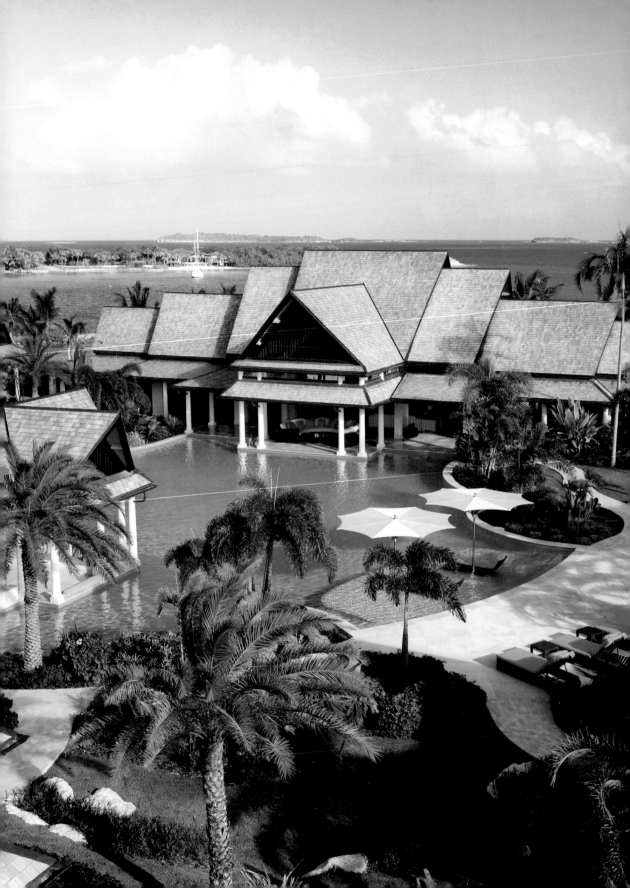

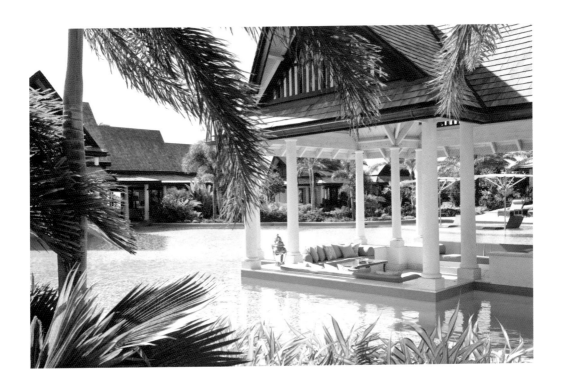

LAZY LIZARD, West Indies

A luxurious fusion of Caribbean and Asian architecture defines this exceptional beachfront estate. The property is essentially a series of eight pavilions gathered around a spectacular free-form swimming pool with floating dining pavilion – all set on five tropical acres (2 hectares).

Conceived as an escape for friends and family, the design is testament to the relaxed, serene and elegant ambience (and very social nature) of the property.

The six bedroom suites are housed in separate pavilions surrounding the main house which includes two master suites with amazing views of the sea.

OPPOSITE PAGE: The large free-form swimming pool with tropical landscaped gardens is the focal point of the estate which fuses Caribbean and Asian architecture.

ABOVE: The free-form swimming pool has a sunken lounge area the extends into the pool – the ideal spot to stay cool on hot days.

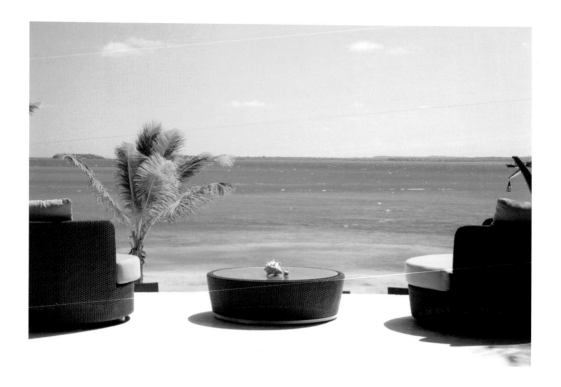

Each bedroom suite features large living areas with sleek and stylish ensuite baths, custom stonework and private outdoor gardens with rain showers.

The two master bathrooms feature baths carved from ivory travertine (a form of limestone). The spacious open air living and dining room, contemporary kitchen, media room and office open onto a spectacular swimming pool set in the middle of the estate with a floating dining pavilion.

A short stroll away is the estate's tennis court with pavilion and fitness centre.

ABOVE: Take in the incredible beachfront location on the Caribbean's warm turquoise waters from a generous sun lounge on the terrace beside the sprawling pool that forms the heart of the villa.

OPPOSITE PAGE: The outdoor master bathroom features a generous bathtub carved from ivory travertine set in a private garden with rain showers.

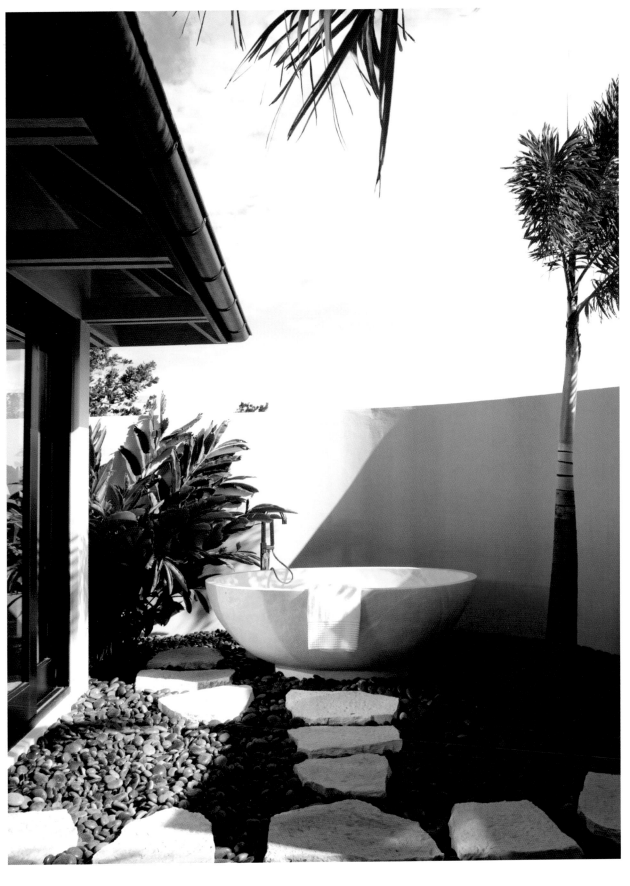

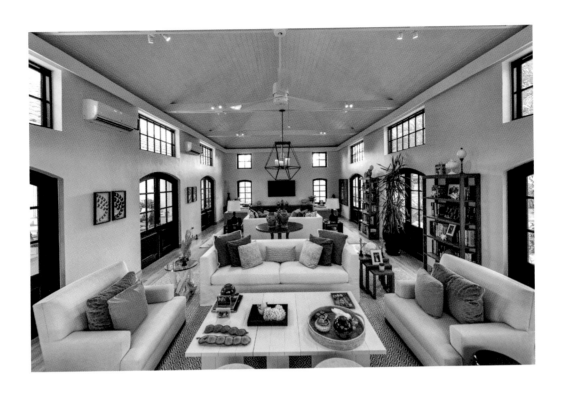

MARIPOSA, Jumby Bay Island, West Indies

Situated at the eastern end of Jumby Bay Island off the coast of Antigua, Mariposa looks out to stunning views of Buckley Bay. It boasts a secluded location spread over an opulent nine acre (3.6 hectare) tropical seascape.

Designed by architects from Leroy Street Studios, Mariposa features alluring interiors by designer Deborah Wecselman.

With eight bedrooms each with their own bathrooms, Mariposa is a peaceful hideaway that captures the spirit of Caribbean living complete with carefully designed outdoor spaces that include a seated dining area, a fire pit with comfortable lounge seating and an outdoor bar.

The property features an infinity pool, tennis and basketball courts, a croquet lawn and putting green.

OPPOSITE PAGE: Think peaceful Caribbean hideaway, think gentle swaying palm trees over white sand and calm azure water. This is what Mariposa is all about.

ABOVE: Designed by Leroy Street Studios architectural firm, Mariposa's interiors were designed by Deborah Wecselman. Deborah began her career as a design associate in the store development department of Ralph Lauren. Deborah's specialty is producing spaces that are classically modern with hints of the past that complement contemporary living.

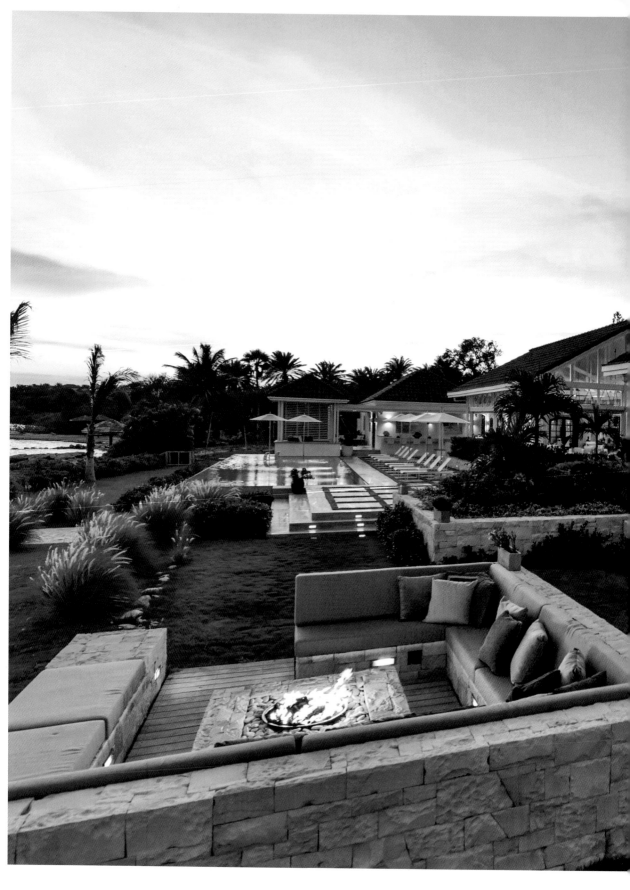

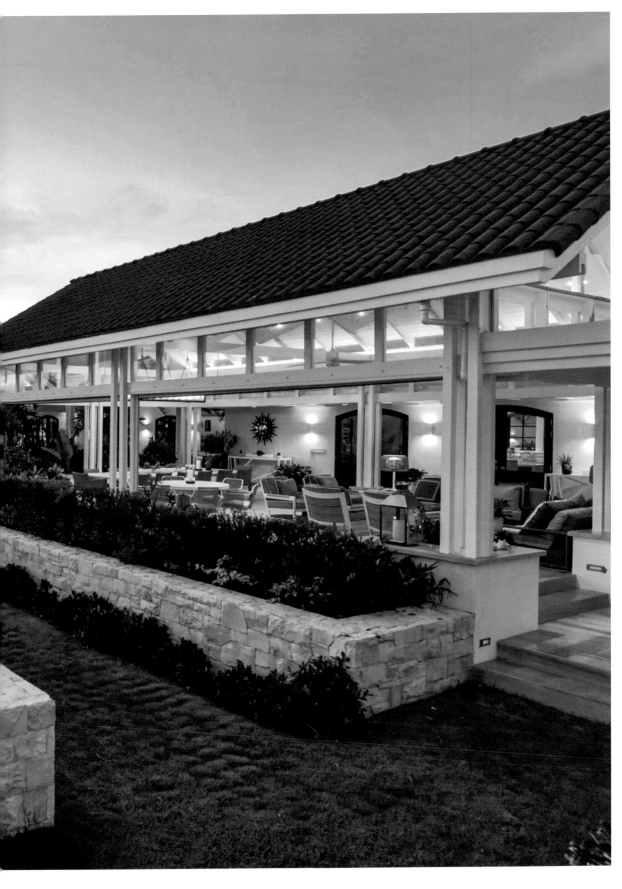

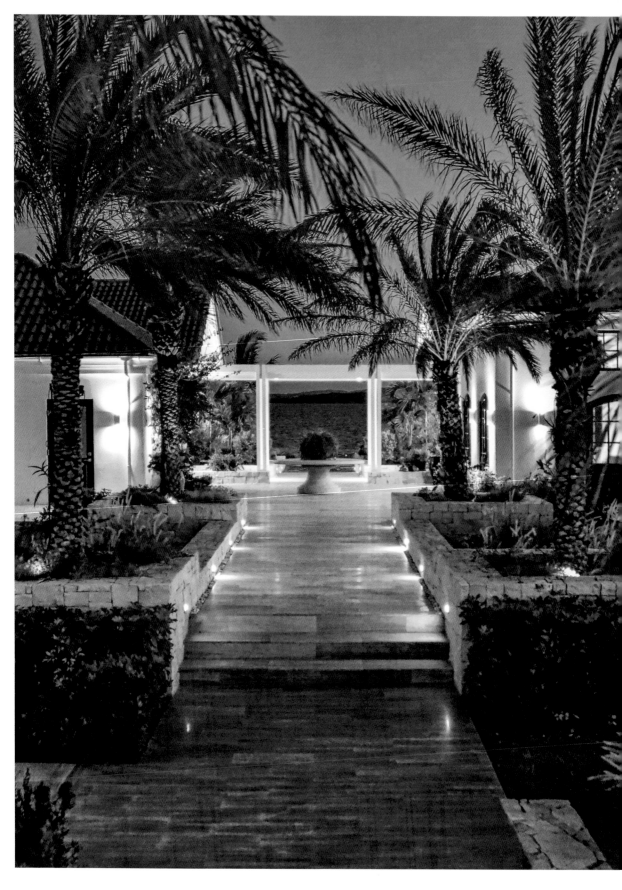

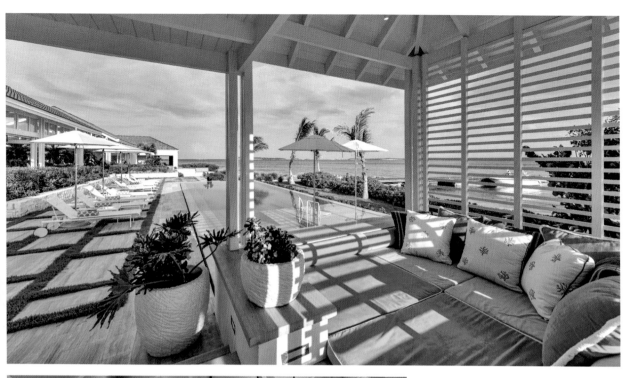

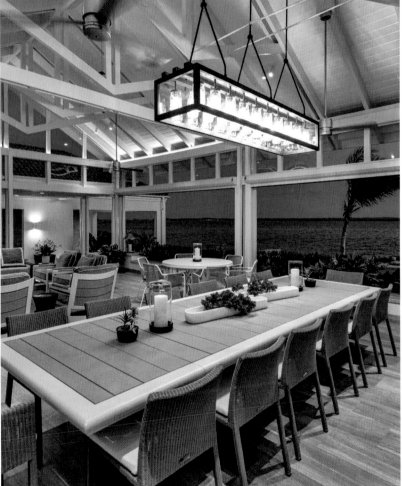

PREVIOUS SPREAD: Ease into the evening with a cocktail from the wet bar, feel the warm breeze as you dine al-fresco and linger into the night around the firepit.

ABOVE: Have a swim in the infinity pool or wade in off the beach, then set out from the private jetty for a paddle or boat ride around the bay. Such decisions.

LEFT: The main living areas run parallel to the pool and shoreline: first the outdoor great room, with a vaulted ceiling and open walls, then the indoor great room, with an equally airy double-height ceiling and rows of graphic black-edged French doors.

OPPOSITE PAGE: Mariposa is set on nine acres (3.6 hectares) on the eastern end of Jumby Bay Island, fronting the turquoise waters of Buckley Bay. Lush green lawns, paved paths and colorful flower beds are the manicured backdrop to this luxurious haven.

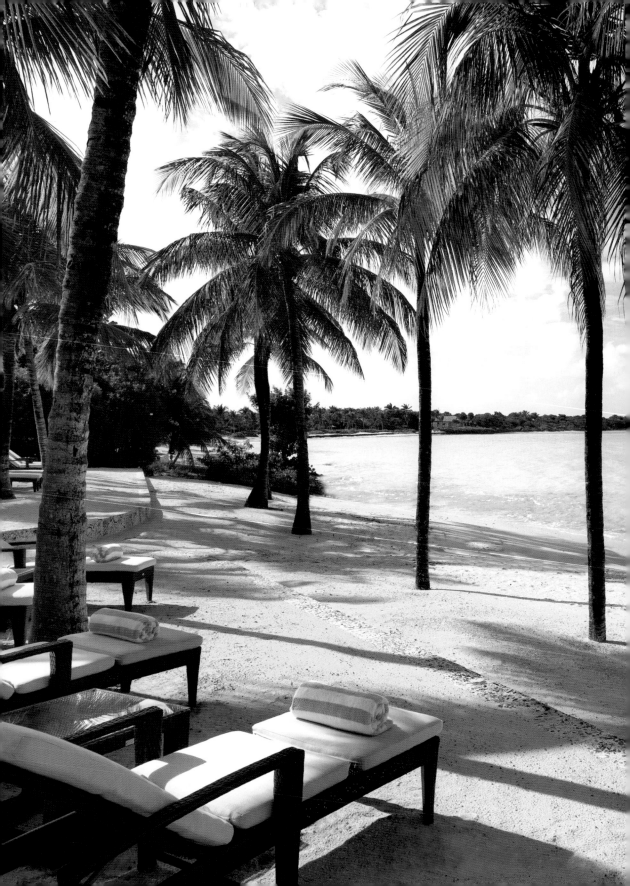

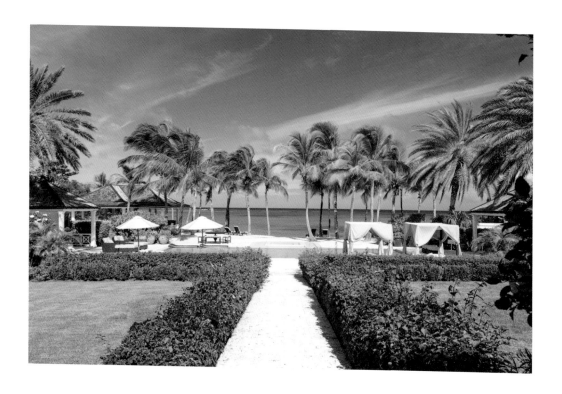

OLEANDER, Antigua, West Indies

Classical Caribbean architecture and colonial-style décor and furnishings blend beautifully in this elegant estate home on Pasture Bay.

Six generous bedrooms with ensuite bathrooms are encased by two large verandahs at the front and back of the waterfront property.

A tranquil paradise in the midst of Antigua, Oleander's breathtaking sea views and three acres (1.2 hectares) of manicured gardens come together with the inviting swimming pool and pool house for perfect indoor/outdoor living.

OPPOSITE PAGE: A sun lounge on the pristine sands of beautiful Pasture Bay beach awaits you at this stunning oceanfront property.

ABOVE: Oleander is a six-bedroom estate set on three acres of landscaped grounds including pool and tennis court.

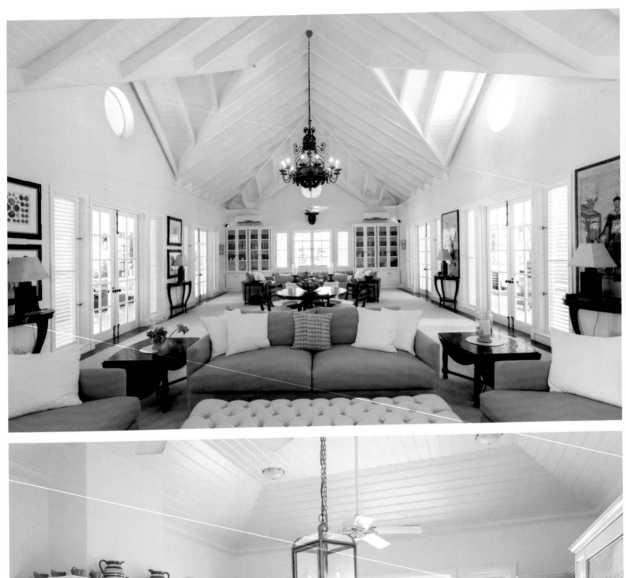

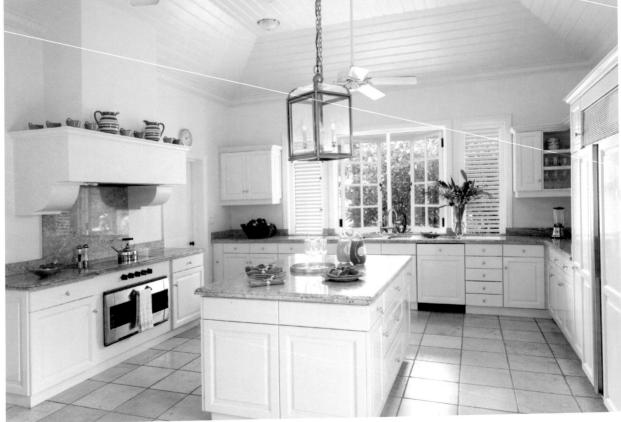

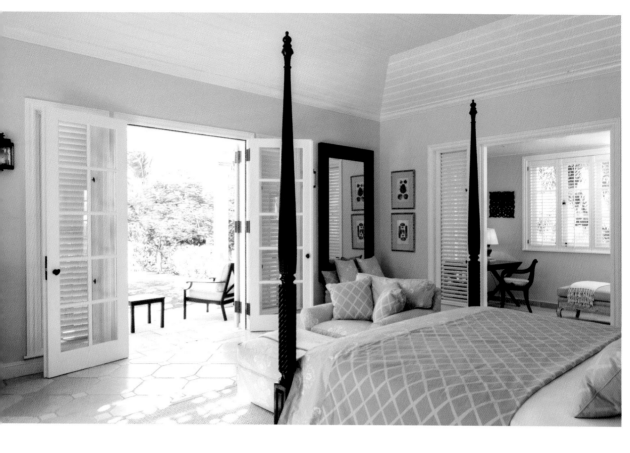

OPPOSITE PAGE ABOVE: Oleander's interiors are the perfect balance of chic beach living and estate elegance. With columned verandas at the front and back, louvered doors and white vaulted ceilings, Oleander's living room is a nod to traditional Caribbean architecture.

OPPOSITE PAGE BELOW: The white Hamptons style kitchen is fully equipped to whip up a gourmet meal or have your private chef rattle the pans.

ABOVE: One of the six bedrooms at Oleander, this one blends the chic beach feel with more traditional influences – dark wood four poster bed, white French doors and white bedding with turquoise accents.

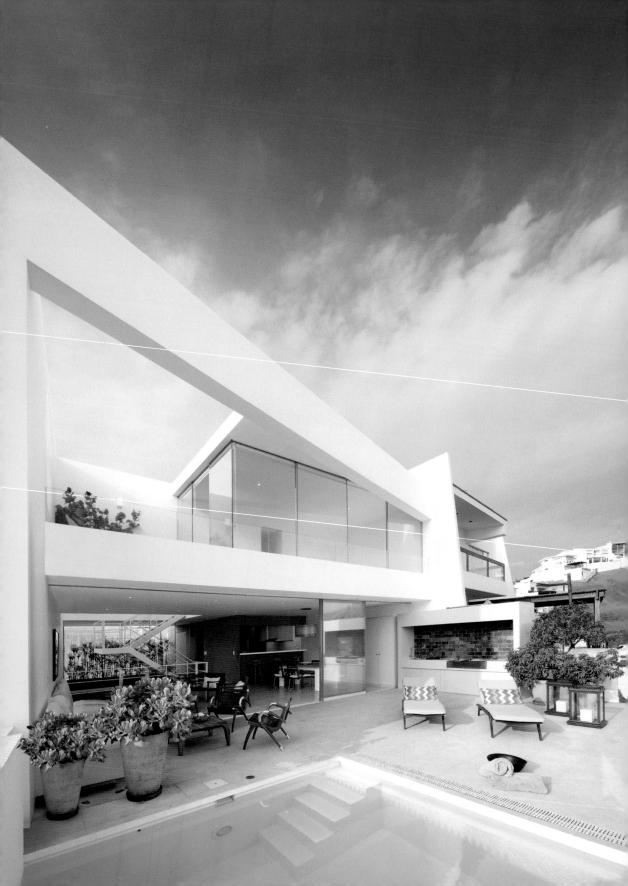

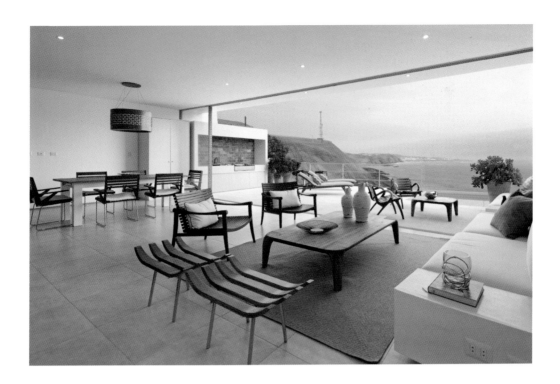

AVE HOUSE, Lima, Peru

Architect, Martin Dulanto Sangalli, describes his stunning contemporary design as "a white box, a habitat platform. The space generated between both elements composes this project."

Located in Cerro Azul (Blue Hill) – a fishing village 131 kilometers (81 miles) south of Lima – this five bedroom, six bathroom home, built in 2014, is spread across three levels.

The basement has the living room, the fourth and fifth bedrooms with bathrooms and a terrace. The central staircase leads to the ground level featuring the courtyard, living room, kitchen, terrace with barbecue and sunbathing area, pool, guest bathroom and the service bedroom and bathroom.

OPPOSITE PAGE: The ground level courtyard, living room, kitchen, terrace, pool, barbecue and sunbathing area.

ABOVE: The contemporary design commands contemporary, neutral furnishings that do not distract from the panoramic view.

FOLLOWING PAGE: The contemporary 'white box' design takes on a different persona as the sun sets and the evening beckons.

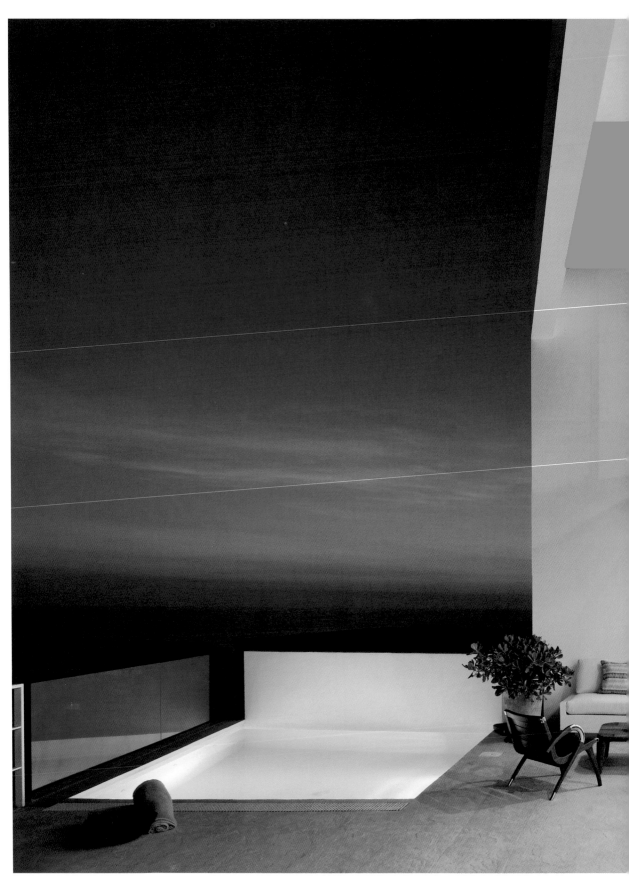

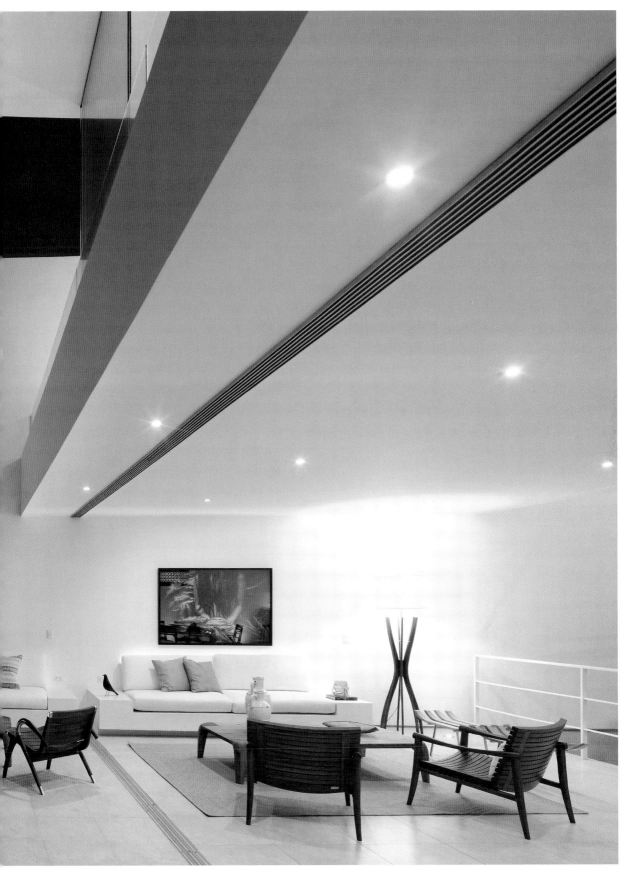

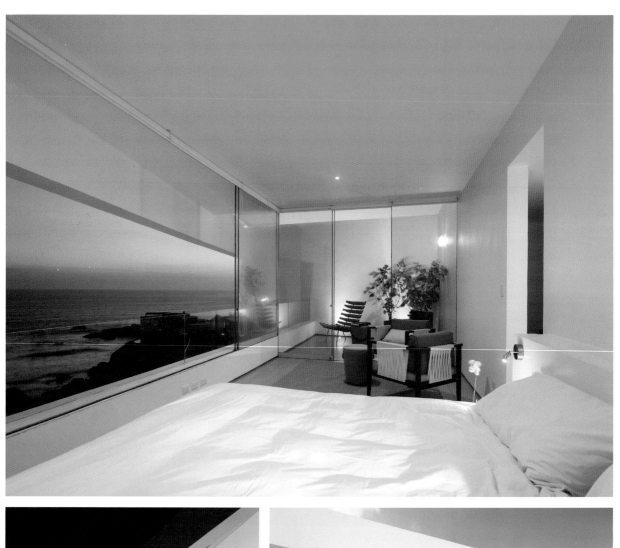

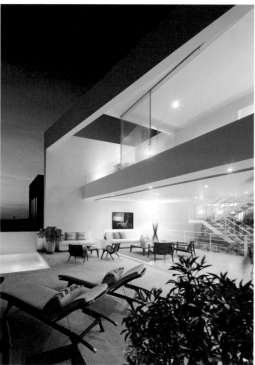

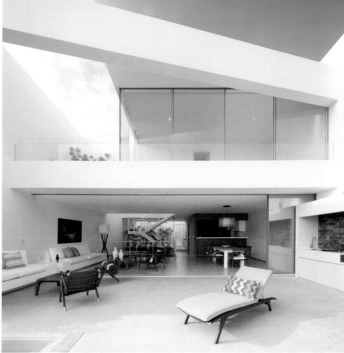

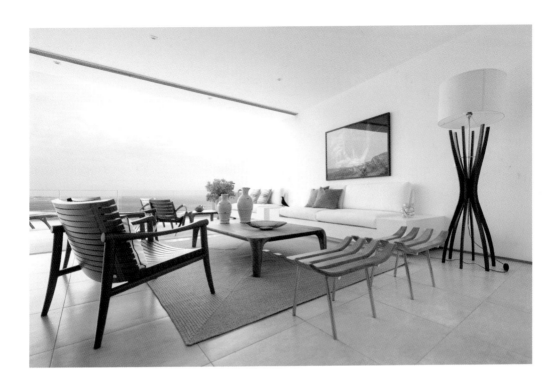

Another level up reveals the master bedroom with balcony, master bathroom and the second and third bedrooms with bathrooms.

Martin Dulanto Sangalli further explains his design below.

"The box is separated from the base creating a large space open to the landscape. The white block contains the master bedroom, which runs through the whole front of the house, facing the sea, and the two guest bedrooms, located on the back of the lot. These three rooms are organized around a hall, which reaches the staircase, and also connects all three levels.

"The 'space between' of the first level contains all social areas (hall, dining room and the terrace room) in a single large space, fully integrated. This is the level of access into the project. In addition, within this space is a box, painted purple, containing the entire service area, including the kitchen. In the basement you can find the two remaining bedrooms of the family, along with the den. Such spaces are organized around the stair hall and are connected by the terrace facing the sea."

OPPOSITE PAGE ABOVE: Waking up to the view framed by floor to ceiling glass, the master bedroom runs the whole length of the front of the house.

OPPOSITE PAGE BELOW LEFT: Relaxing on the sun lounge in the evening, the perfect location to enjoy Lima's sunsets.

OPPOSITE PAGE BELOW RIGHT: Built in 2014, architect Martin Dulanto Sangalli describes AVE house as "a white box, a habitat platform and the space generated between both elements".

ABOVE: The first level contains the social areas – including this living area with floor to ceiling views of the ocean.

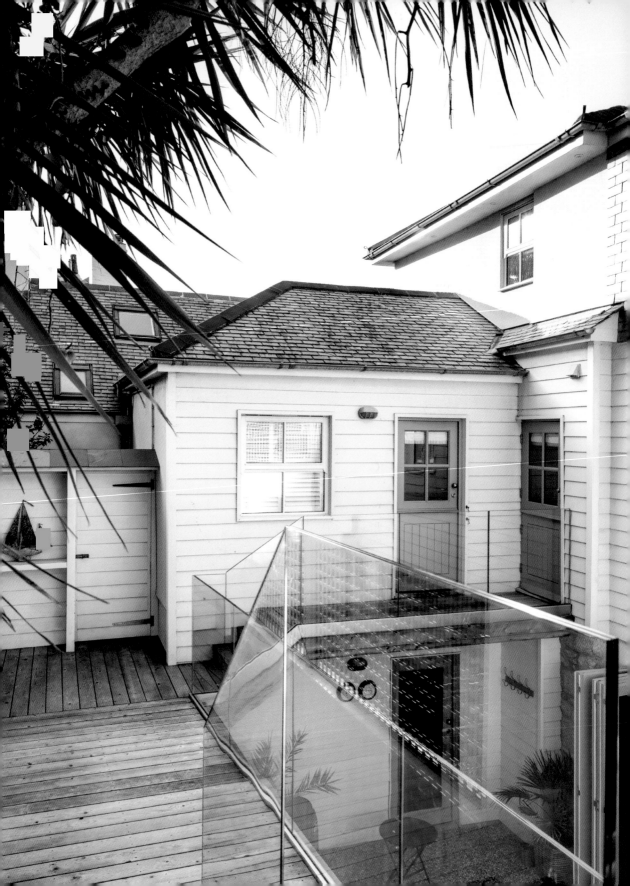

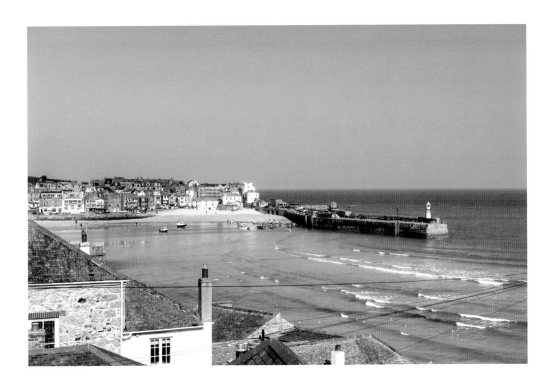

St Ives, Cornwall, England

Interior designer, Suzy Fairfield, was lured by one of the oldest homes in St Ives, Cornwall to transform the charming but formerly claustrophobic and austere building that dates back to 1540, into an enchanting, light-filled six-bedroom home.

The ancient building's history has been respected, combining original features like the striking granite walls with contemporary additions.

The home, tucked away in a quaint hillside street in the heart of St Ives, enjoys views over the town rooftops and out to sea.

The third-floor master bedroom views out to sea do not disappoint whilst the spacious open-plan kitchen and dining area, featuring bi-fold doors that look out to the contemporary garden, is a fabulous space and heart of the home.

The property's seaside location influenced the crisp, clean palette of cool, neutral colors with understated touches such as ticking linen and bleached nautical stripes, carefully sourced to set the perfect tone for laid-back coastal living.

OPPOSITE PAGE: The home, which dates back to 1540, has been lovingly transformed combining original features with modern additions.

ABOVE: Watching the waves gently roll in, it's easy to forget this house is right in the heart of the town of St Ives.

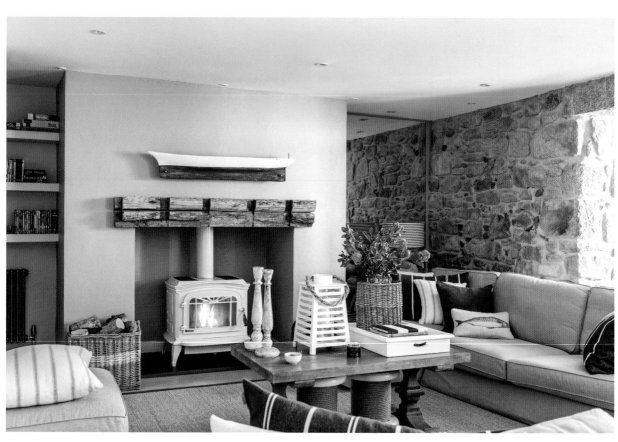

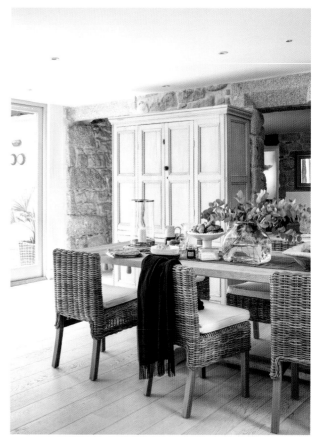

ABOVE: When the seaside weather is less than ideal, the inviting lounge area with its cast iron stove fireplace is the perfect place to keep warm.

RIGHT: Family and friends relax around the large dining table in a room with the fusion of old and new. Exposed granite meets white-washed walls as light floods through the floor-to-ceiling glass doors running the length of the room.

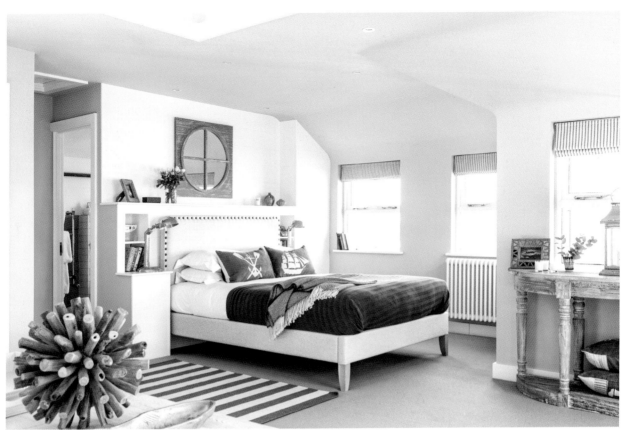

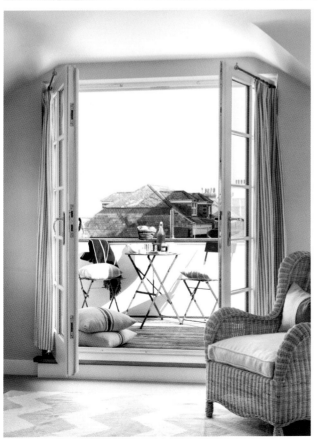

ABOVE AND LEFT: The master bedroom at the top of the three-storey house with its chic, nautical vibe, opens on to the balcony with far-reaching views over the rooftops and out to sea – the perfect spot for morning coffee and a browse of the local newspaper.

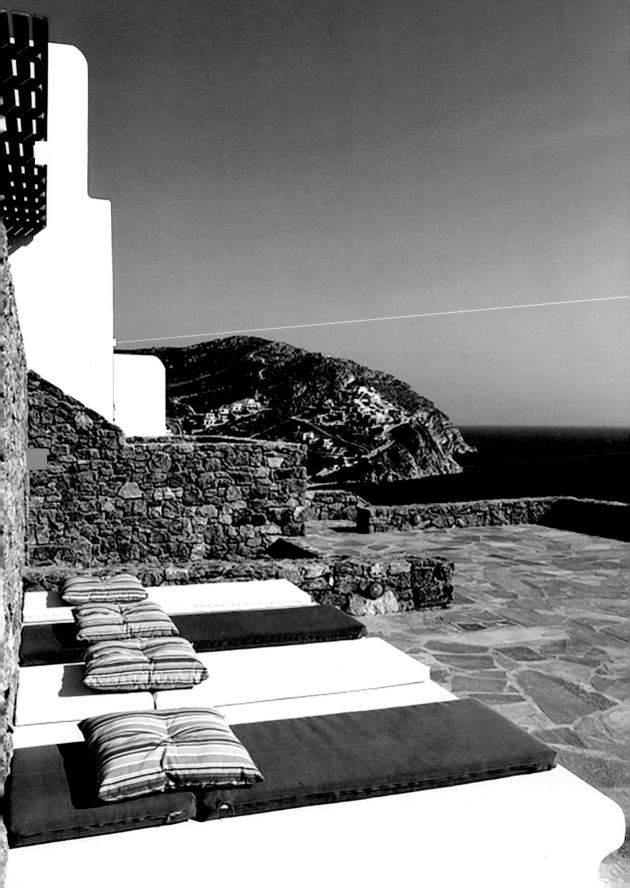

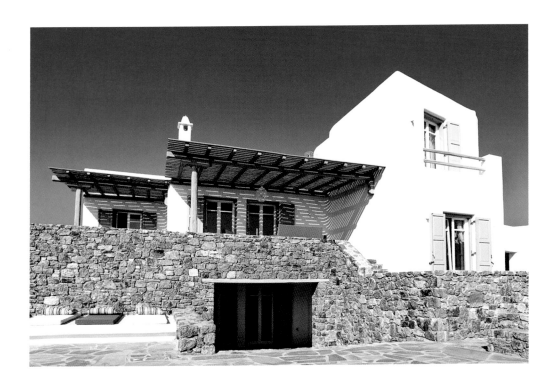

ELIA VILLA, Mykonos, Greece

The dreamy Cycladic architecture combination of white and blue is perfectly presented in this contemporary take on the traditional at Elia Villa. Water is visible from every corner of the property, either Elia, Agrari beaches or the vast infinity pool will be in your sight.

Overlooking Elia Beach on the Greek island of Mykonos, Elia Villa was designed with three elements in mind – white, stone and water.

The whitewashed exterior and interior is mostly neutral and simple with splashes of color in the form of art, antique pieces and furnishings.

OPPOSITE PAGE: The perfect spot for relaxing following a dose of Mykonos' famous nightlife.

ABOVE: The cliffside white Cycladic five bedroom villa enjoys uninterrupted ocean views and direct access to the Elia beach.

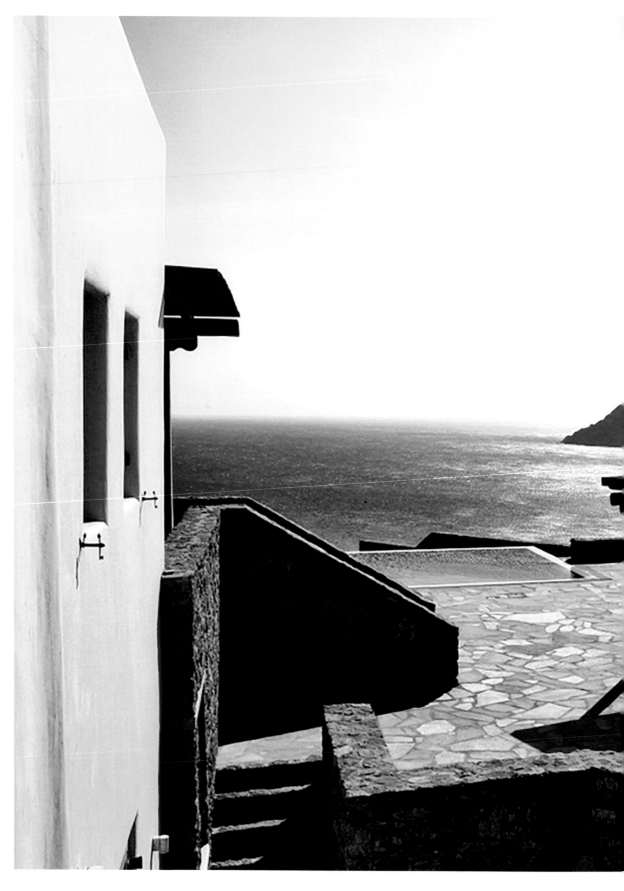

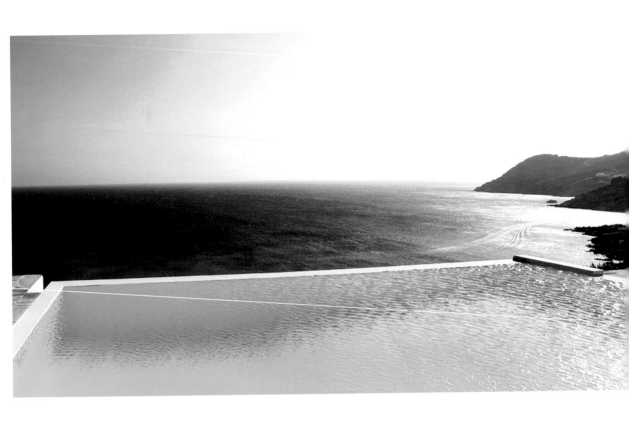

PREVIOUS SPREAD: Water, water everywhere. From every corner, this contemporary villa was designed to take in the spectacular views.

ABOVE: The vast infinity pool lives up to its name with a stunning view of the ocean.

RIGHT: A contemporary take on traditional Cycladic architecture, the villa's striking whitewashed walls, white furnishings with timber accents is simple and chic.

FAR RIGHT: Largely monochrome and minimalist, the white interiors are broken up with the odd splash of color.

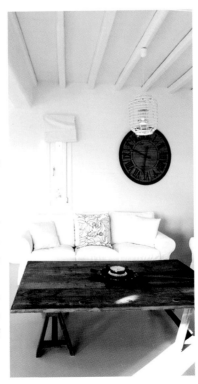

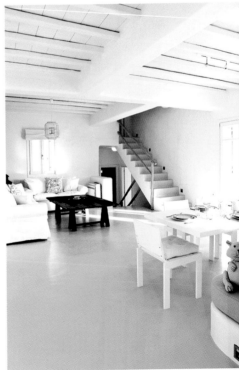

The smooth curved edges of the villa spread over four levels. The upper level is home to the living space, kitchen and a bathroom. One floor above this is a dreamy bedroom and bathroom with such breathtaking water views you'll think you're floating out to sea on a boat. Another master bedroom and bathroom on the ground floor has equally stunning views and below that, on the lower level is a second living space with three bedrooms and bathrooms.

The six cave-like bathrooms of the villa are made of polished concrete and appear to be carved out of the walls.

A dip in the infinity pool will have you thinking you could dive straight into the azure blue sea from there.

Sunset with its symphony of colors in the sky and on the sea is the perfect time to relax with a cocktail under the shade of the pergola.

ABOVE: Uninterrupted ocean views from every corner of the villa, overlooking Elia beach, one of the larger beaches on Mykonos, which is a popular location for water and jet skiing.

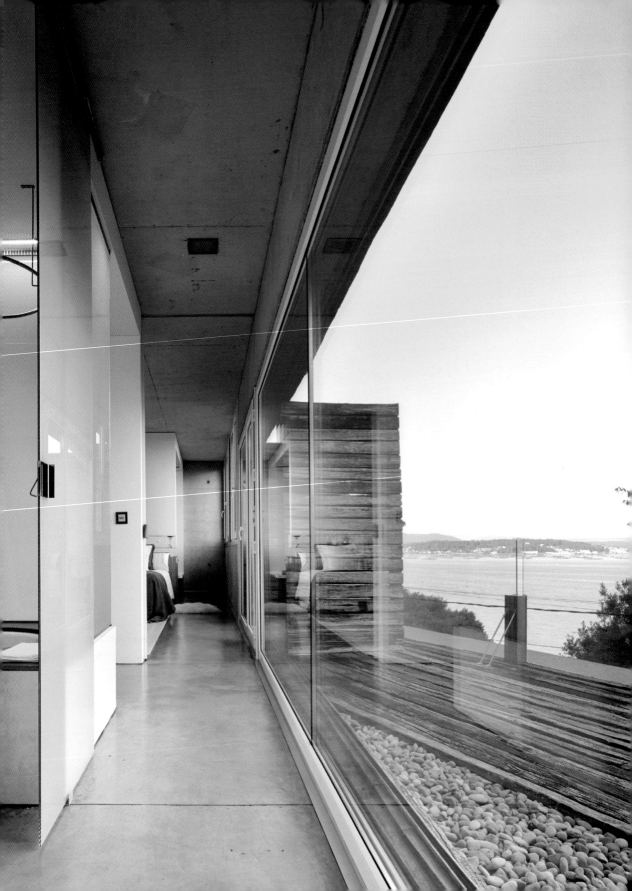

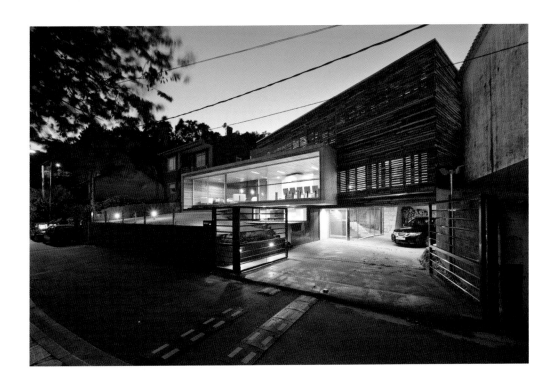

DEZANOVE HOUSE, Galicia, Spain

Dezanove House, an award-winning home with splendid sea views, is situated on an almost private beach in a small fishing village in the Arousa estuary in Spain's northwest.

Designed by Spanish architect Inaki Leite, the three bedroom, four bathroom home was inspired by the natural coastal environment. It incorporates charmingly weathered recycled "bateas" wood – the platforms placed at sea by the local mussel fisherman along the natural rock faces.

The wood is exposed to everything the sea and coastal weather can throw at it for over 25 years before being sent to recycling, usually for use in vineyards or gardens.

Inaki Leite's use of this wood in architecture is innovative. The beams were treated and halved to yield two diverse surfaces. The outer of the wood beam kept the original rough texture and was used for the outer façade whilst the inside cut of the beam was used within the interior to provide visual warmth which has a Scandinavian-inspired aesthetic.

OPPOSITE PAGE: The house borrows from the tradition of the surroundings and reveals itself through its design and detailing. Protected by rock and open to the sea views, the living room faces south to capture the warmth of the sun.

ABOVE: Architect Inaki Leite's inspiration came from the reclaimed eucalyptus wood of the "bateas" – the mussel production platforms you see in the estuary. All shapes, technology and materials are inspired by the local fishing industry.

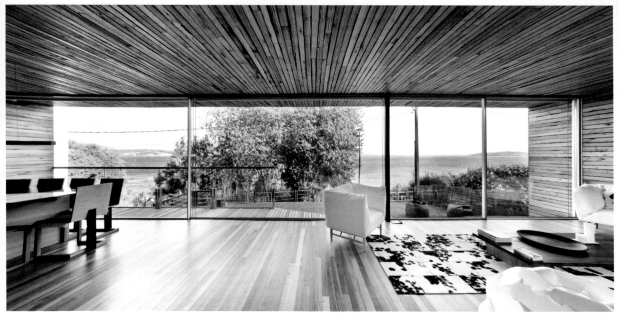

ABOVE TOP: The age of the wood is not hidden. The different outer and inner faces of the wood are used to create different sensations. In the living room, the wood is purposely set to frame and direct the view to the exterior.

RIGHT: The building process was challenging with the shape and slope of the plot, the local planning restrictions and the very hard rock found on the back of the site.

OPPOSITE PAGE: The space is divided into two interconnecting levels. The more private one can be closed from the outside and protected from the sun with the folding wooden shutters facing south. The house resembles the old booths on top of the mussel platforms, and similarly to them, some parts of the house seem to float.

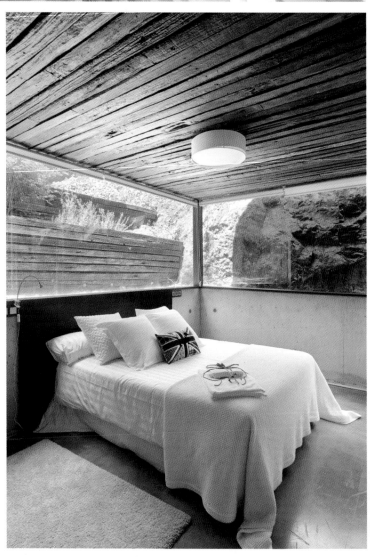

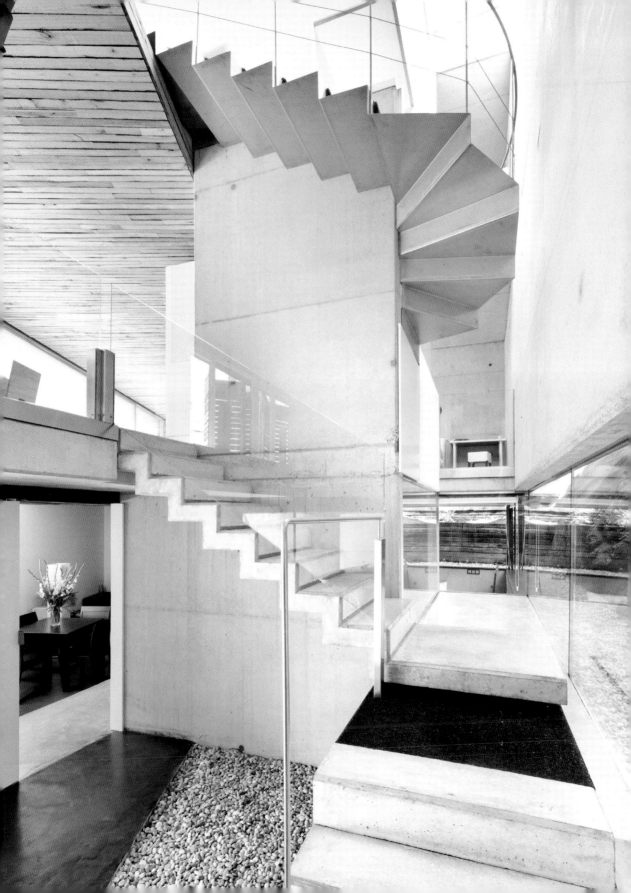

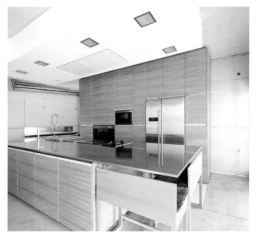

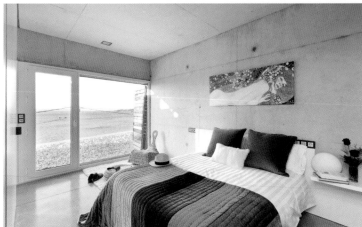

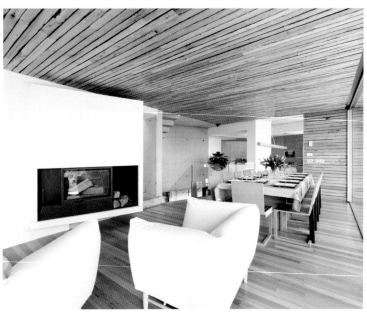

ABOVE: The kitchen is spacious with clean lines. It is a key social space where guests can mingle freely.

RIGHT ABOVE: The bedrooms are peaceful sanctuaries with muted neutral tones.

RIGHT: Architect, Inaki Leite, designed the lighting, the wooden lamp in the dining area, the batea wood dining table and chairs, leather door handles, the kitchen units and steel staircase. "This makes the house very bespoke and only using materials of the surroundings and skills of local craftsmen," says Leite.

BELOW: The living room is Inaki Leite's favorite room. "It is really peaceful and relaxing," he says. "I believe the use of the wood direction and framing the view makes a nice picture of the estuary."

OPPOSITE PAGE: This view of the house shows how it respects its natural surroundings.

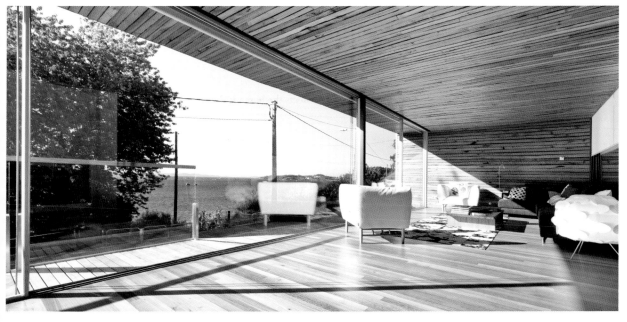

The design also incorporates the naked rock that protects the home and also opens up the space to the sea and sunlight.

The main floor features a sizeable south facing glass wall showcasing sea and garden views with a fireplace and lounge area and an oak-panelled kitchen, perfect for entertaining family and friends.

The exposed concrete and stainless steel staircase takes you to the master bedroom with ensuite, and a rooftop terrace with retractable shutters, as well as an extra terrace bedroom with separate bath. Another stairway leads to the main entrance and two bedrooms on the ground floor.

As well as the use of locally sourced materials, every section of the home was created by local craftsmen, including the finishes and furnishings.

The energy efficient home with solar power, insulation and ventilation systems and a purifying vertical moss garden was thoughtfully designed with respect to nature and the environment.

SANGRIA

INGREDIENTS

1 bottle claret
60 ml (2 fl oz) brandy
60 ml (2 fl oz) white rum
60 ml (2 fl oz) Cointreau
1 liter (1¾ pt) orange juice
2 teaspoons sugar
slices of orange and
 lemon, to serve
selection of chopped fruit,
 to serve
10 cinnamon sticks,
 , to serve

SERVING BOWL

1 large punch bowl

Serves 10

METHOD

» Pour all ingredients into punch bowl with 4 cups ice
 cubes and stir well.
» Serve in cocktail glasses.

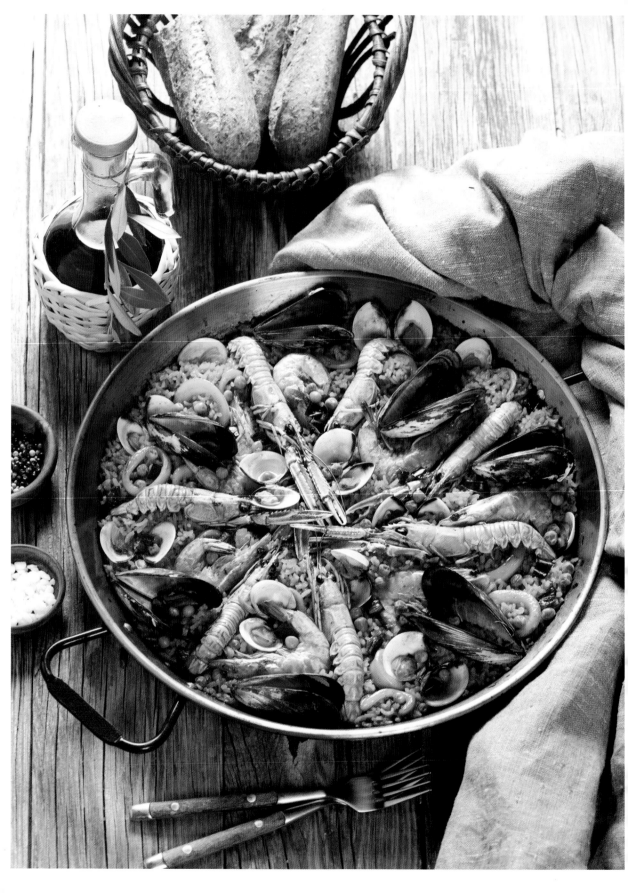

SEAFOOD PAELLA SALAD

INGREDIENTS

4 cups chicken stock
510 g (18 oz) uncooked large
 prawns (shrimp)
510 g (18 oz) mussels in shells,
 cleaned
15 threads saffron
4 tablespoons warm water
2 tablespoons olive oil
1 onion, chopped
2 ham steaks, cut into 1 cm
 (½ in) cubes
400 g (14 oz/2 cups) arborio rice
½ teaspoon ground turmeric
115 g (4 oz) fresh or frozen peas
1 red capsicum (bell pepper),
 diced

GARLIC DRESSING

4 tablespoons olive oil
4 tablespoons white wine vinegar
3 tablespoons mayonnaise
2 cloves garlic, crushed
2 tablespoons fresh parsley,
 chopped
freshly ground black pepper

Serves 6

METHOD

» Place the stock in a large saucepan and bring to the boil. Add the prawns and cook for 1–2 minutes or until the prawns change color. Remove and set aside. Add the mussels and cook until the shells open. Discard any mussels that do not open after 5 minutes. Remove and set aside. Strain the stock and reserve. Peel and devein the prawns, leaving the tails intact. Refrigerate the seafood until just prior to serving.

» Soak the saffron threads in a small dish with the warm water for 10 minutes. Heat the oil in a large saucepan, add the onion and cook for 4–5 minutes or until soft. Add the ham, rice and turmeric and cook, stirring, for 2 minutes. Add the reserved stock, the saffron threads and the soaking water and bring to the boil. Reduce the heat, cover and simmer for 15 minutes or until the liquid is absorbed and the rice is cooked and dry. Stir in the peas and red capsicum (bell pepper) and set aside to cool. Cover and refrigerate for at least 2 hours.

» To make the dressing, place the oil, vinegar, mayonnaise, garlic, parsley and black pepper to taste in a food processor or blender and process to combine.

» To serve, place the seafood and rice in a large salad bowl, spoon over the dressing and toss to combine.

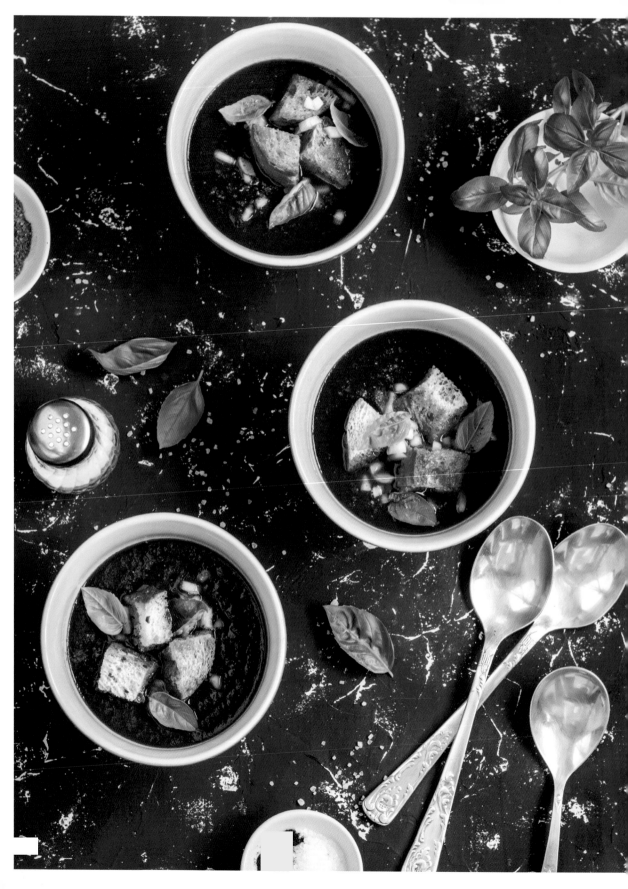

GAZPACHO

INGREDIENTS

2 slices of stale bread

2 kg (4 lb 6 oz) tomatoes, roughly chopped

1 cucumber, peeled and chopped

1 green capsicum (bell pepper), deseeded and chopped

1 small onion, chopped

2 cloves garlic, chopped

5 tablespoons olive oil

1–2 tablespoons wine vinegar

1 teaspoon cumin seeds or ground cumin

salt, to taste

1 French loaf for croutons, to serve

2 tablespoons oil

½ red onion, finely chopped, to serve

basil leaves, to serve

Serves 6–8

METHOD

» Soak bread in a little water, and squeeze it out before using (the bread helps to thicken the soup and give it a nice consistency).

» Blend all vegetables and garlic in a blender or food processor, and push through a sieve into a bowl. Use the blender again to beat bread, oil and vinegar together. Add some of the tomato blend, the cumin seeds and salt to taste. Add a little water and mix into the bowl with the soup. Add a few ice cubes and leave to become cold. You can add more water if necessary.

» To make the croutons, cut the French loaf into chunky slices then cut again to make big cubes. Heat the oil in a frypan and fry the croutons until crispy on the outside. Set aside.

» Serve in individual bowls with the croutons, finely chopped red onion and basil leaves.

Note: Traditionally this soup was made by crushing the ingredients with a mortar and pestle and then adding cold water. Gazpacho traditionally should be served in wooden bowls and eaten with a wooden spoon. You can make large quantities of gazpacho as it keeps well.

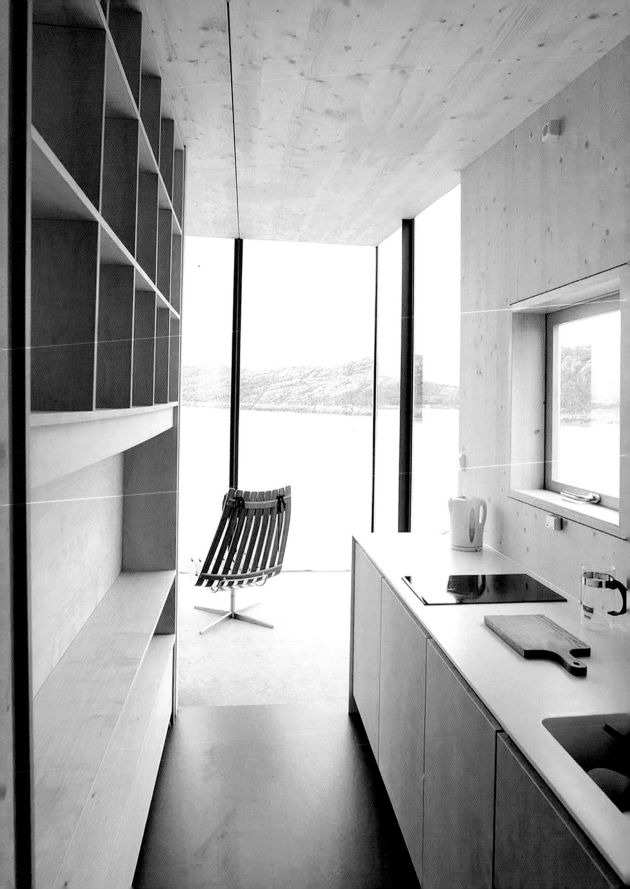

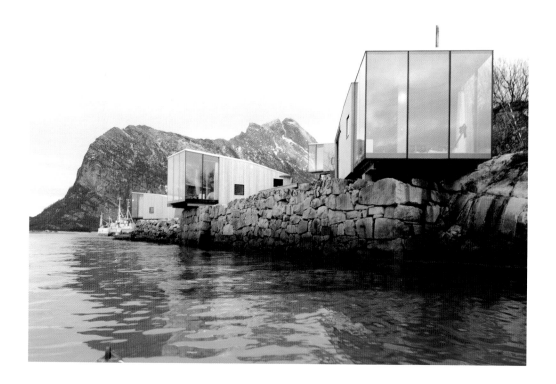

SEA CABINS, Manshausen Island, Norway

Arctic exploration couldn't get any cooler than these timber and glass cabins overhanging the coastline of Manshausen Island, part of the Steigen archipelago in northern Norway. The island lies in the middle of the Grøtøy strait between the peaks of the Lofoten mountains and the Barents Sea.

The four cabins on the fifty-five acre (22.25 hectare) island were conceived and developed by Norwegian polar explorer and author, Børge Ousland, who commissioned Norwegian architect, Snorre Stinessen, to design the unique base for Arctic Circle enthusiasts with a penchant for hiking, fishing, skiing and diving. It is an outdoor adventurer's dream, with endless winter and summer sports and dramatic unspoiled natural beauty.

Each of the four cabins are placed to maximize the breathtaking views whilst providing privacy for the occupants despite floor to ceiling glass walls facing the Barents Sea. Three of the four cabins cantilever over the stone quays that formed moorings for fishing boats, while the fourth is set at an angle to the coastline on a rocky shelf.

OPPOSITE PAGE: Constructed and assembled on site, the prefabricated cabins were designed to limit the impact on the pristine environment.

ABOVE: Three of the four sea cabins overhang the stone seawall with the fourth set on a rocky outcrop.

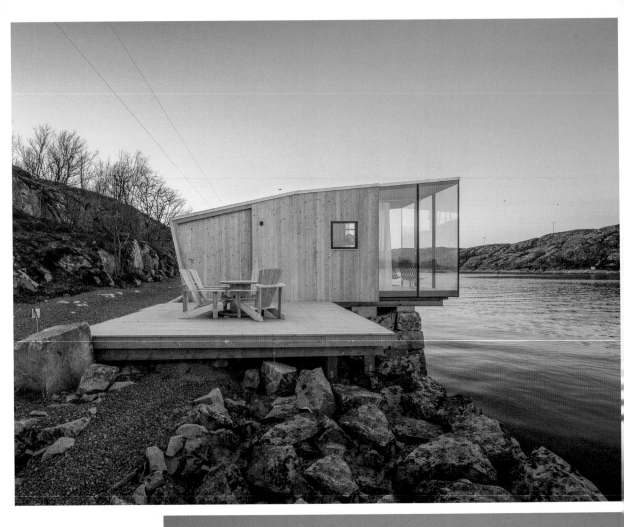

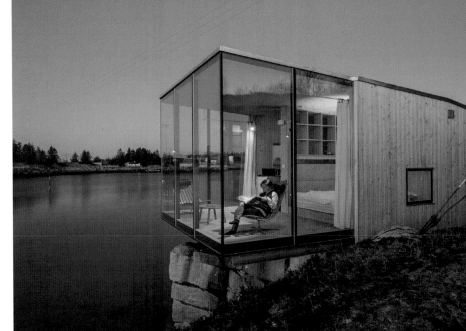

ABOVE: The huts feature one glazed end that projects out towards the sea.

RIGHT: Each cabin has two double bedrooms and a sleeping alcove for children and can accommodate up to five people.

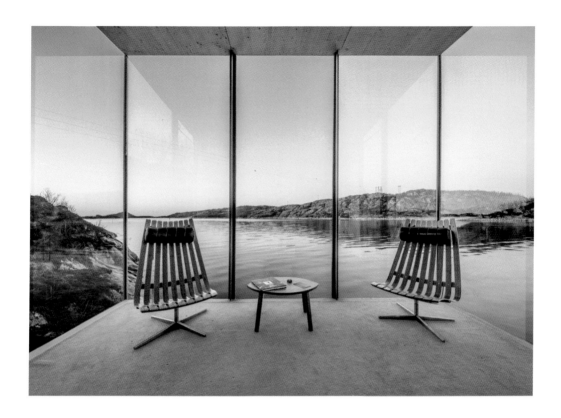

Each cabin has two double bedrooms and a sleeping alcove for children which can accommodate up to five people. Pale wood cladding, furnishings and white Corian fittings in the kitchen and bathroom complete the Nordic feel. (Corian is a brand name for a solid surface material, composed of acrylic polymer and alumina trihydrate (ATH) which is derived from bauxite ore. It was created by E.I. du Pont de Nemours and Company (DuPont).

Stinessen explains the design: "The main bed is positioned in the main room, slightly withdrawn from the floor to ceiling glass, to enable the visitor an around-the-clock experience of the outside elements, while still being comfortably sheltered."

The timber cabins were prefabricated then positioned on site which helped limit the environmental impact on the pristine environment and alleviate the construction issues of such a remote location.

Fashioned from two layers of wood, the external cladding is designed to turn silvery grey over time, while the internal layer will retain its coloring.

Glazing is glued to the exterior of the building, helping to create an even fascia designed to withstand Manshausen's harsh winds whilst delivering unhindered views of the sea and island.

ABOVE: Pale wooden furnishings throughout mirror the color of the cladding.

OVERLEAF: The Aurora Borealis (Northern Lights) are visible from the cabins at certain times of the year.

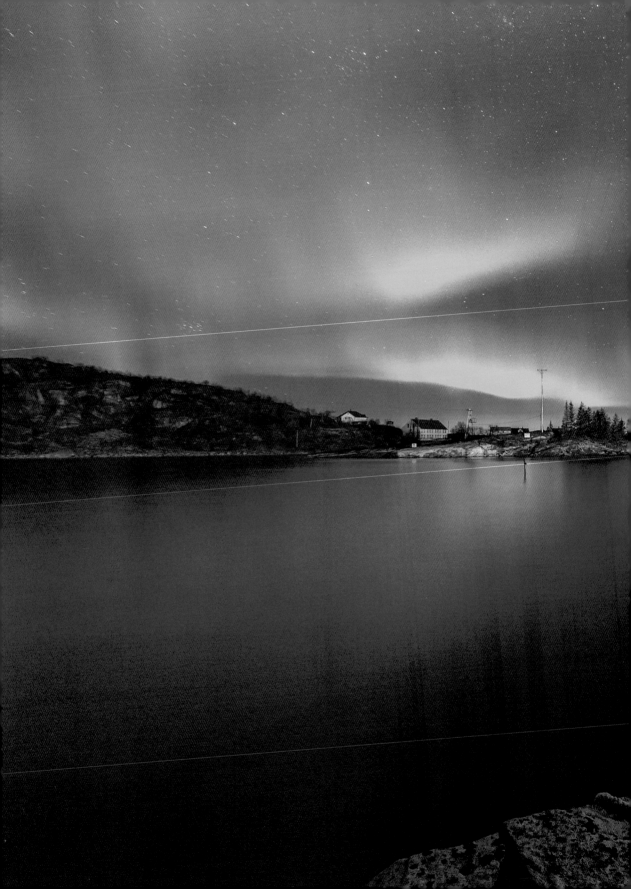

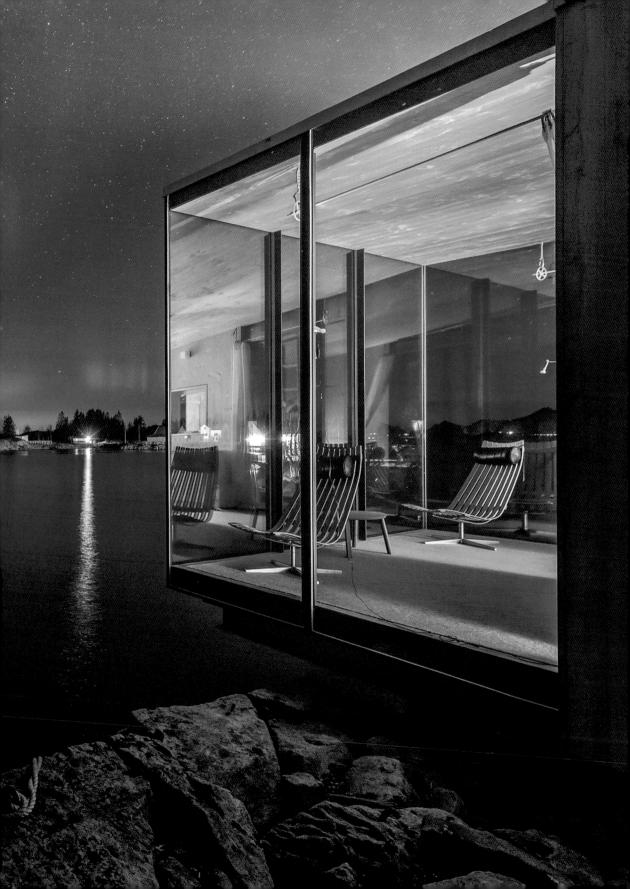

SALMON POACHED IN WINE

INGREDIENTS

1 kg (35 oz) salmon fillets
250 ml (8 fl oz/1 cup)
　white wine
1 bay leaf
1 sprig parsley
¼ teaspoon salt
freshly ground
　black pepper
1 lemon, juice and
　grated zest

Serves 4

METHOD

» Brush the inside of the slow cooker with olive oil.
» Rinse the salmon fillet and dry with absorbent paper. Place the fillet in the bottom of the slow cooker.
» Add the wine, bay leaf, parsley, salt, pepper, lemon juice and zest. Cover and cook on low for 3–4 hours.
» Serve either hot or cold.

Note: Light and substantial, this sophisticated salmon recipe is a foolproof dinner option. It is delicious cold with a salad and crispy bread and butter.

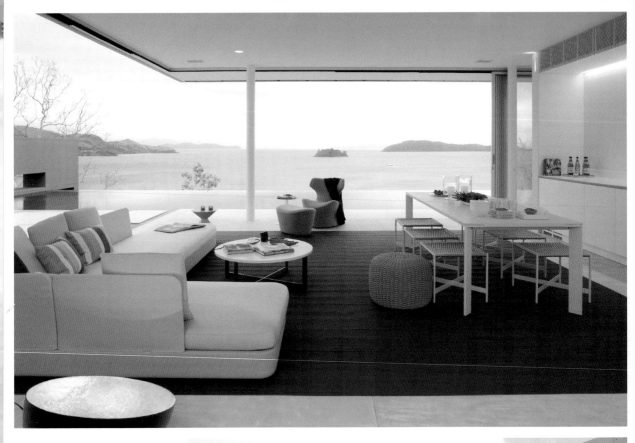

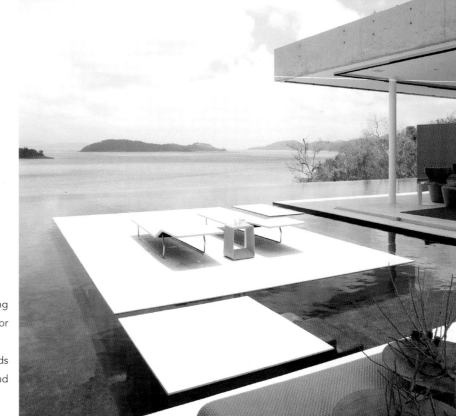

ABOVE: The open upper living area embraces an outdoor/indoor lifestyle.

RIGHT: Azuris' design responds to three key elements of its island location – light, air and water.

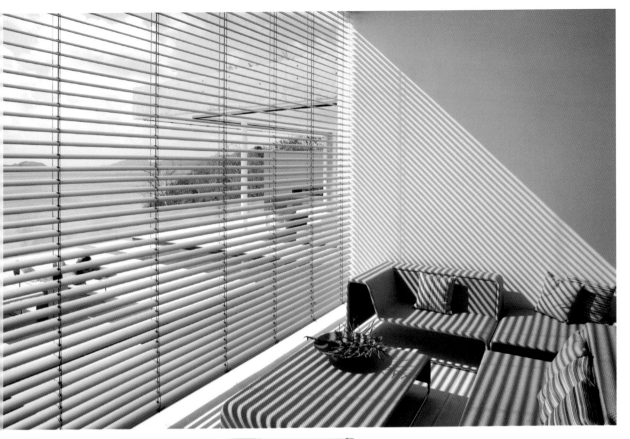

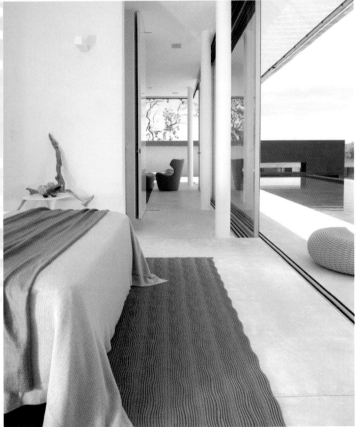

ABOVE: Walls and shading devices are easily opened and adjusted to optimize air flow and moderate sunlight creating a comfortable environment that reduces the need for air-conditioning or artificial lighting.

LEFT: "The bedroom and its relation to the swimming pool is the easiest feature to fall in love with," says D'Ettorre. "The distance from bed to pool is only meters away which beckons you to take a dip the moment you awake."

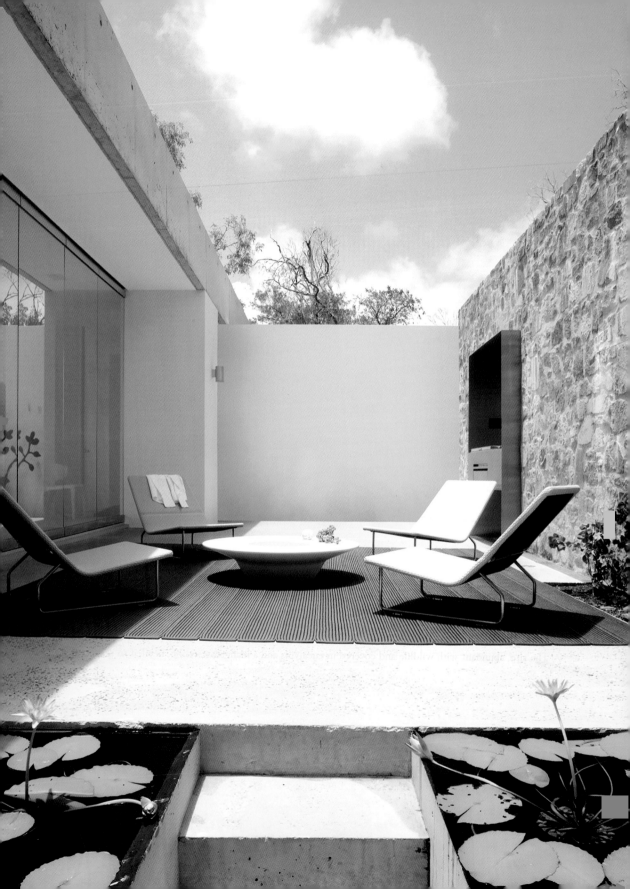

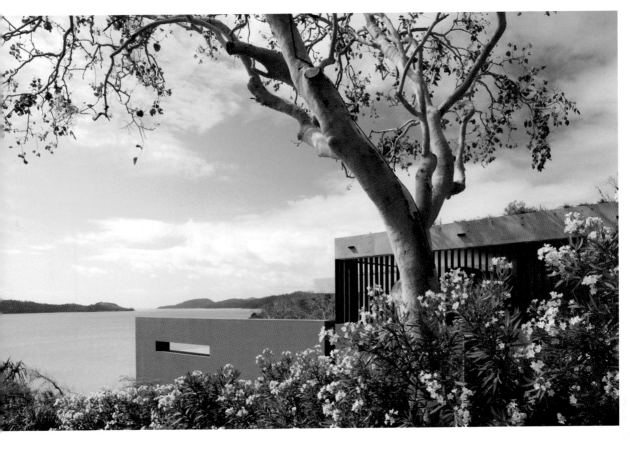

Situated on a site that falls steeply away to the water's edge, on approach, the only part of the house visible is a green roof planted with native species, which further draw the eye out towards the horizon and the spectacular view.

The contemporary design adopts a pavilion form, with floor to ceiling sliding glass doors, bedrooms and living areas spread over three levels. Internal courtyards are tranquil spaces of pools and ponds.

Construction materials are concrete, stone and glass – chosen for their rawness and transparency respectively. The house spans between two dominant walls. The living area, main bedroom and pool are on the top level for privacy, with guest rooms and an undercover sheltered terrace on the lower level. The western façade opens up entirely to the view whilst the two side walls and natural stone wall anchor the home into the earth.

The site, abundant with wildlife and covered in eucalypts and a mangrove swamp, needed to respect the flora and fauna. With water scarce on the island, 40,000 liters (8,800 gallons) of rainwater is collected in tanks within the basement. Water is also recycled, treated and used to water the landscape.

OPPOSITE PAGE: The entry courtyard is shielded from the road by high stone walls. The courtyard is a quiet contemplative place with a cooling reflection pond with waterlilies. The entrance courtyard opens directly onto the main living floor. A steel barbecue has been integrated into the massive stone wall, creating a casual outdoor cooking zone not far from the kitchen and dining area.

ABOVE: The house sits inconspicuously into the landscape so that is difficult to imagine what lies beyond the unobtrusive external walls.

PERFECT STEAK

INGREDIENTS

4 steaks of choice
2 teaspoons crushed garlic
2 teaspoons oil
salt and pepper

GARLIC BUTTER

60 g (2 oz) butter
1 teaspoon garlic, crushed
1 tablespoon parsley flakes
2 teaspoons lemon juice

Serves 4

INGREDIENTS

» Combine the garlic butter ingredients in a mixing bowl. Set aside.

» Bring the steaks to room temperature. Mix the garlic, oil and salt and pepper together. Rub onto both sides of the steak. Stand for 10–15 minutes at room temperature.

» Heat the barbecue until hot and oil the grill bars.

» Place the steak on the barbecue and sear for 1 minute on each side. Move the steak to the cooler part of the barbecue to continue cooking over a moderate heat, or turn the heat down. If the heat cannot be reduced then elevate the steaks on a wire cake rack placed on the grill bars. Cook for a total time of 5–6 minutes for rare, 7–10 minutes for medium and 10–14 minutes for well done. Turn once during cooking. Allow to rest for 5 minutes.

» Serve on a heated steak plate and top with a dollop of garlic butter. Serve with potatoes.

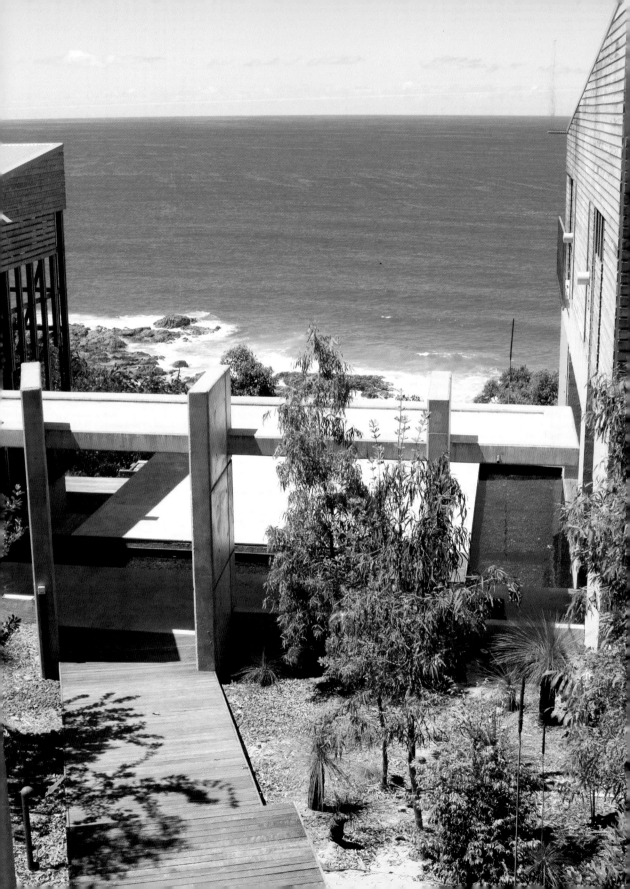

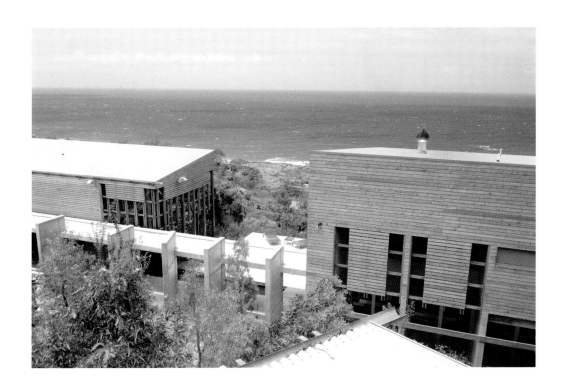

ALINGHI BEACH HOUSE, Agnes Water, Australia

With the basic philosophy of having as little impact as possible on the environment, Alinghi, was designed by award-winning Australian architect, James Grose of Bligh Voller Nield (BVN) and voted one of the world's top five beach houses.

The house is one of six homes situated in the exclusive Rocky Point estate, consisting of 14 acres (5.5 hectares) of bushland and sitting on absolute beachfront, approximately six kilometers (3.5 miles) south of Agnes Water in Queensland.

Renowned for environmentally sensitive design, James Grose's idea was to create a sanctuary which allowed the home owner to live a tranquil lifestyle amongst nature without foregoing style and luxury.

Upon arrival, walking down the stairs to what seems like thick bushland, the sounds of the ocean envelop you, then, at the last step, amazing views of the Pacific Ocean open out.

Alinghi has been described as a "floating shipping container" – albeit a luxurious one – built to feel like you're floating on the ocean.

OPPOSITE PAGE: Upon arrival, you walk down the stairs to what seems like thick bush land but you can hear the ocean. It's only as you step on the last stair you get to take in the amazing ocean views.

ABOVE: Alinghi is like a "floating shipping container, built to feel like you're floating on the ocean". Each room has a different view of the ocean.

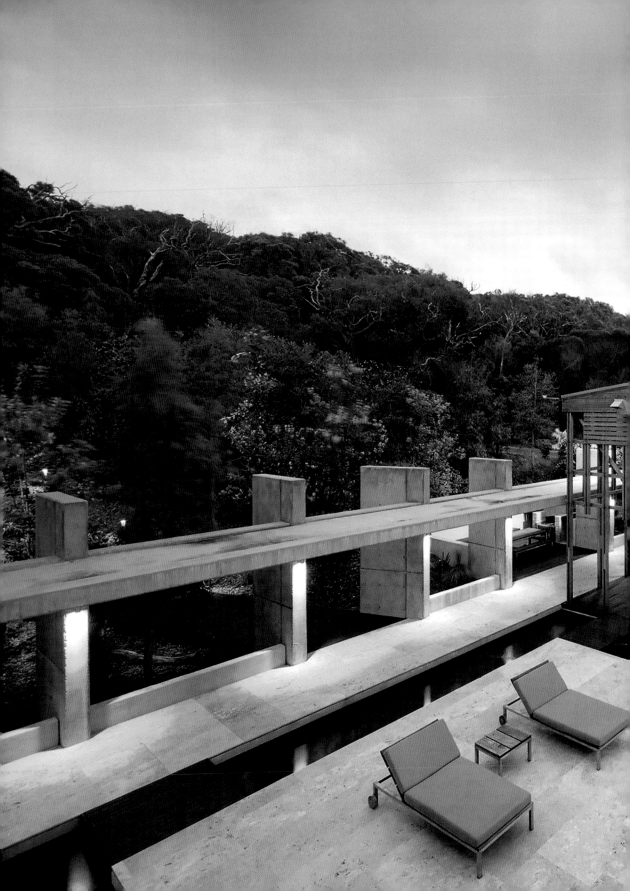

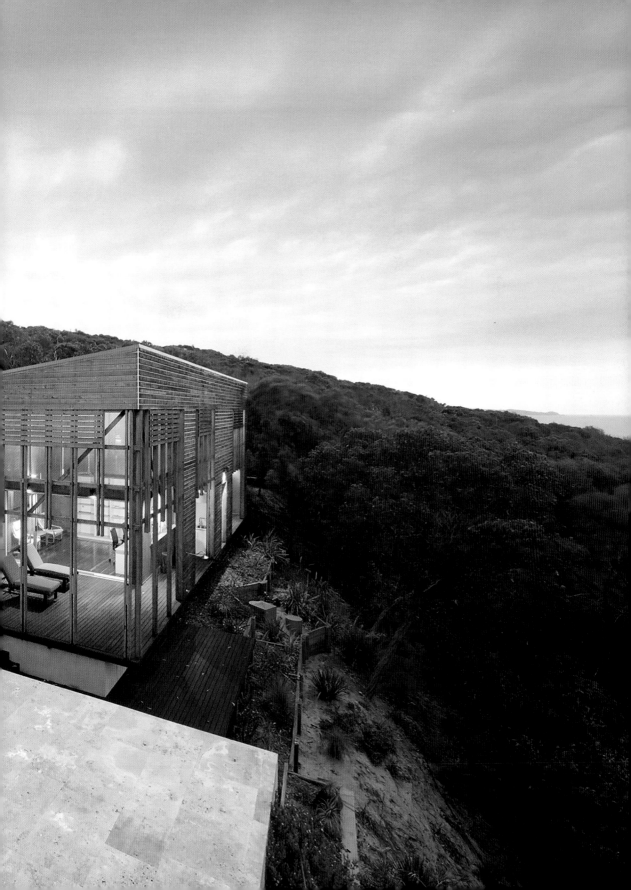

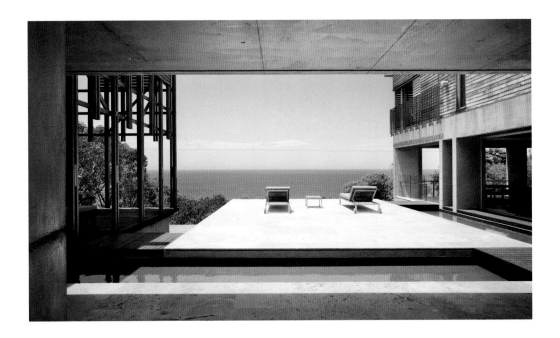

Two pavilions form the accommodation linked by a concrete-covered way. The main pavilion is designed with large living spaces opening onto a variety of semi-enclosed areas providing retreat from the wind or for basking in the Queensland sun. The second pavilion is a retreat with bedroom and private study. Both buildings are adjacent to the travertine platform on the north and south and to the west, the open concrete walkway framing the bush (travertine is a form of limestone).

The main pavilion and retreat pavilion are situated around a central stone terrace overhanging the ocean.

With a view to die for and the gentle sound of waves crashing below, doors off the bedrooms open completely to make the most of the sights and the sounds.

External materials and colors were wisely chosen to "disappear" over time, fading to a silver grey, blending with the landscape and the silvery bark of the trees. Arctic cedar clads the exterior of the house. Hardy and low maintenance, the timber has faded beautifully with exposure to the Queensland sun.

Alinghi is self-sufficient for water with tanks collecting abundant rainfall, whilst airconditioning is unnecessary as clever design, allowing cross-ventilation, and the position of the house combine to allow cool ocean breezes to waft throughout. As the sun rises and sets, different areas of Alinghi allow shelter from the sun at different times of the day.

Alinghi, along with the five other houses on the estate, share a private beach at Honeymoon Bay, a 30-meter (32-yard) saltwater swimming pool by the ocean, entertaining cabana with barbecue facilities and grass tennis court.

Wildlife such as wallabies, echidnas, goannas, turtles and a diversity of birds are plentiful. Purposely designed, Alinghi's external lighting is all low-voltage so as not to upset the neighborly creatures, in particular nesting turtles whom return to Rocky Point to breed.

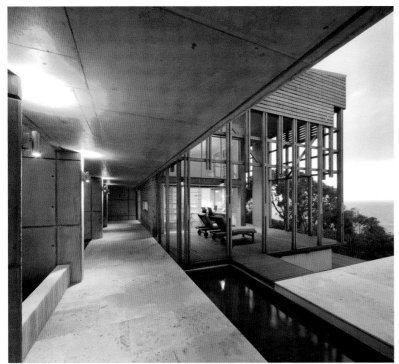

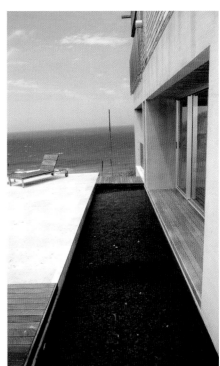

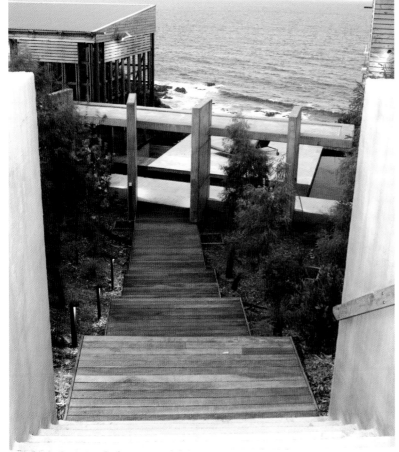

PREVIOUS SPREAD: The unique environment is untouched flora and fauna at its best. Indigenous wildlife includes black cockatoos, wallabies and the area is home to one of the few nesting sites for loggerhead and green turtles.

OPPOSITE PAGE: The view is mesmerizing and the sound of the crashing waves is hypnotic. The doors in the bedrooms all open up completely so you are lulled to sleep by the sound of the ocean and woken by spectacular sunrises.

ABOVE LEFT: The house comprises two elements – the main house and the bedroom pavilion, which are situated around the central 'platform', a huge stone terrace overhanging the ocean.

ABOVE RIGHT: External materials and colors wisely chosen to 'disappear' over time.

LEFT: Stairway to Whitsunday heaven.

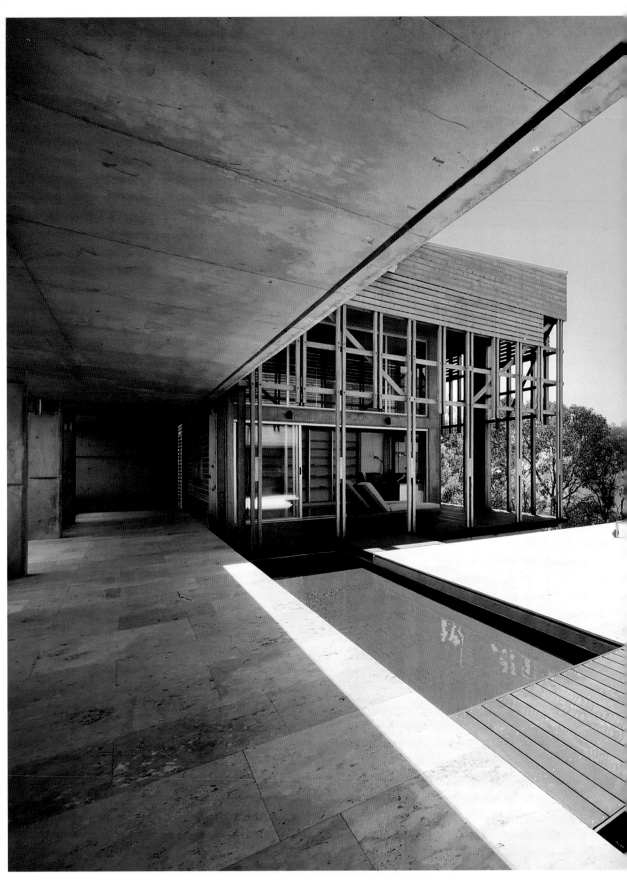

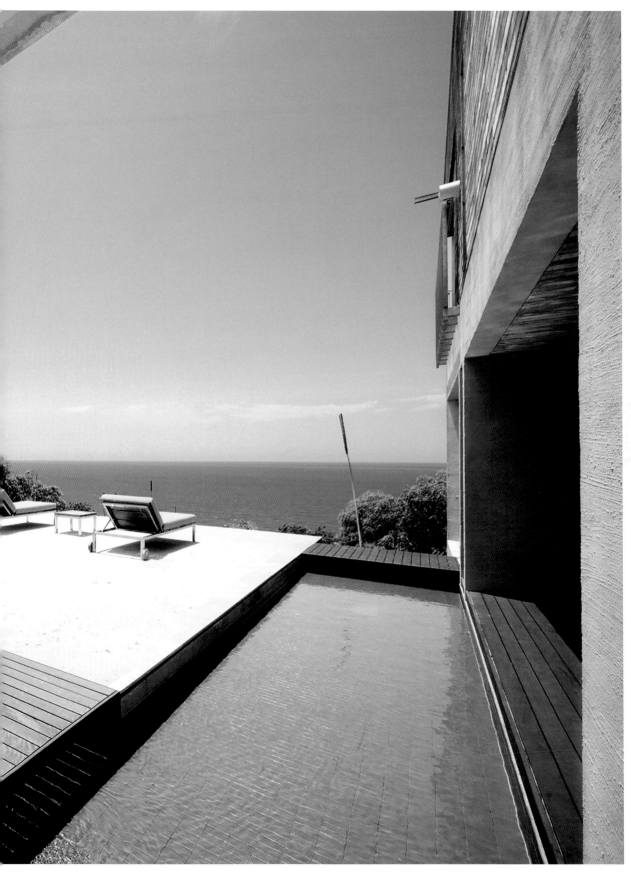

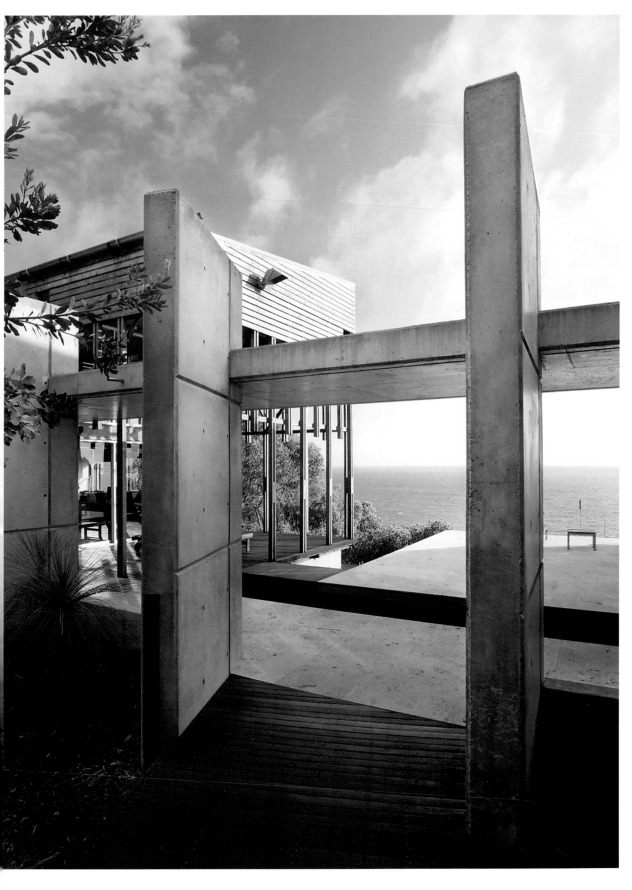

ABOVE: At the right time of year, migrating whales can be seen from the house: the terrace is an ideal spot for whale spotting.

OPPOSITE PAGE: Despite being the ultimate in luxury, the residence is architecturally designed to be environmentally sensitive. The eco-friendly beachfront hideaway boasts sleek interiors and state of the art technology.

PREVIOUS SPREAD: Lounging on a deck chair on the terrace in the sun is just one way to enjoy the vista of this stunning beach house.

FOLLOWING SPREAD: Large floor to ceiling windows create a seamless indoor/outdoor living feel that stretches out all the way to the horizon.

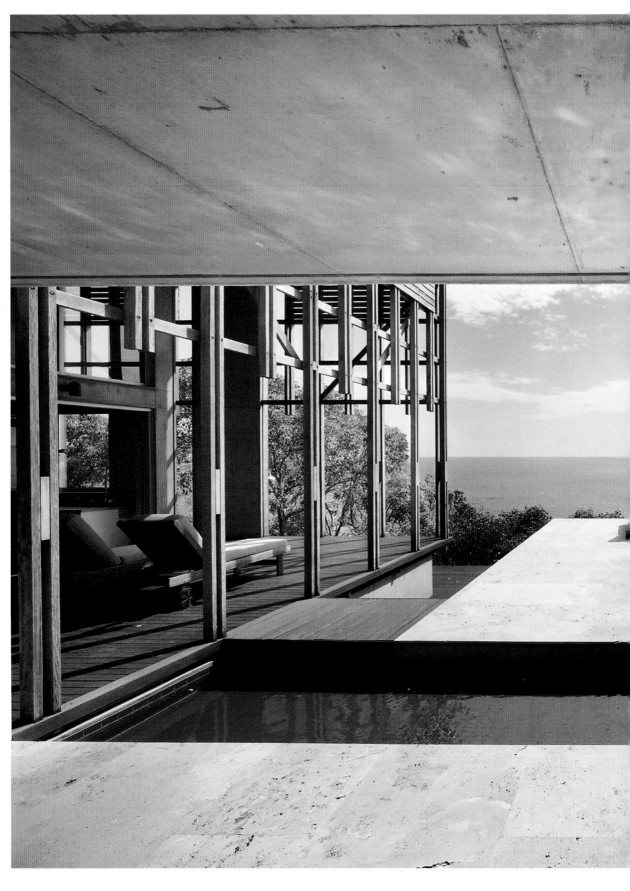

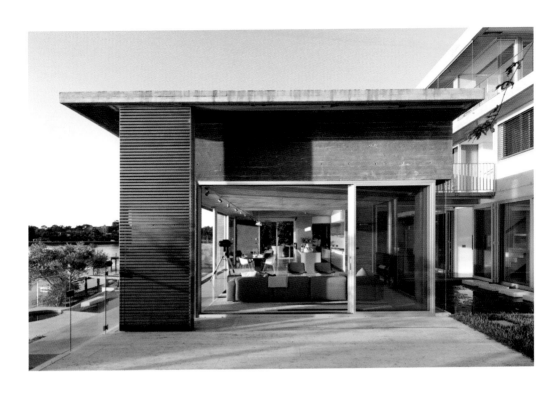

LINK HOUSE, Sydney, Australia

Located on the Sydney Harbour foreshore in Chiswick, the home's owner built his vision on the original site of his childhood home.

The design brief for Renato D'Ettorre Architects was to separate the living and sleeping quarters for this busy, young family who love to entertain.

Completed in 2012, the design attempts to blur the edges between indoors and outdoors whilst maintaining privacy as well as openness and maximizing the spectacular water views across Five Dock Bay.

The public space of the living area is housed in a glass pavilion with large glass folding doors which can be opened to bring the outside in. The pavilion, surrounded by gardens, terraces and breezeways, emphasizes the bay environment, the sun, the breezes and the views.

OPPOSITE PAGE: The feeling of lightness and openness strikes you immediately as you enter Link House – blurring the edges between indoors and outdoors.

ABOVE: The parents of the home's owner had built the original house in the 1970s. It was a tough decision to knock it down and rebuild – but the results are spectacular.

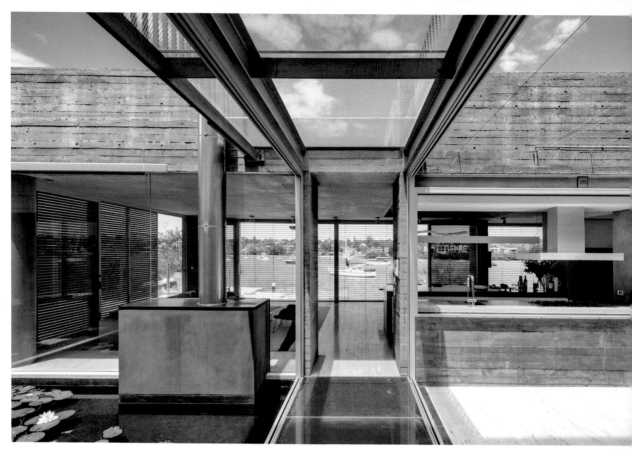

The pavilion space also houses the kitchen, dining and sitting areas, fireplace, and a rooftop terrace to showcase the spectacular water views.

The sleeping quarters pavilion is over three levels. The children's bedrooms and bathrooms are on the entry level, a lounge area, utility spaces, commercial kitchen and steam room occupy the second and third levels with the parent's master bedroom on the top level which also includes a rooftop courtyard, vegetable garden and orchard.

The owners had seen one of architect Renato D'Ettore's earlier concrete houses and wanted a similar construction utilizing low-maintenance materials.

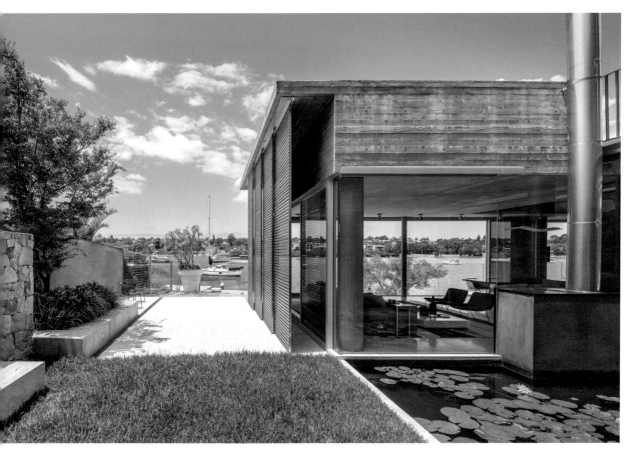

The two pavilions are joined at ground level by a glass link spanning a large fish pond, surrounded by an internal garden and courtyard. Featuring a fixed glass floor and roof, its retractable glass walls open to the south-facing courtyard and north-facing garden.

The internal courtyard is the heart of the family home. It's the perfect space for gathering family and friends for a barbecue or pizza from the home's pizza oven.

The owner, a passionate foodie who works within the food industry, wanted a concrete bench in the kitchen, a walk-in fridge and separate domestic and industrial kitchens.

The architect says: "We've created a robust house with durability without making it look industrial."

ABOVE AND OPPOSITE PAGE: The courtyard, the garden and fish pond unfold as you enter. The quality of the glass link is impressive immediately on entering.

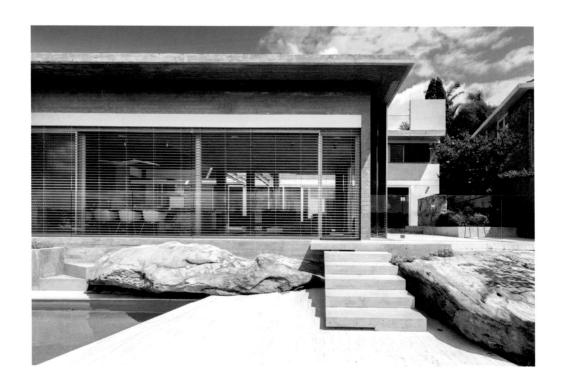

ABOVE: Because the owners had built a new swimming pool only a year before deciding to build their new house, it was designed around the existing pool.

OPPOSITE PAGE: The owner, a passionate foodie, wanted a concrete bench in the kitchen, a walk-in fridge and separate domestic and industrial kitchens.

OVERLEAF: "The roof terrace is my favorite space," says architect, Renato D'Ettorre. "It is where the sun can be enjoyed throughout most of the day in summer and winter. It beckons the visitor upon entering the house to explore the terrace and the panoramic view of the surrounding bay and gardens."

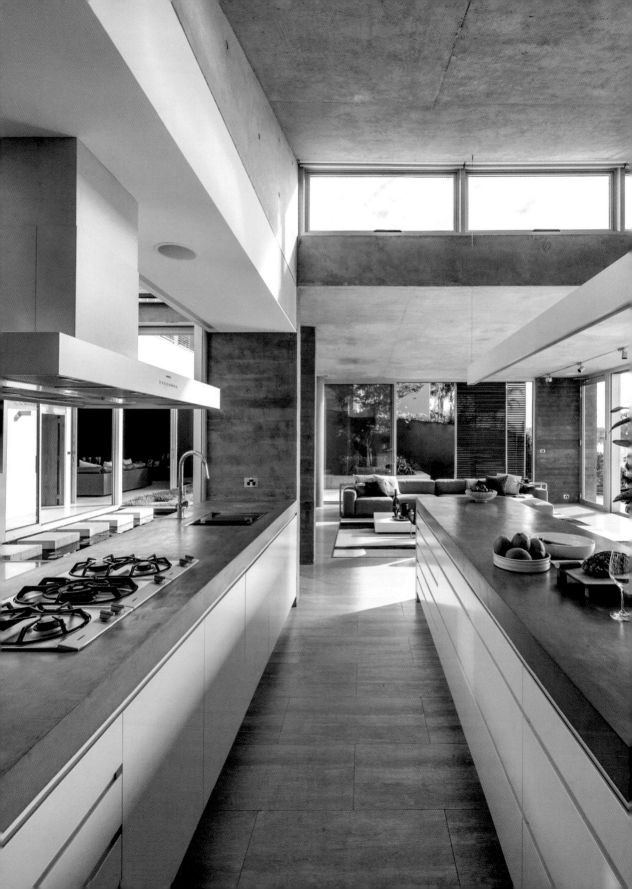

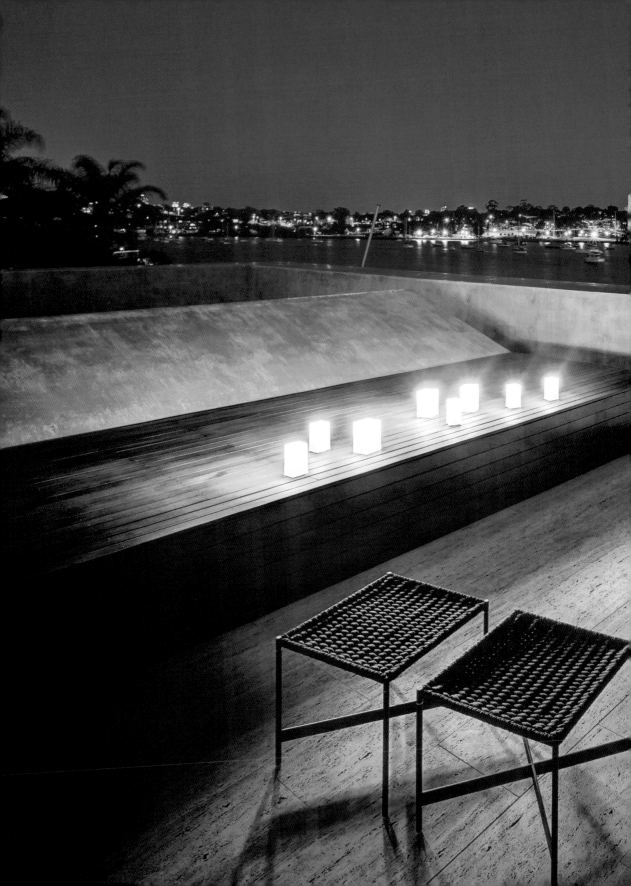

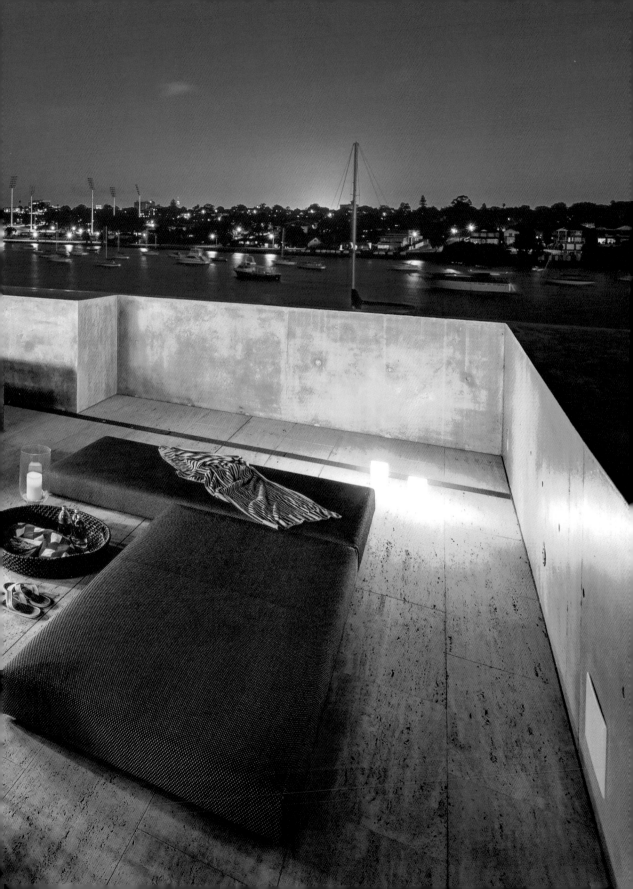

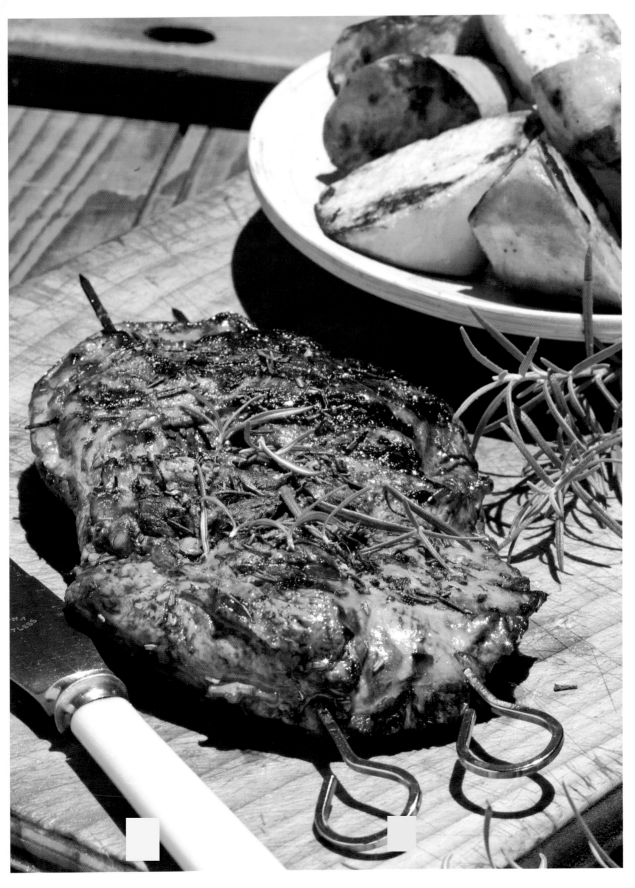

Leg of Lamb
with Rosemary Rub

INGREDIENTS

1½ kg (45½ oz) boneless
 leg of lamb, butterflied
125 g (4 oz/½ cup) fresh
 rosemary leaves,
 roughly chopped
1 tablespoon celery salt
½ teaspoon black pepper,
 freshly ground
½ teaspoon coriander
 powder
½ teaspoon mild Indian
 curry powder
2 tablespoons olive oil

Serves 4

METHOD

» Lay the leg of lamb out as flat as possible and ensure that the meat has an even thickness. This can be difficult as the muscle structure varies – you may have to slice the meat to flatten it. Skewer into place to maintain a flat appearance.

» Mix the rosemary, salt, pepper, coriander and curry powder together. With your fingers, sprinkle/spread half the rub ingredients over the cut side of the lamb and then massage it in.

» Put the leg of lamb onto a medium-hot barbecue grill cut-side down. Cook for five minutes.

» Lightly brush the skin side of the lamb with oil and turn the leg over to cook for 10–15 minutes with the hood down (if your barbecue has one).

» Brush the partially cooked cut side with a little oil and sprinkle over the remaining rub. Turn the meat over again, drop the hood, and leave to cook on the skin side for 10 minutes.

» Turn the leg one more time to the open flesh side and cook for a further 10–15 minutes with the hood down. Remove from the barbecue and let rest for five minutes.

» Slice the meat and serve with salads or vegetables of your choice.

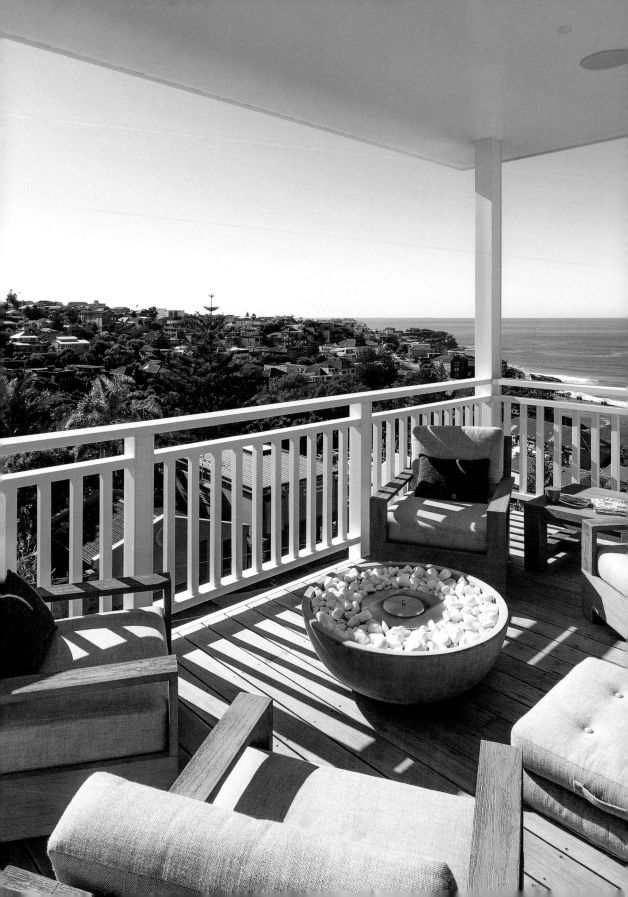

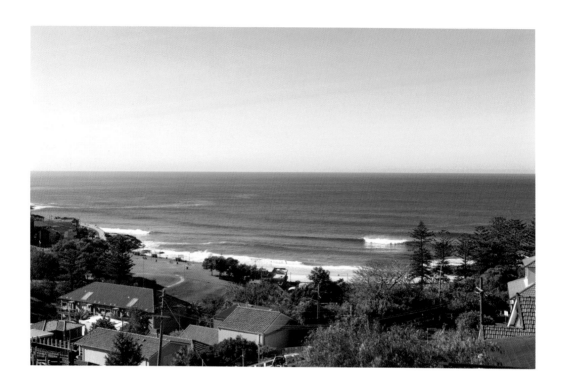

BRONTE HOUSE, Sydney, Australia

With sweeping ocean views over Sydney's Bronte Beach and north to Bondi's Ben Buckler headland, at the right time of year this stunning three-level, four bedroom, four bathroom home has a front row seat for the annual humpback whale migration.

Inspired by the owner's time spent living in the Hamptons, New York and London, architect, Richard Briggs, combined the owner's design aesthetic alongside beachside living practicality.

The top floor living area overlooks the breathtaking view with the kitchen and dining area opening up to the long, deep balcony with built-in bar top, perfect for resting your favorite tipple after a long day.

Banquette seating runs along under the long bank of windows whilst the lounge area at the other end of the room, opens up to a large, covered deck that looks over the pool and out to sea.

On the entry level, there are three bedrooms, all with custom joinery while the north-facing master bedroom's sliding doors open up to a balcony with beach views.

Luxury details such as bespoke joinery, solid timber tongue-and-groove paneling, vaulted ceilings, stone fireplace, American Oak floors, custom kitchen and an outside shower to rinse off the sand and salt from your dip in the ocean all come together to provide the ultimate in sophisticated but relaxed coastal living.

OPPOSITE PAGE: Watch the whales go by as you take your morning coffee on the long, deep balcony.
ABOVE: Sweeping ocean views over Sydney's Bronte Beach and north to Bondi's Ben Buckler headland.

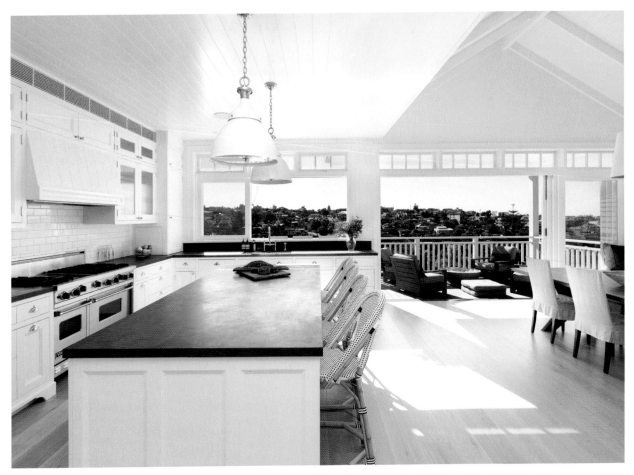

ABOVE: Inspired by time spent living in the Hamptons, New York and London, architect Richard Briggs combined the owner's design aesthetic alongside beachside living practicality.

RIGHT: Bespoke joinery design by James Lee-Warner Furniture brought the owner's Hamptons dreams alive with hand painted custom joinery. The real heart of the house is this top floor living space, a favorite of the owner.

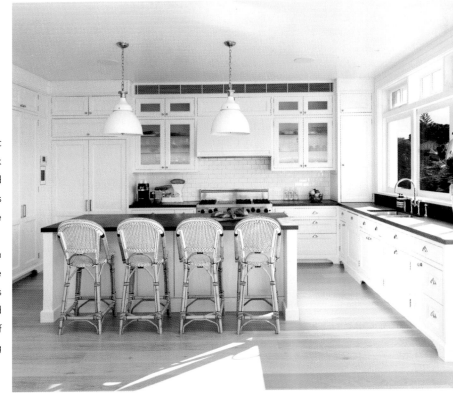

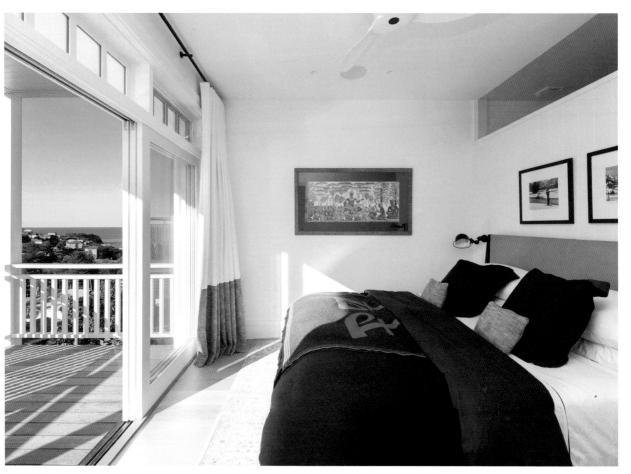

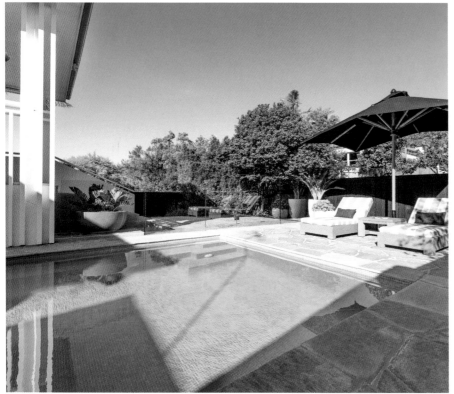

ABOVE: Three bedrooms are located on the entry level, all with custom built-in wardrobes by James Lee-Warner Furniture. The north-facing master bedroom has tall sliding doors opening onto a wide balcony with views over the beach and Bronte gully.

LEFT: A covered deck with sea views also looks over the pool and the grassy backyard with its putting green and basketball hoop.

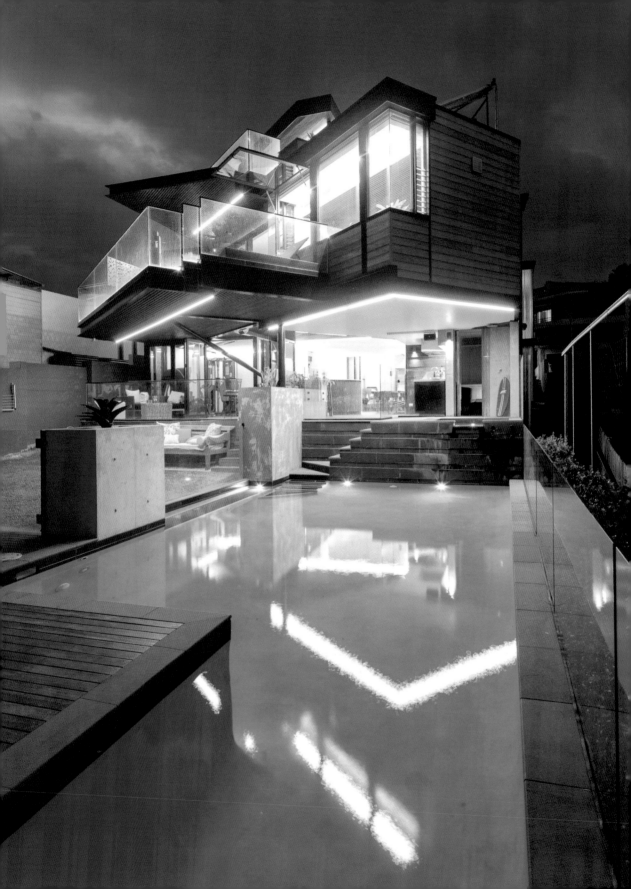

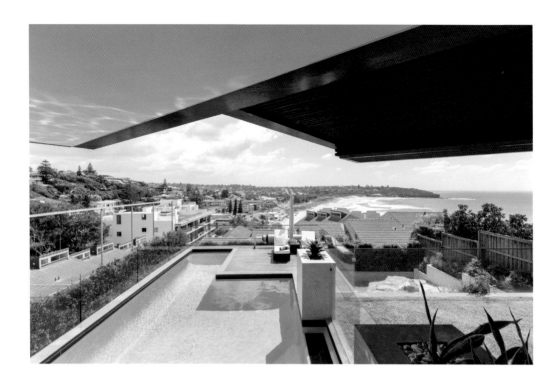

FRESHWATER HOUSE, Sydney, Australia

Perched high on the cliff above Freshwater on Sydney's northern beaches, Freshwater House is a harmonious design with the seaside landscape that celebrates its spectacular location with contemporary architecture uniquely crafted for a young family. It's functional, versatile and filled with light and endless views.

The masterfully engineered three split-level construction spans 520 square meters (622 square yards) and yet remains home-like and comfortable whilst optimizing all that is Freshwater.

Standing within the house, you literally feel you're within the landscape. Set into the escarpment, the design utilizes its layers to create space delineation and zoning across the split levels. The sun, breeze and light have all influenced the project.

The home features five bedrooms, three ensuites, two bathrooms with separate WC, children's playroom, lounge, dining and substantial kitchen. Then there's the cocktail bar, games room, three-car garage, pool, spa, sauna, theatre room, gymnasium, study and 17 square meter (20 square yard) walk-in master wardrobe.

The indoor spaces all lead seamlessly outdoors, taking advantage of the two-hundred-degree ocean views.

OPPOSITE PAGE: Architect Poune Parsanejad: "Every design decision, angle and framing utilizes the magic surrounding the house. The views, light, breezes and framing out neighbors' properties, all command focus upon the sand, waves, sun rise and set and evening light display."

ABOVE: Perched high on the escarpment above Freshwater Beach, the home's swimming pool is in harmony with the seaside view.

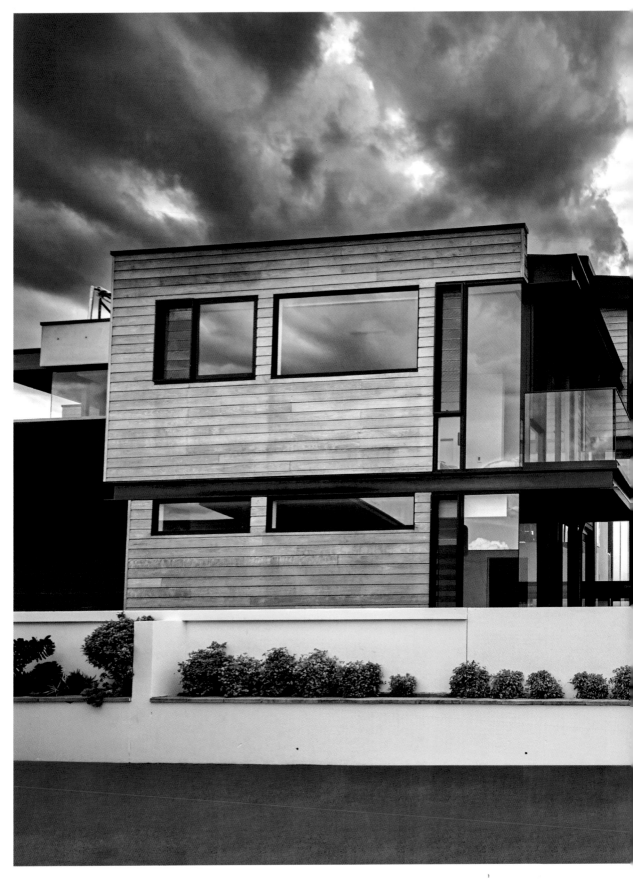

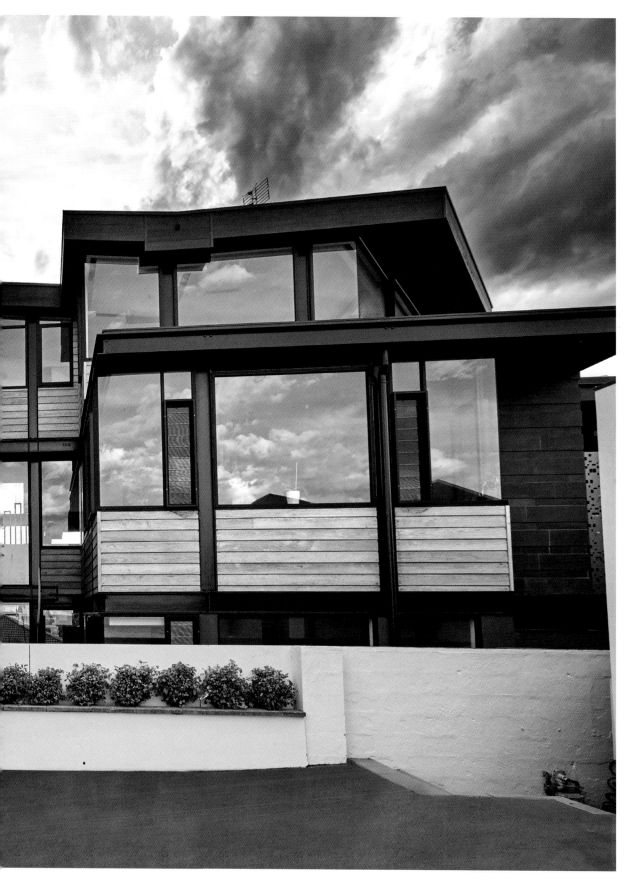

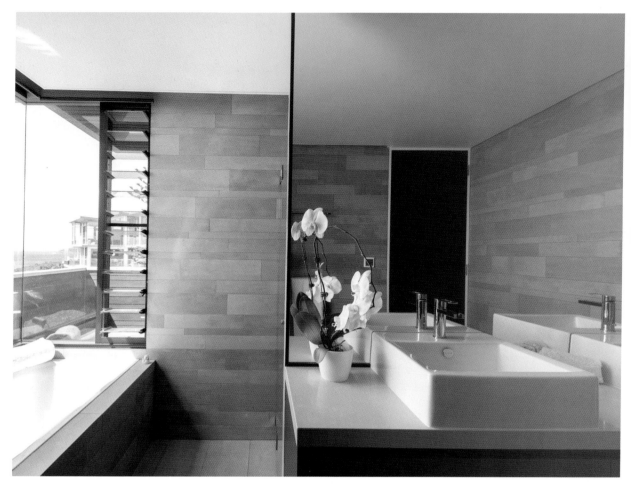

PREVIOUS SPREAD: Freshwater House is in harmony with the seaside landscape, celebrating its location with a bold statement of contemporary architecture and structure.

ABOVE: The muted grey of the bathroom is harmonious with the residence's surrounds.

RIGHT: Anyone for beach cricket?

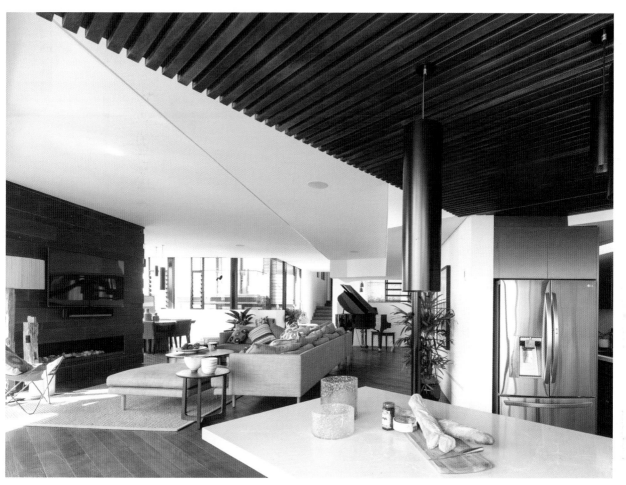

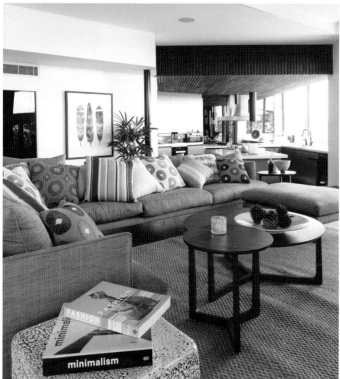

ABOVE: The three split-level construction boasts five bedrooms, three en suites, two bathrooms, kids playroom lounge, dining and generous kitchen.

LEFT: The indoor living spaces include an open plan kitchen.

OVERLEAF: The main bedroom has sweeping views of the district, Freshwater Beach and the Pacific Ocean.

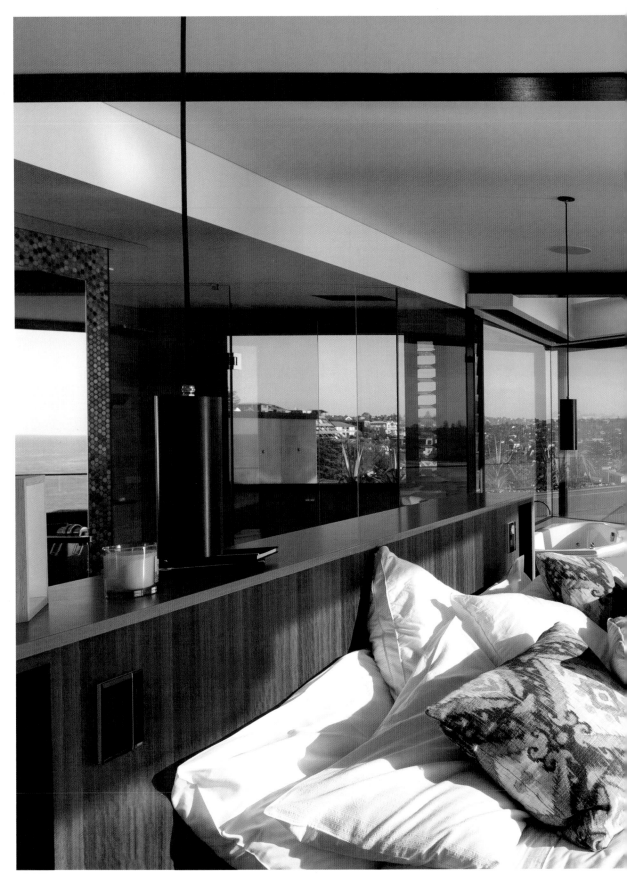

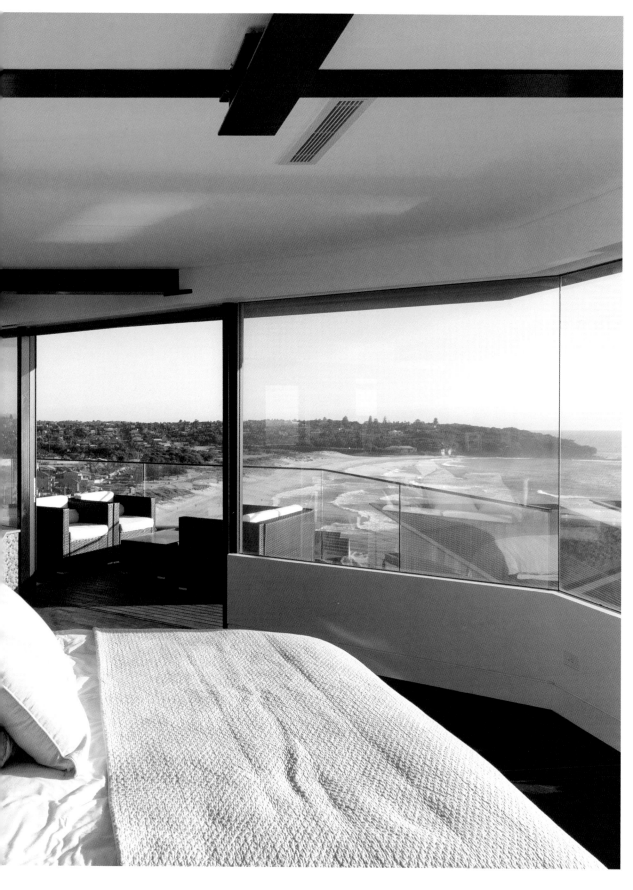

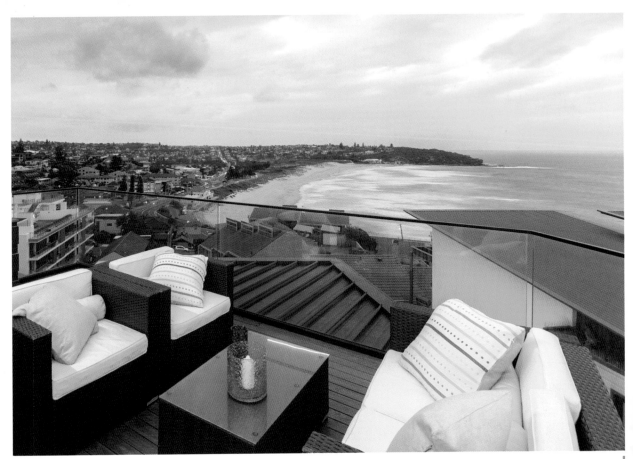

ABOVE: The deck has a majestic view north over Freshwater Beach.

RIGHT: Every detail, down to lighting in the stairwell, was carefully considered.

OPPOSITE PAGE: The versatile deck area is perfect for gathering family for a Sunday brunch or for impromptu social gatherings with friends.

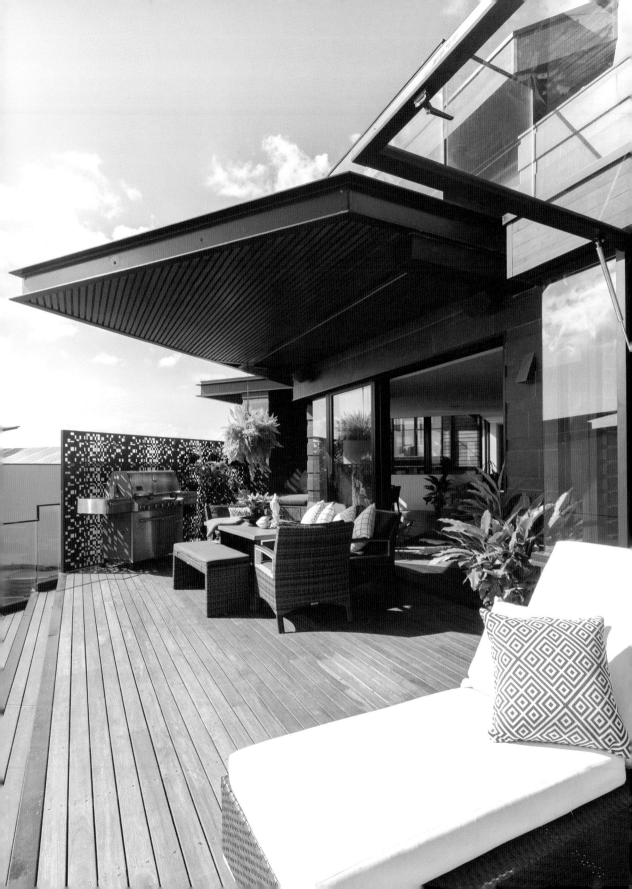

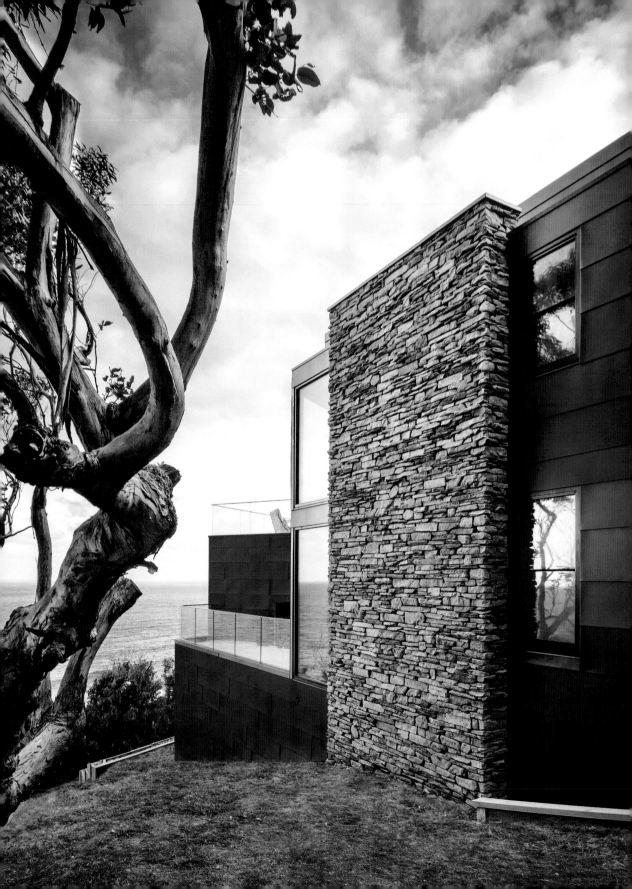

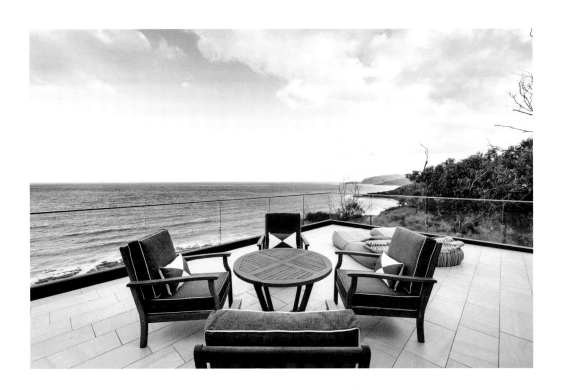

SEA RANCH, Mornington Peninsula, Australia

Although not a registered architect, developer and builder, Daryl Turnbull, has designed and constructed enough high-end residences in the southern suburbs of Melbourne to know what he wanted for his design on the stunning coast of the Mornington Peninsula in Victoria.

Sea Ranch's design vision was to construct a visually stimulating monolithic structure with the use of Anthra black VM Zinc sheeting nestling into the coastal hillside on a stone base.

Although the use of the zinc was intentionally dominant, the selection of the flat lock panel system, which is quite textured and organic, adds interest and helps to soften the building. The use of natural materials and a natural color palette allow it to blend seamlessly into the bush surround.

The result set a new benchmark for architecture and luxury in Wye River. The sophisticated open plan design embraces the light and showcases every aspect of the almost unbelievable view. The breathtaking four bedroom home offers views of the ocean, beach and windswept coastline.

Set a mere 50 meters (55 yards) above the crashing sea below, the sights and sounds of the ocean take care of any worries or stress levels before you nestle in beside a roaring fire in the living area.

OPPOSITE PAGE: A visually stimulating monolithic structure with the use of Anthra black VM Zinc sheeting nestling into the coastal hillside on a stone base.

ABOVE: With the crashing sea below, the terrace is a breathtaking and bracing spot to take in the rugged coastline and water views.

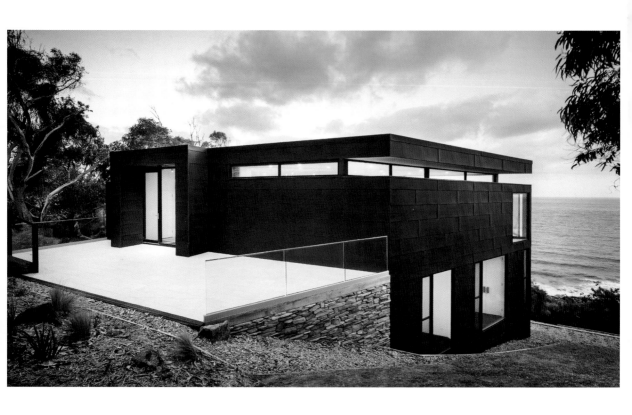

ABOVE AND OVERLEAF: Sea Ranch offers a wondrous nature experience. All manner of Australian fauna have made themselves at home in the surrounding trees including koalas, king parrots, rosellas, cockatoos and kookaburras. Echidnas also make an appearance regularly, meandering through the garden.

OPPOSITE PAGE: Luxurious master en suite with bath and stunning ocean view. Don't be surprised to see seals playing in the waves below or whales migrating.

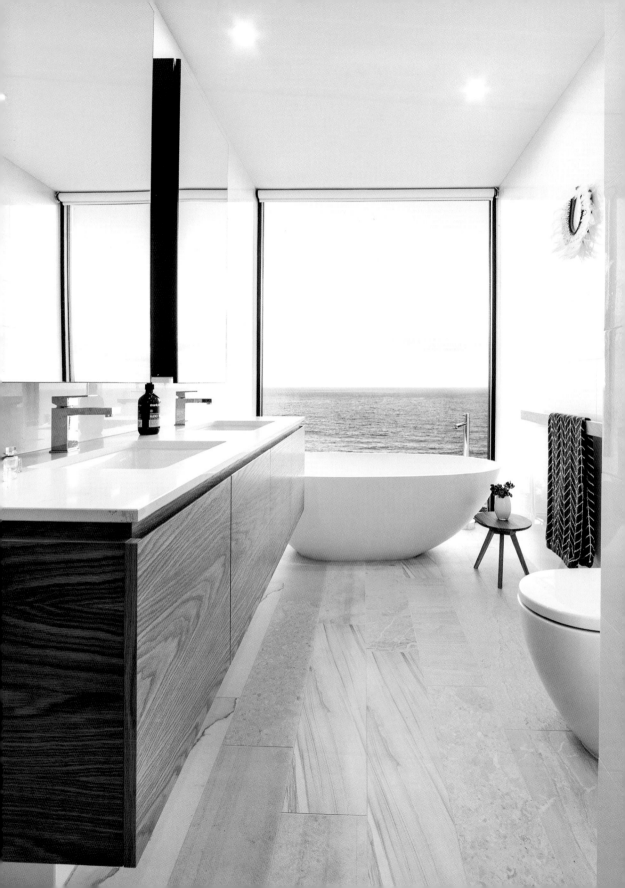

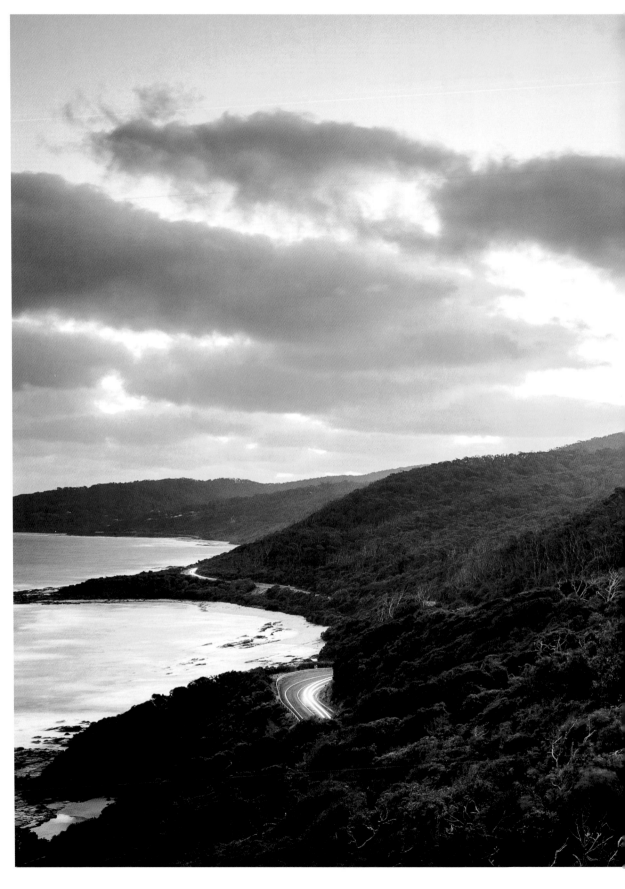

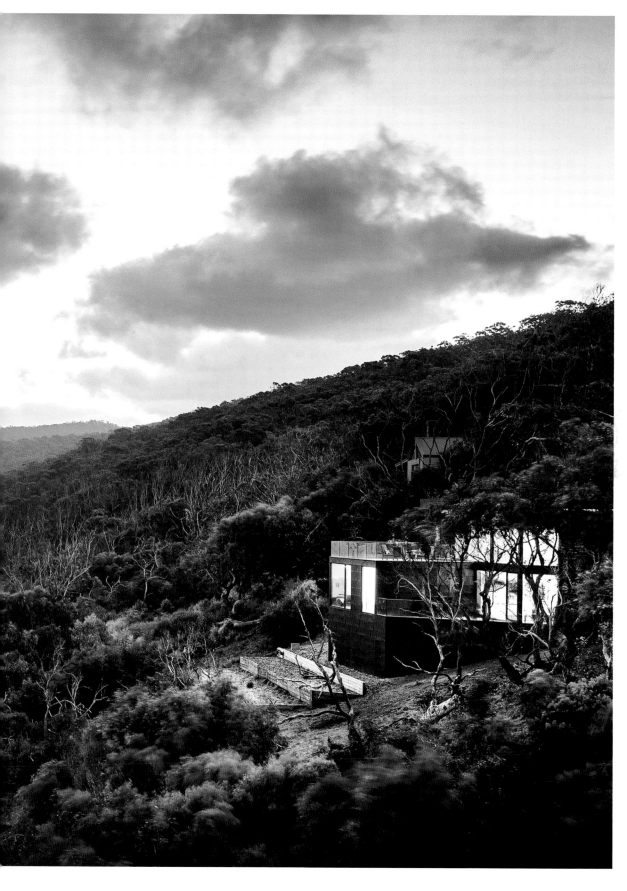

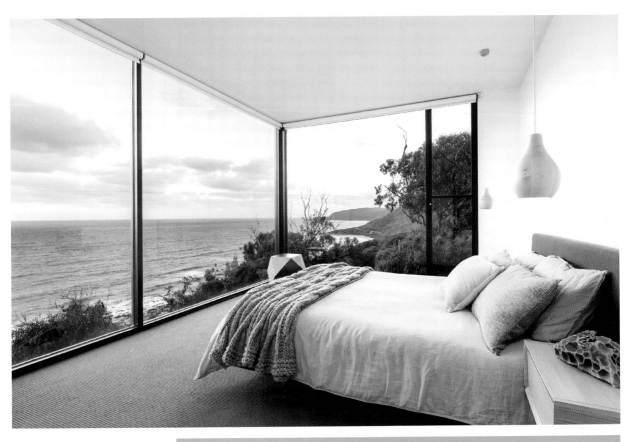

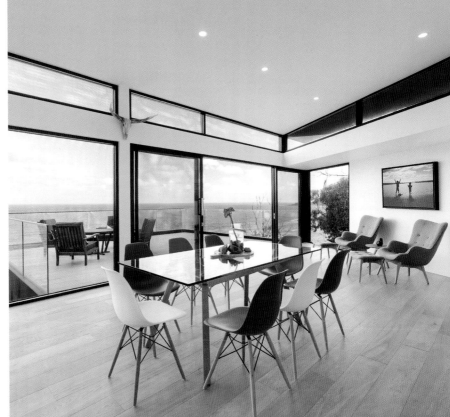

ABOVE: Lazing in one of the four bedrooms is easy with stunning views like this. Leave the blinds open in the evening and it feels like you're sleeping among the stars.

RIGHT: Lingering over a lovingly prepared meal is easy in this sophisticated open plan dining area.

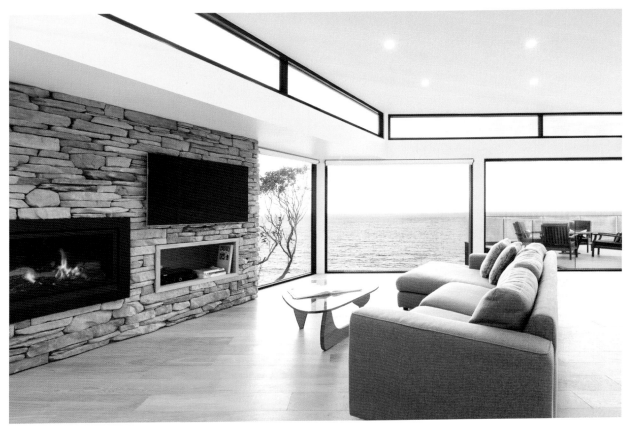

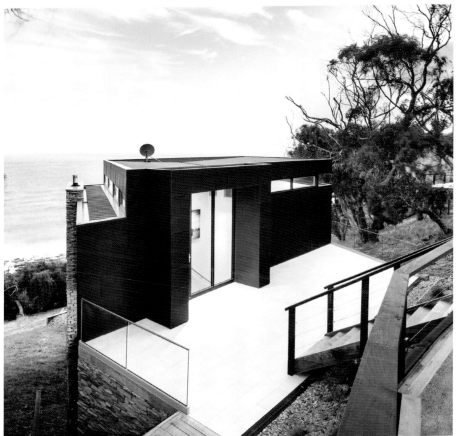

ABOVE: The floor to ceiling ocean-facing glass windows offer 180 degree beach views from Wye Point to Kennett River. A gas log fire keeps everyone cosy no matter what the weather outside.

LEFT: The entrance stairway that leads to sheer beauty.

OVERLEAF: The light filled open plan first floor invites you to relax and take all before you in. The outside terrace and floor-to-ceiling ocean facing glass provides 180 degree views from Wye Point to Kennett River.

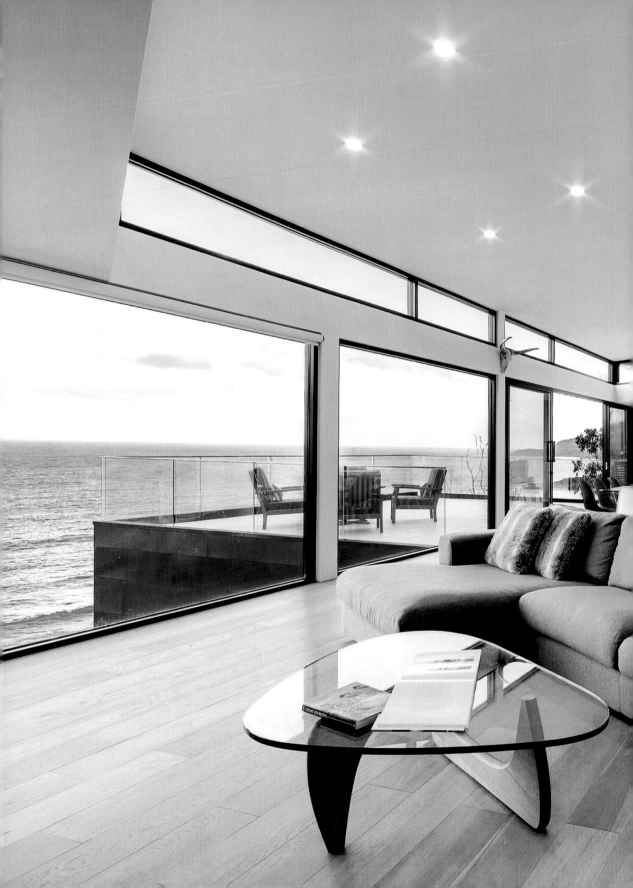

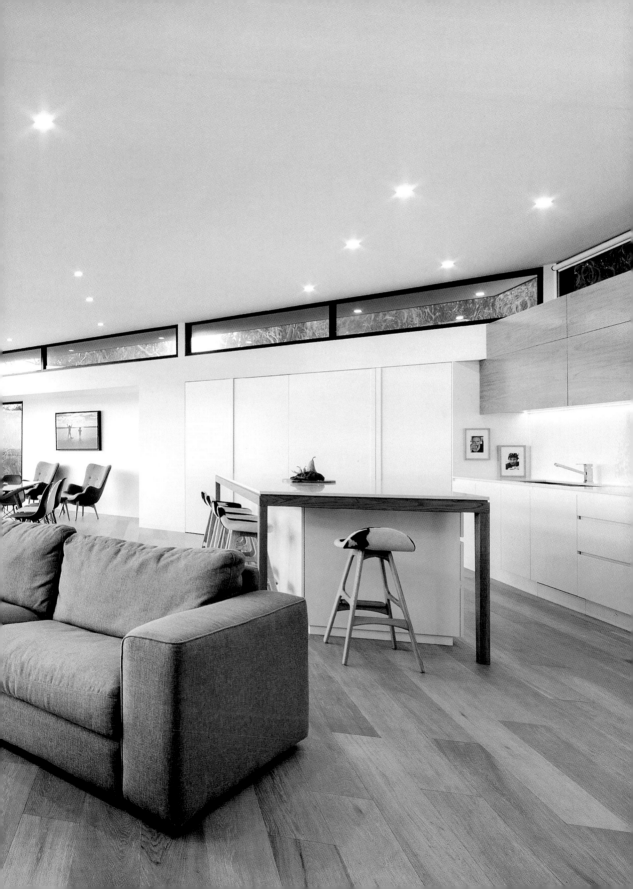

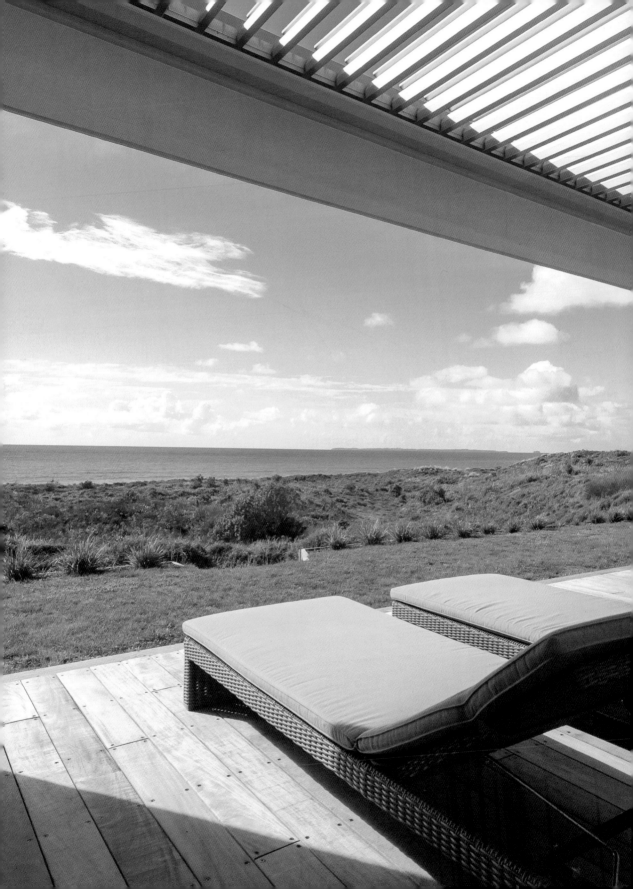

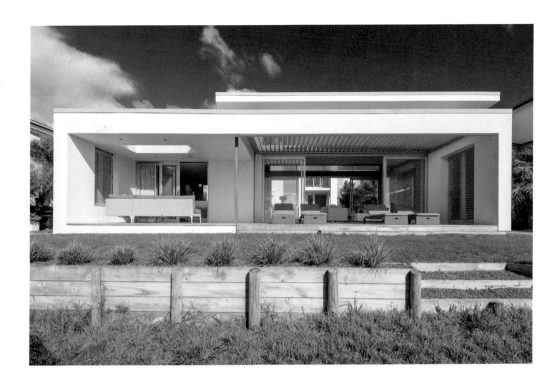

SEGEDIN HOUSE, Mt Maunganui, New Zealand

This comfortable yet elegant four bedroom beach house in Mt Maunganui, a town in the Bay of Plenty of New Zealand's North Island, was designed to connect the stunning outdoors with a simple, refined interior.

Designed by Eva Nash of Rogan Nash Architects in Auckland, the house is a collection of spaces, which allow the light to pour in whilst centering around the living areas and the generously proportioned fireplace.

Inviting yet sophisticated, this house works equally well as a family holiday retreat and a permanent residence.

The coastal location was inspiration for the house, conceived as two distinct pavilions separated by a glass walkway and a large sheltered courtyard. The front pavilion has over-sized glass sliding doors and allows for all the living and entertaining spaces. The rear pavilion is built of concrete block and contains four bedrooms and three and a half bathrooms. The courtyard design maximizes the sun and views while providing shelter from the coastal winds.

OPPOSITE PAGE: Located at Mt Maunganui on New Zealand's east coast, Segedin House was inspired by its coastal location.

ABOVE: Segedin House is both a permanent residence and a beach retreat.

225

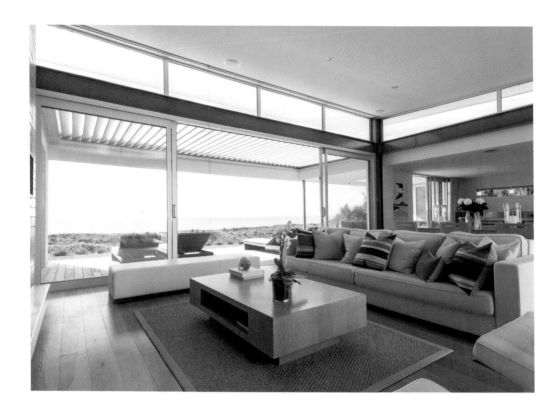

The house is oriented to make the most of the sun, to create warm light-filled living areas, minimizing the need for artificial lighting and heating. Louvres on the northern façade of the house allow for shading to the large areas of glass which avoids overheating.

Concrete block (both exposed and rendered) was used in the construction of the home as well as glass and steel.

The front pavilion is seaward-facing and uses large glass doors and exposed structural steel to create a light-filled open plan living area. Honed concrete block is used internally to act as a heat sink, as well as a visual anchor for the fireplace. The rear pavilion is private and solid built from concrete block which continues from exterior to interior.

The house, built for Eva Nash's mother in 2005, and modified in 2013, is a favorite project of the architect.

"I particularly like the exposed structural steel in the living room," says Eva. "The honesty of this material gives an aesthetic lightness to the space while providing visual interest."

OPPOSITE PAGE ABOVE: Architect Eva Nash says: "The house is oriented to make the most of the sun, to create warm, light-filled living areas, minimising the need for artificial lighting and heating."

OPPOSITE PAGE BELOW: A walkway and a large sheltered courtyard divide the two pavilions.

ABOVE: The front pavilion has over-sized glass sliding doors and allows for all the living and entertaining spaces to be bathed in natural light and take advantage of the seaside view.

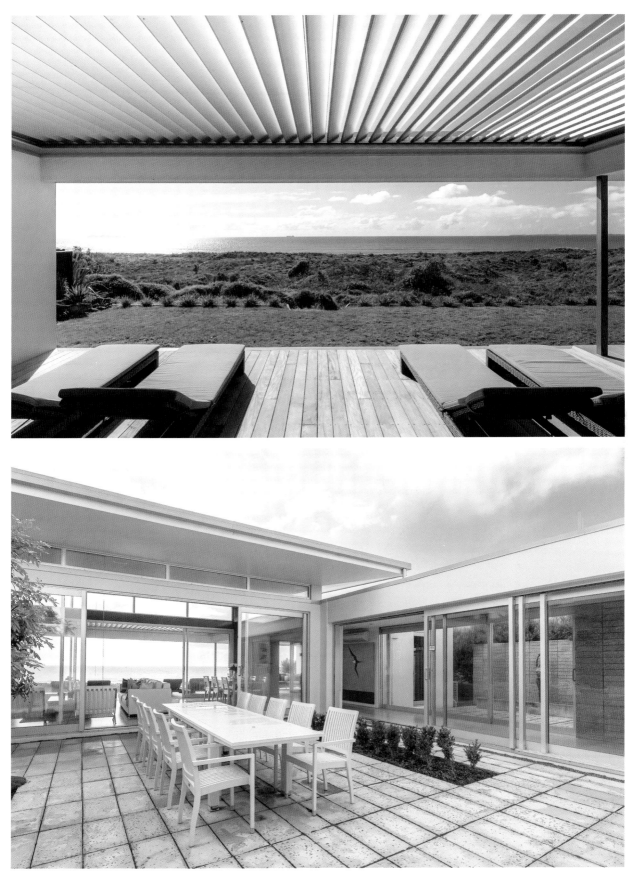

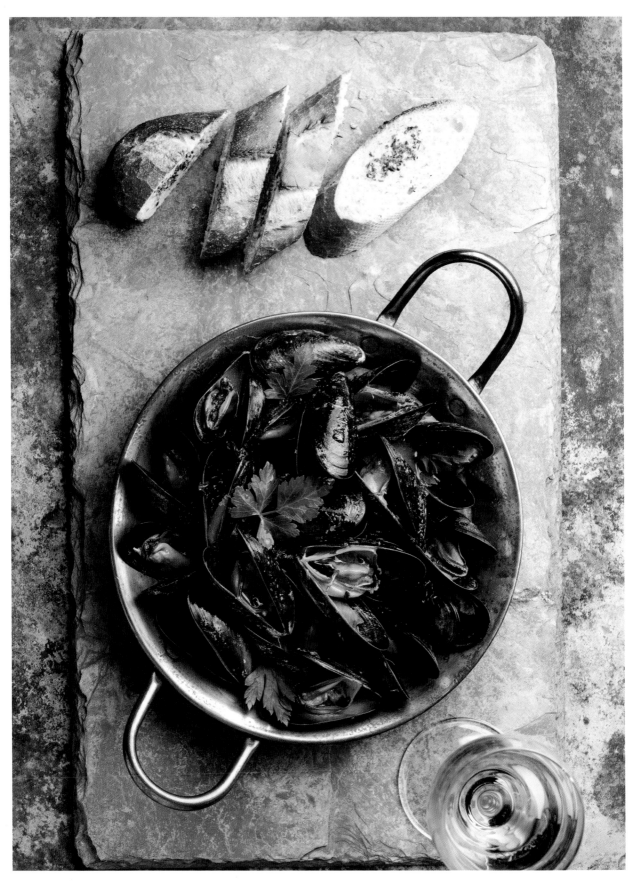

MUSSELS WITH GARLIC AND PARSLEY

INGREDIENTS

1½ kg (3 lb) fresh mussels (green or black), scrubbed and debearded

250 ml (8 fl oz/1 cup) white wine

10 tablespoons butter

6 tablespoons spring onions (scallions), finely chopped

6 large garlic cloves, minced

4 tablespoons fresh parsley, chopped

2 tablespoons fresh lemon juice

1 teaspoon grated lemon rind

METHOD

» Add white wine to a heavy large Dutch oven and bring to the boil. Add the mussels, cover and cook over high heat until mussels open, shaking pan occasionally, about 5 minutes. Drain mussels, reserving the liquid. Transfer mussels to bowl; discard any that do not open. Cover bowl with foil.

» Melt butter in same Dutch oven over medium-high heat. Add spring onions and garlic and sauté until tender, about 3 minutes. Add 3 tablespoons of the parsley, lemon juice, lemon rind and reserved liquid from mussels and bring to boil. Season to taste with pepper. Drizzle garlic butter over mussels. Sprinkle with the remaining parsley and serve.

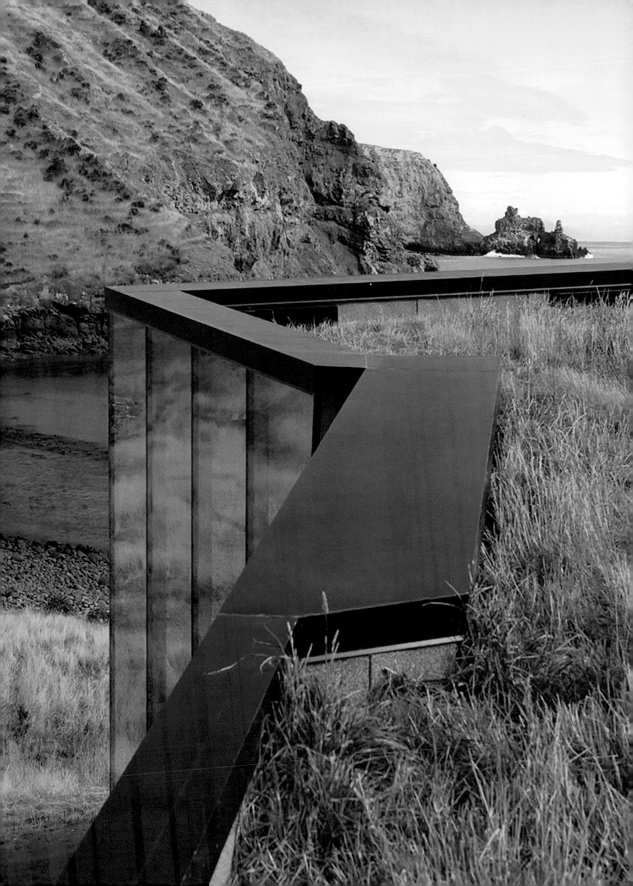

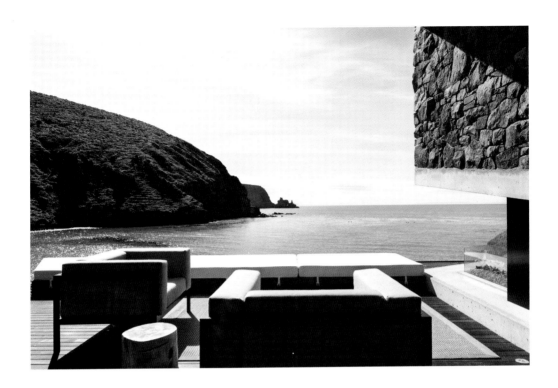

SEASCAPE RETREAT, Pigeon Bay, New Zealand

The ultimate romantic escape, Seascape Retreat is a stunning beachside cottage, conceived and designed by Auckland architect, Andrew Patterson of Patterson Associates.

Accessible only by helicopter or 4-wheel-drive vehicle, this award-winning home is set into a rock escarpment in a tiny boulder strewn South Pacific cove on New Zealand's South Island.

With the snowcapped Southern Alps to the west and the Pacific Ocean on your doorstep, the Canterbury region is approximately an hour south of Christchurch. The retreat consists of just three rooms — a lobby, living/sleeping area and bathroom. The open plan includes a main living area, with split-level separation between the bedroom area, with glass walls overlooking the ocean.

OPPOSITE PAGE: Designed by architect Andrew Patterson, the home is constructed of quarried stone, steel, glass with a poured concrete floor and an earth turfed roof.

ABOVE AND PAGES 212–213: The remote, secluded location along the Banks Peninsula of New Zealand's South Island in only accessible for helicopter or four-wheel drive.

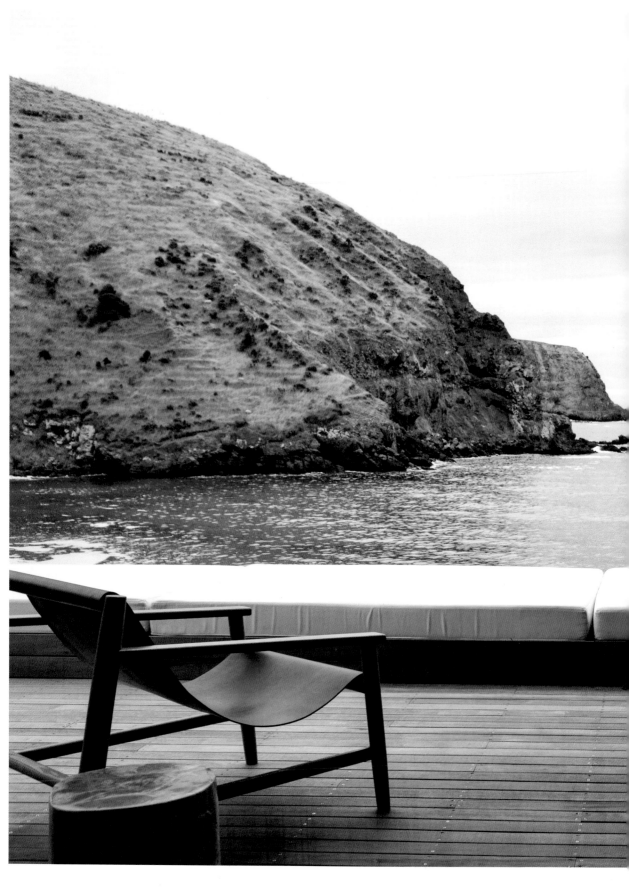

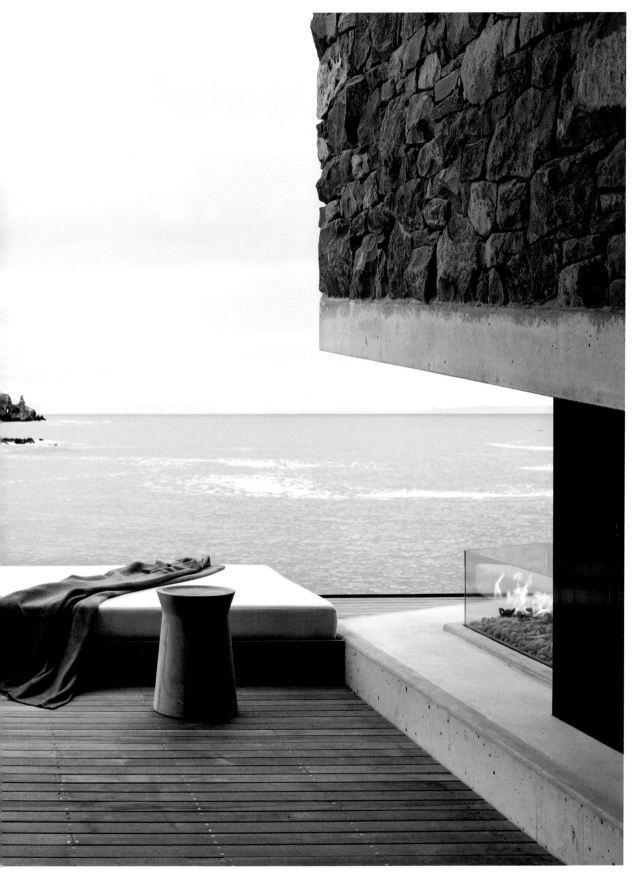

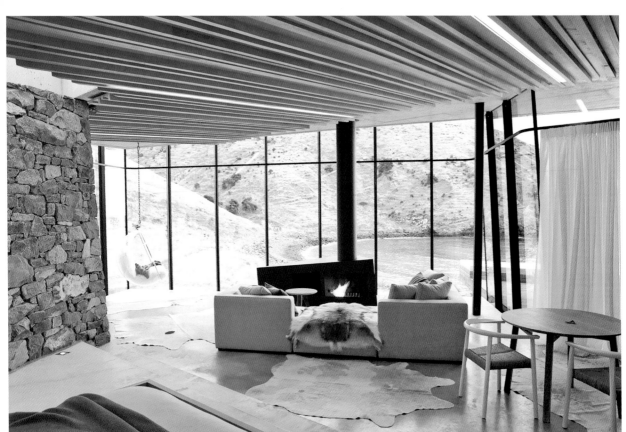

ABOVE: It doesn't get more romantic than lounging in front of the fire on an animal hide.

RIGHT: The open plan layout includes the main living area with a split level separation between the bedroom area with glass walls overlooking the coast.

OPPOSITE PAGE ABOVE: The bedroom area overlooks the open plan layout of the main living area.

OPPOSITE PAGE BELOW LEFT: The dramatic rock, concrete and sleek modernism are softened by soft, neutral furnishings.

OPPOSITE PAGE BELOW RIGHT: The suspended Eero Aarnio Bubble chair is the perfect spot to take in the restful beauty of the location.

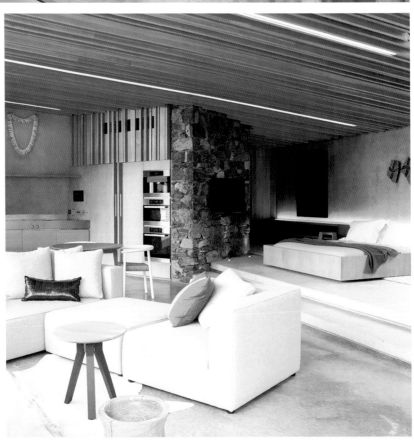

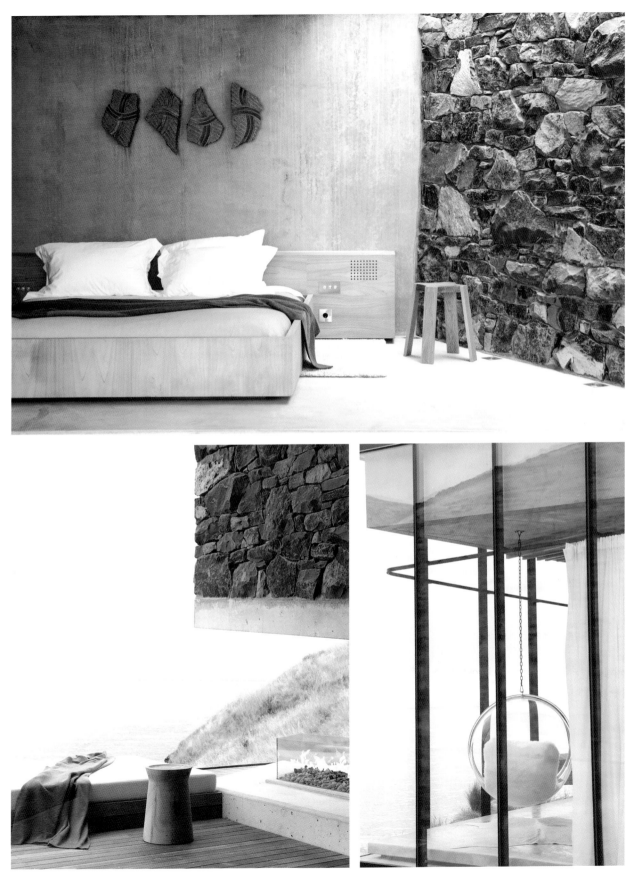

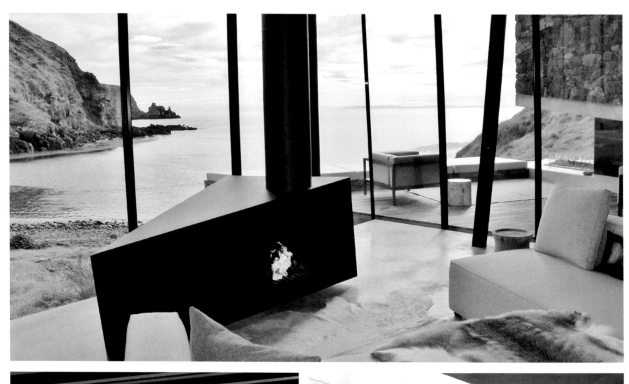

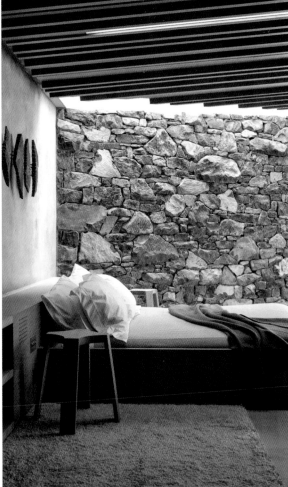

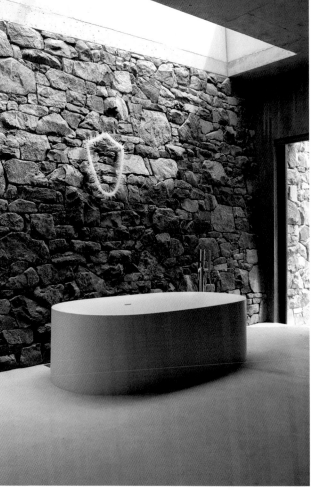

A modern, sleek kitchen is off to the side whilst the cave-like bathroom at the back, with its deep free-standing tub with view out to the terrace, also takes in the breathtaking view of this area known for its vast territory of grassy surrounds, sparkling lakes and snow-capped mountains.

Constructed using local materials, largely using rock quarried nearby, steel, glass, in-situ poured concrete floors and an earth turfed roof, the structure is seamlessly integrated into the escarpment above to protect occupants from falling debris.

The cottage is self-sustainable – it has on-site water harvesting and a wastewater treatment system.

The overall plan is an interlocking geometry responding to both near views of the bay and far views out to rocky spires. The house is lined with horizontal macrocarpa wood (macrocarpa is a Californian cypress tree with a large spreading crown of horizontal branches and leaves that smell of lemon when crushed). This timber forms integrated joinery, wall and ceiling panels behind double glazed low e-glass in storm and shatter proof steel mullions which utilize earthquake resistant sliding heads. Such features are essential given Christchurch (also on New Zealand's southern island) has been struck by two large earthquakes in recent times.

The dramatic rock, concrete and sleek design is softened with soft neutral textiles, animal hides and contemporary furnishings that include the suspended Eero Aarnio Bubble chair – the perfect spot for reading, taking in the view or relaxing in front of the fire with a glass of wine. The outdoor lounge area with fireplace and spa pool complete the romantic dream. Simply add Champagne.

OPPOSITE PAGE ABOVE: Lounge in front of the fire taking in the breathtaking views.

OPPOSITE PAGE BELOW LEFT: Soft, neutral textiles soften the dramatic, sleek modern design of the bedroom.

OPPOSITE PAGE BELOW RIGHT: The cave-like bathroom features a deep, free-standing tub with a view out to the terrace.

OVERLEAF: The interlocking geometric design corresponds to both views of the bay and distant views out to Rocky Spire appearing as if you are floating on the open sea.

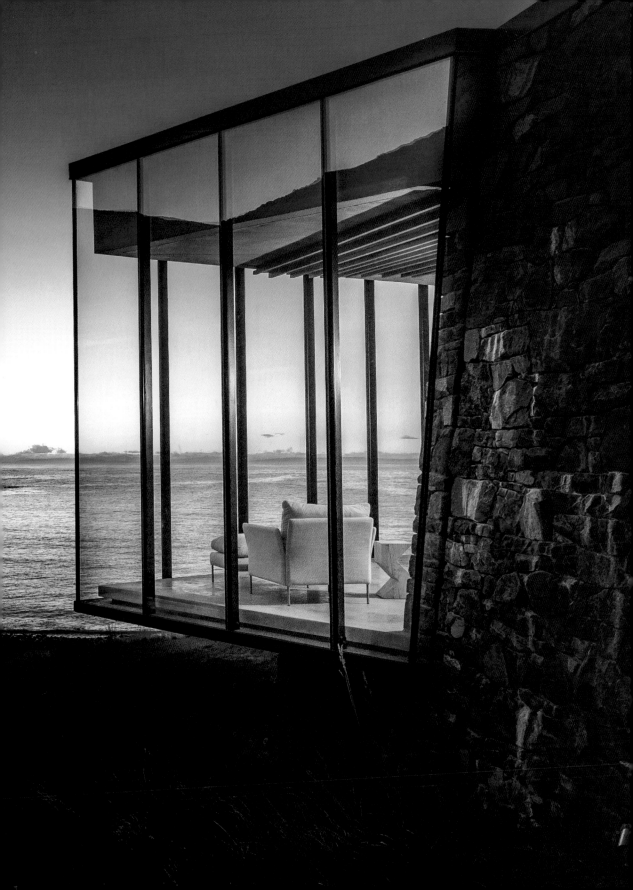

FRIED WHITEBAIT

INGREDIENTS

500 g (17½ oz) fresh
 whitebait
sea salt, crushed
plain (all purpose) flour,
 for coating
olive oil, for frying
lemon wedges, to serve
fresh bread and butter,
 to serve

Serves 4

METHOD

» Rinse whitebait and drain well, then dry with
 absorbent paper.
» Toss lightly in flour and place in a wire basket. Fry in
 deep, hot oil. Drain well.
» Reheat oil and fry whitebait again, until very crisp.
 Drain on absorbent paper again, then sprinkle with
 rock salt and serve with lemon and bread and butter.

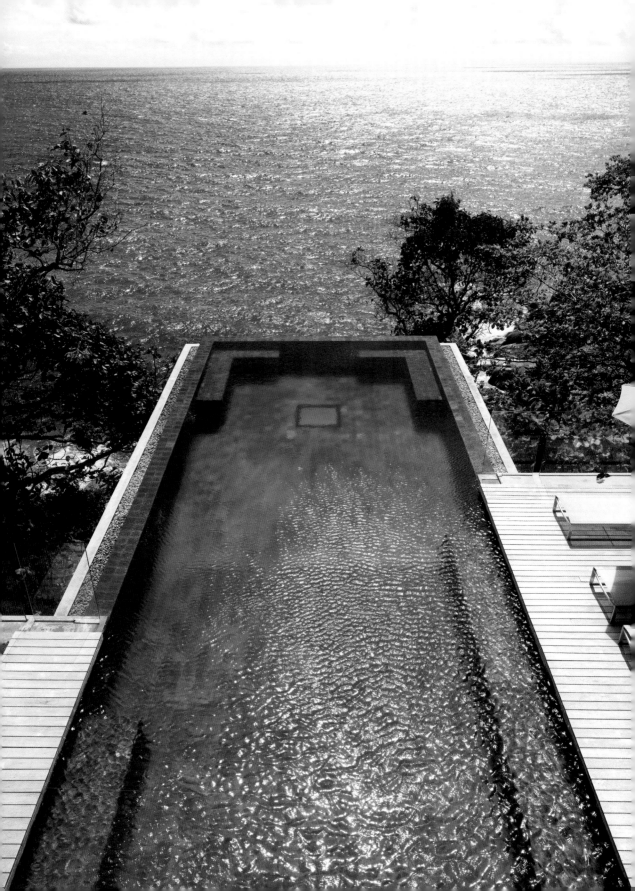

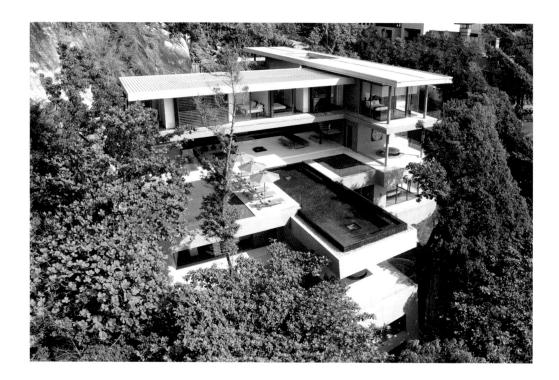

AMANZI KAMALA, Phuket, Thailand

Nestled in a cascading, west facing ravine in a secluded spot along Cape Amarin on the west coast of Phuket is Amanzi Kamala. With stunning views over the azure blue Andaman Sea, it's easy to see why the exclusive area, where Amanzi Kamala sits, is known as Millionaire's Mile.

Set in a densely forested cliff above the water's edge, Original Vision architects' principal defining element is the rock.

OPPOSITE PAGE: The stunning glass-bottomed pool which juts out to the horizon is the focal point of this waterfront house.

ABOVE: Laid out over three intersecting levels, the main floor with its open plan living and large folding glass panelled walls blur the lines between indoors and outdoors.

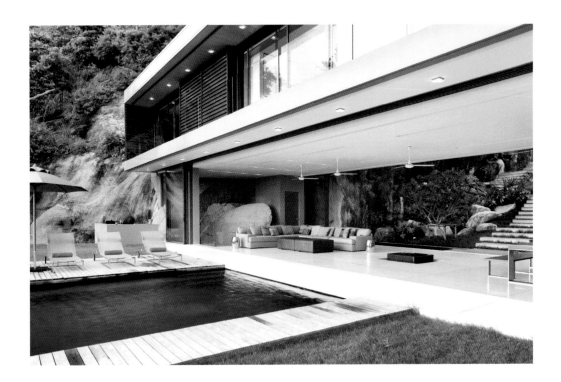

The architect's commission to do this demanding, but ultimately spectacular, site justice was both daunting and exciting.

The focal point of this ultra modern 2,644 square meter (3,162 square yard) design, laid out over three traversing levels, is the cantilevered glass bottomed swimming pool, drawing the eye to the stunning view.

The main floor comprises spacious open plan living areas, with the granite rock face defining one edge, and large folding glass panelled walls that open the entire floor into an open-air pavilion overlooking the pool and ocean. The entire home appears to grow out from the rock and extends through the living areas, the upper terraces and down the steep jungle path to the secluded shale beach below.

Above the main floor is the main bedroom which is level with the master suite and three other bedrooms all with bathrooms, each with impressive, continuous ocean views. Sliding doors can be opened to allow ocean breezes to cool the spaces.

Below the main floor are two more bedrooms with bathrooms, a large games and family room and private spa. Access to steps leading to rock pools and the ocean below is from this level.

The property is dramatically proportioned overall, adapting to its environment with outdoors and indoors becoming one integrated space. The living spaces are enhanced by the lush, tropical private gardens that have been planted over two levels.

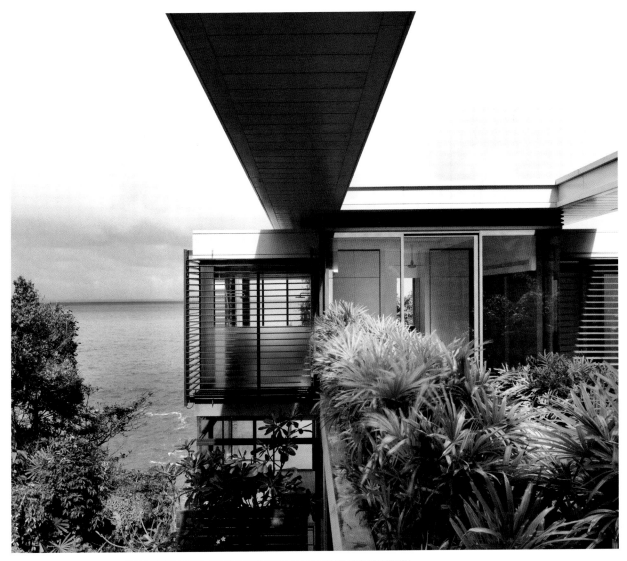

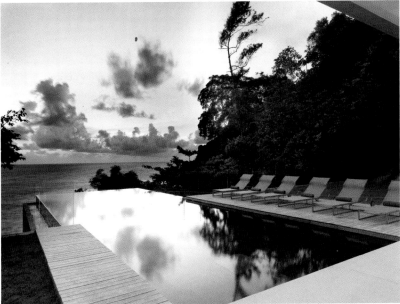

OPPOSITE PAGE: A simple but dramatic version of luxury and sharp architectural design highlights the beauty of the surrounds.

ABOVE: Glass louvered windows take full advantage of the cooling sea breezes.

LEFT: The cantilevered infinity pool is a main feature of the design.

FOLLOWING SPREAD LEFT: The rock is the focal point throughout and extends from the pool area, through the living areas and to the upper terraces.

FOLLOWING SPREAD RIGHT: Floor to ceiling glass sliding walls add to the dramatic open plan living areas.

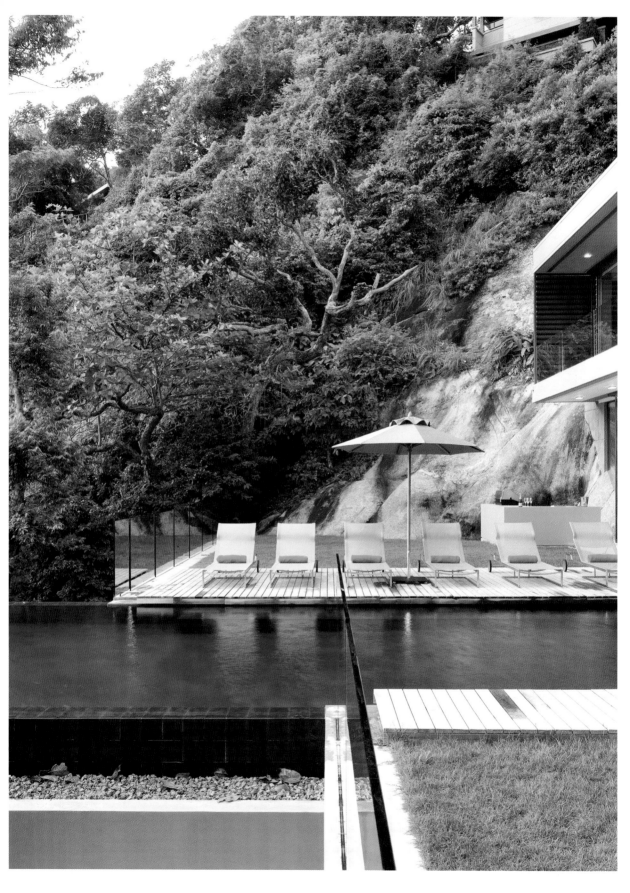

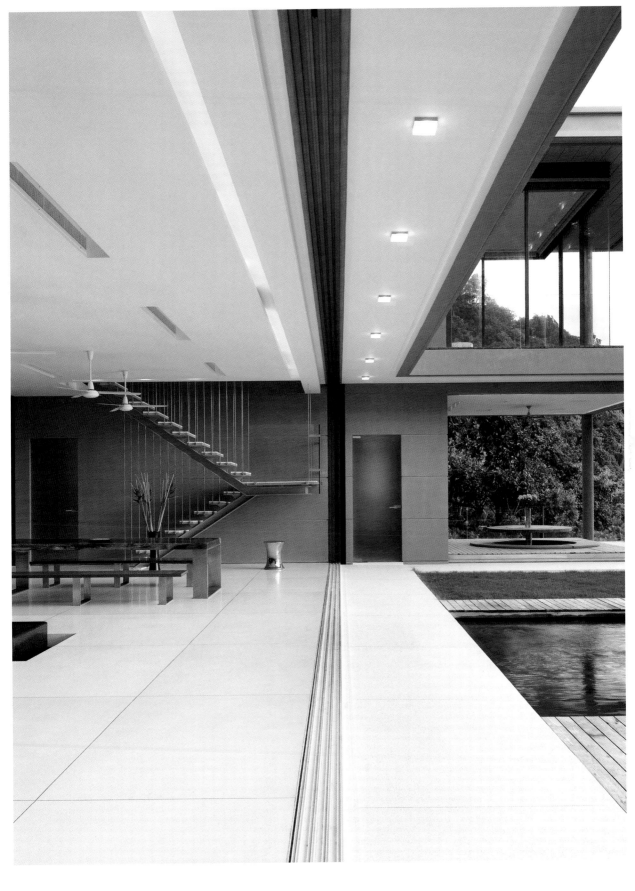

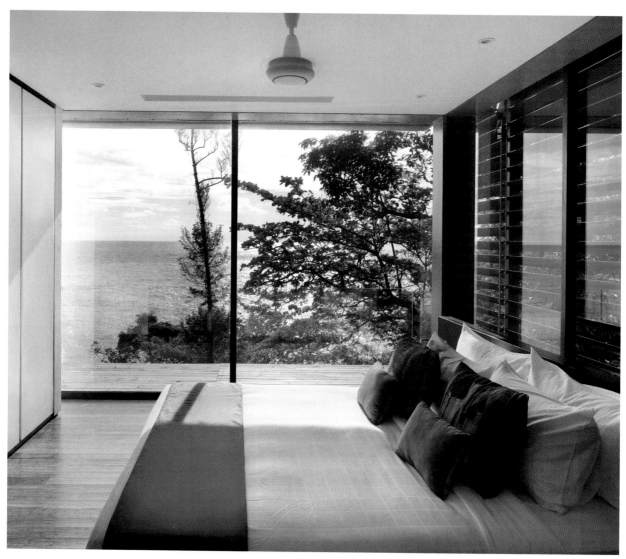

ABOVE: One of the six bedrooms with en suite bathrooms. No need to get out of bed to take in the view.

RIGHT: Louvers in the bathroom for privacy if needed or leave open so no obstruction to the view.

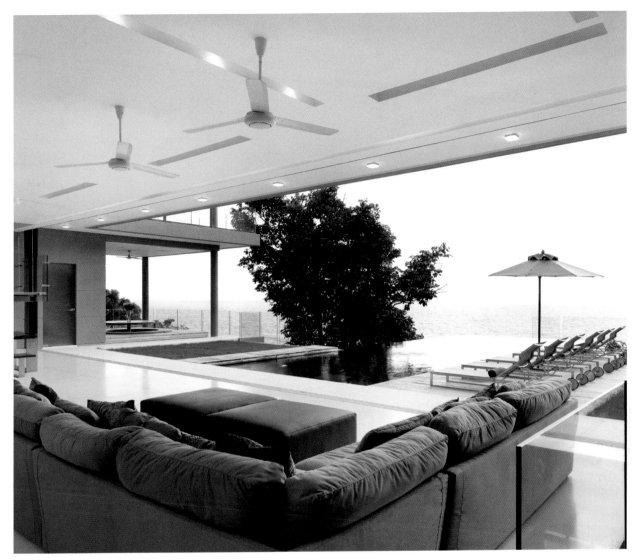

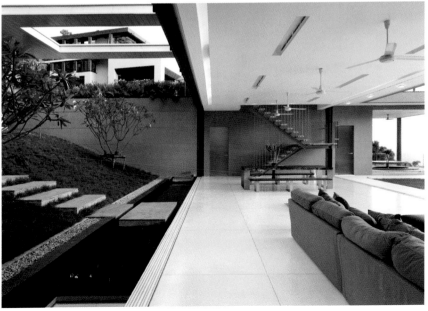

ABOVE: The open plan living area with oversize sofa and dining area is designed for relaxation and comfort.

LEFT: The entire floor of living area is an open air pavilion.

SHRIMP AND RICE NOODLES THAI STYLE

INGREDIENTS

450 g (15½ oz) flat rice
 noodles
150 g (5 oz) green prawns
 (shrimp) peeled
1 clove garlic, finely diced
2 spring onions (scallions),
 sliced
100 g (3½ oz) red or
 orange capsicum (bell
 peppers), thinly sliced
1 teaspoon vegetable oil
1 tablespoon fish sauce
juice of 1 lime
1 teaspoon white wine
 vinegar
lime slices, to garnish

Serves 3–4

METHOD

» Put noodles in a heat proof bowl pour over boiling
 water and cover. Let stand for 5–7 minutes, then drain
 and toss in half the sesame oil and reserve.
» Heat the remaining oil in a hot wok, add the garlic,
 spring onion and capsicums. Stir fry for 1 minute then
 add the prawns. Cook for a further 2–3 minutes or until
 they are just about cook through.
» Add the cooked noodles, fish sauce, vinegar and lime
 juice to the wok and toss to combine and heat the
 noodles.
» Serve with lime slices.

Tip: Add fresh chilli or flakes if you like it spicy.

BAKED FISH
WITH SPICY SOY SAUCE

INGREDIENTS

1 kg (35 oz) whole snapper
2 teaspoons peanut oil
1 tablespoon lemon juice
pinch of salt
lemon slices
boiled rice, to serve

SAUCE

2 teaspoons peanut oil
2 garlic cloves, crushed
2 teaspoons root ginger,
 grated or crushed
1 small red chilli,
 deseeded and sliced
4 spring onions (scallions),
 sliced
2 tablespoon soy sauce
1 tablespoon kecap manis
 (sweet soy sauce)
125 ml (4 fl oz) water

Serves 4

METHOD

» Preheat the oven to 200°C (400°F).
» Make two diagonal cuts on each side of the fish, then brush with oil and lemon juice. Season with salt and place slices of lemon in the cavity of the fish. Wrap the fish in baking paper or aluminium foil and place on a baking sheet. Bake in preheated oven for 30–40 minutes or until cooked.
» To make the sauce, heat the oil in a small saucepan. Add the garlic, ginger, chilli and spring onions and cook for 1–2 minutes. Add the soy sauce, kecap manis and water and cook for 2–3 minutes.
» When the fish is cooked, transfer to a large serving dish and pour the sauce over. Serve with side bowls of boiled rice.

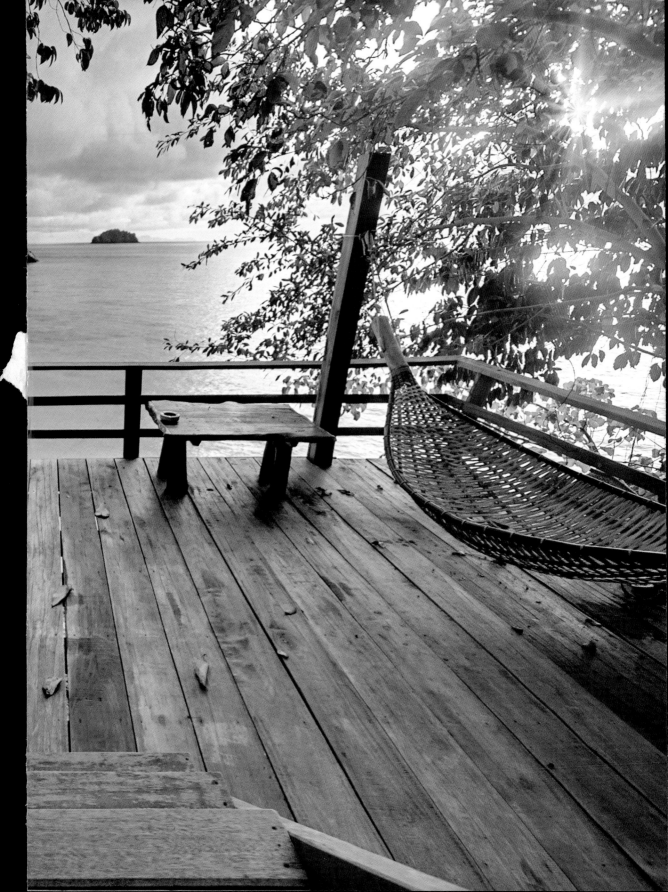

ACKNOWLEDGEMENTS

A special thanks to the individuals and companies who gave their time during the production of this book. It is possible to 'live the dream' with some of these Coastal Homes. The residences below can be leased through the following.

ALINGHI, Agnes Water, Queensland, Australia
 www.alinghi.com.au
BOUTIQUE HOMES
 www.boutique-homes.com
 Casa Altiplano, Jalisco, Mexico
 Tulum Villa, Yucatan, Mexico
 Casa Kalika, Punta Mita, Mexico
 Dezanove House, Galicia, Spain
 Elia Villa, Mykonos, Greece
 The White House, Santa Teresa, Costa Rica
 Seascape Retreat, Pigeon Bay, Canterbury, New Zealand
 Seacabins, Island of Manshausen, Norway
 Amanzi Kamala, Cape Sol, Phuket

CASA KIMBALL, Dominican Republic
 www.casakimball.com
ROSEWOOD HOTELS
 www.rosewoodhotels.com/en/jumby-bay-antigua
 Frangipani, Jumby Bay, West Indies
 La Casa, Jumby Bay, West Indies
 Lazy Lizard, Jumby Bay, West Indies
 Mariposa, Jumby Bay, West Indies
 Oleander, Jumby Bay, West Indies
SEA RANCH, Mornington Peninsula, Victoria, Australia
 www.searanch.com.au
VILLA AZUL CELESTE, Puerto Vallarta, Mexico
 www.villaazulceleste.net

This edition published in 2018 by New Holland Publishers
First published in 2017 by New Holland Publishers Pty Ltd
London • Sydney • Auckland

131–151 Great Titchfield Street, London WIW 5BB, United Kingdom
1/66 Gibbes Street, Chatswood, NSW 2067, Australia
5/39 Woodside Ave, Northcote, Auckland 0627, New Zealand

newhollandpublishers.com

ISBN 9781921024900

Group Managing Director: Fiona Schultz
Project Editor: Susie Stevens
Designer: Andrew Davies
Cover design: Lorena Suzak
Proofreader: Sarah Menary
Production Director: James Mills-Hicks
Printer: Times Offset (M) Sdn Bhd, Malaysia

10 9 8 7 6 5 4 3 2 1

Keep up with New Holland Publishers on Facebook
www.facebook.com/NewHollandPublishers

RECIPE INDEX